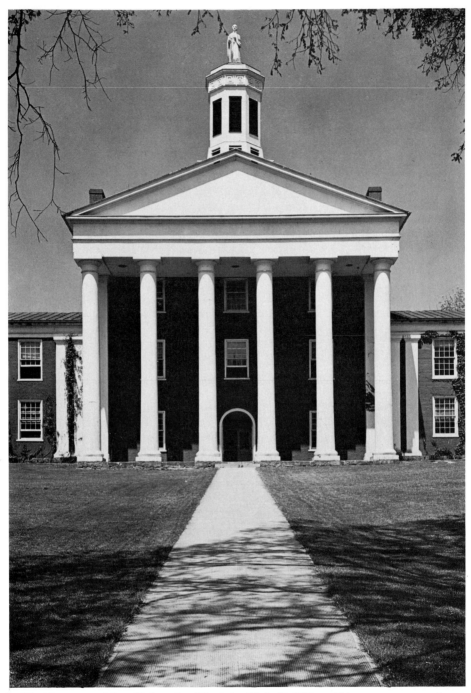

1. Washington and Lee University, Virginia, Main Building. This represents normal exposure and normal development of the negative. The brightnesses were placed on their appropriate zones, and the negative enlarges well on No. 2 Kodabromide. In this case an "average" reading indicated an exposure comparable to the "planned exposure" (page 29).

THE NEGATIVE
EXPOSURE AND DEVELOPMENT

ANSEL ADAMS

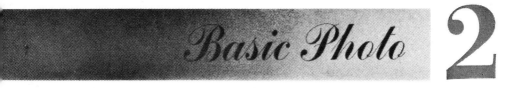

NEW YORK GRAPHIC SOCIETY • BOSTON

FOREWORD

The function of this series, *Basic Photo,* is to present a philosophy of technique and application. Every example and statement is set forth with the hope that the photographer and the serious student will use it as the basis for personal experiment and for the development of a personal approach.

Photography, in the final analysis, can be reduced to a few simple principles. But, unlike most arts, it seems complex at the initial approach. The seeming complexity can never be resolved unless a fundamental understanding of both technique and application is sought and exercised from the start.

Photography is more than a medium for factual communication of ideas. It is a creative art. Therefore emphasis on technique is justified only so far as it will simplify and clarify the statement of the photographer's concept. These books are intended to present essential ideas and to suggest applications of photographic methods to practical problems of artistic expression. Our object is to present a working technique for creative photography.

Book 2 deals with exposure and development of the negative, and with some aftertreatments of the negative. It contains tables and formulas and many detailed expositions of procedure. In this reprint of 1964 some corrections, changes and additions have been made to bring the book up-to-date. The body of the text has not been changed as this would constitute a major revision. To conform to the most recent Zone System terminology: for *brightness,* read *luminance* (brightness is a subjective term), for *Zone V density,* read *Density Value V,* etc., for *Zone V print value,* read *Print Value V.* The meanings remain the same, but the new terminology is more precise. *Luminance* is measured in candles-per-square foot units (c/ft^2).

It must be clearly understood by everyone that the philosophy and approach set forth in this book are definitely those of Ansel Adams, and while of course there is no deviation from basic principles, terminology and the inclusion of expressive factors may differ in some instances from conventional photographic terminology and practical procedure. It is my firm conviction that a useful bridge between sensitometry and the more scientific aspects of the medium, and practical creative work, has never been adequately constructed. This book sets forth a working procedure based on my personal methods—as expressed in my own photography and in my teaching. I ask of my readers a degree of attention consistent with serious study, and I also urgently suggest that the testing and general procedures be fully carried out so that the photographer may grasp the full significance of visualization and planned execution in creative photography.

I extend my appreciation and thanks to my friends and associates who have helped so generously in the preparation of this book. The diagrams and the book design are by Milton Cavagnaro.

I dedicate these books to everyone who is interested in the development of straightforward photography and who believes in the simple statement of the lens.

Library of Congress Catalog Card Number: 76-50535
International Standard Book Number: 0-8212-0717-2

New York Graphic Society books are published by Little, Brown and Company. Published simultaneously in Canada by Little, Brown and Company (Canada) Limited
Printed in the United States of America
HOR

TABLE OF CONTENTS

Illustrations

DESCRIPTION OF TERMS USED IN THIS BOOK

INTENSITY This refers to the light *source*, not to the light reflected from the subject.

INCIDENT LIGHT . . . The light falling upon a subject from a source of illumination—sun, sky, flash or photoflood lamps, reflector, etc.

REFLECTED LIGHT The light reflected from the subject to the spectator or the lens. My philosophy of photographic procedure is based on the evaluation of the light reflected from the subject and not on evaluation of the incident light. I support this philosophy on the basis of esthetic and emotional factors more than on physical considerations.

REFLECTANCE . . . A property of the subject; for example, "white marble has higher reflectance than red brick." Reflectance may be stated in percentage—Caucasian skin has a reflectance of 35%, black velvet of 2%, etc., signifying that these subjects reflect 35% and 2% respectively of the incident light falling upon them.

LUMINANCE . . . This refers to the light reflected from the subject: it is a property of both subject and lens image. It depends upon the intensity of the incident light and the reflectance of the subject.

BRIGHTNESS . . . A subjective interpretation of Luminance.

BRILLIANCY I use this term in relation to prints rather than the term *reflectance* (which is the technically accepted term). I do so because *brilliancy* is not only a quantitive term, but signifies emotional and esthetic qualities. It is the *arithmetic* equivalent of reflection density, which is a logarithmic value.

TRANSMISSION Transmission of a negative is that fraction of the light falling upon the negative which passes through it; if 4 units of light fall upon a given part of the negative and 2 units pass through the transmission is $\frac{1}{2}$ or 50%. But as we are more interested in the light-stopping power of the negative than in the light-transmitting power, we use the inverse of Transmission, which is—

OPACITY . . . This is defined as the reciprocal of the Transmission $(0 = 1/T)$. If the negative has a transmission in a given part of 1/10 or 10%, the Opacity is 10; if the transmission is $\frac{1}{4}$ or 25%, the Opacity is 4. Opacity, being an arithmetic value, is a simpler term which the nonscientific photographer can comprehend.

DENSITY . . . This is defined as the logarithm of the reciprocal of the transparency; that is, it is the logarithm of the opacity. In sensitometry, "density" is used in preference to "opacity" because it simplifies calculations and the plotting of the characteristic curves. It is measured on a densitometer, and *must* be expressed only in logarithmic terms. Its equivalent, opacity, is ex-

pressed only in arithmetic terms. Hence, we say. "density 1.70" or its arithmetic equivalent (its antilog) "opacity 50."

It must be made clear that while *log density* and *arithmetic opacity* are interchangeable terms in the description of the light-stopping power of a negative, they represent different mathematical concepts, and in calculations are not interchangeable. Throughout this book I use the term *opacity* to represent the light-stopping powers of negatives: I use the term *density* only when necessary and then usually follow with the equivalent opacity value. I do not use the term "opacity" merely to create a new terminology, but because I am confident that the average person is not conversant with logarithms. It is much easier for him to comprehend the quantitative meaning of the phrase "an opacity range of 1 to 25" than the phrase "a density range of 1.40."

GAMMA . . . A value derived from the angle of the straight-line section of the D-log E curve in reference to the base which signifies the degree of contrast of the negative in relation to the contrast of the subject, and which is modified by the nature of the emulsion and the degree of development. Gamma is important in sensitometry and in color-separation work (color printing and reproduction). It has little or no meaning in practical black-and-white photography.

NOTE: The new terminology of the Zone System offers more precise and logical definitions:

NEW TERMS	PREVIOUS TERMS
Subject Values	Subject Zones
Luminance (measured in c/ft^2)	Brightness
Density Values (negative)	Density Zones
Print Values (or Transparency Values)	Print Zones

COMPARISON TABLE

TRANSMISSION—DENSITY—OPACITY

A partial listing of comparative numbers.

Refer to the PHOTO-LAB-INDEX for fuller table.

Transmission	Density	Opacity	Transmission	Density	Opacity
1.0000	0.00	1.000	0.03162	1.50	31.62
0.9772	0.01	1.023	0.02512	1.60	39.81
0.7943	0.10	1.259	0.01995	1.70	50.12
0.6310	0.20	1.585	0.01585	1.80	63.10
0.5012	0.30	1.995	0.01259	1.90	79.43
0.3981	0.40	2.512	0.01000	2.00	100.00
0.3162	0.50	3.162	0.00794	2.10	125.9
0.2512	0.60	3.981	0.00631	2.20	158.5
0.1995	0.70	5.012	0.00501	2.30	199.5
0.1585	0.80	6.310	0.00398	2.40	251.2
0.1259	0.90	7.943	0.00316	2.50	316.2
0.10000	1.00	10.000	0.00251	2.60	398.1
0.07943	1.10	12.59	0.00199	2.70	501.2
0.06310	1.20	15.85	0.00158	2.80	631.0
0.05012	1.30	19.95	0.00125	2.90	794.3
0.03981	1.40	25.12	0.00100	3.00	1000.0

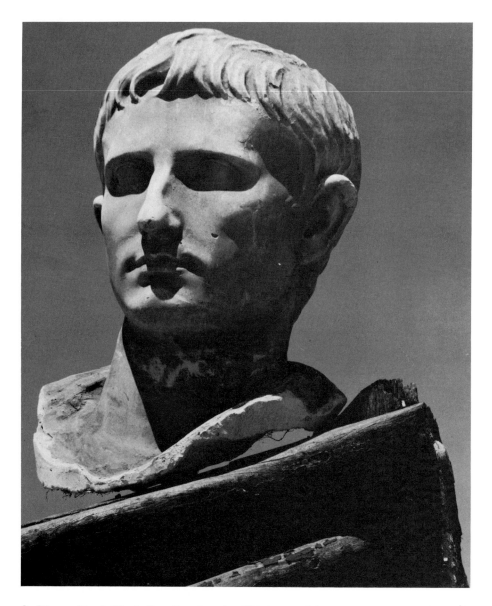

2. Plaster Head, Movie Lot, Los Angeles. This is a good demonstration of control of brightness values by exposure and development. The negative is scaled to a normal paper (No. 2 Kodabromide). The brightness range of the subject was considerable; the lowest value (the wood in shadow) was 6.5 c/ft²; the white plaster in the sunlight was slightly over 800. Placing the 6.5 value on Zone I automatically places the white plaster on Zone VIII. However, I desired a value approximating Zone VI for the sunlit portions, so the development was less than ⅔ normal (Zone VIII to Zone VI—see line 2 on exposure chart, page 27). Had I placed the white plaster values directly on Zone VI, the lower shadow values would have been lost. The shadows that are now rendered in about Zone V would have been brought to Zone III, and of course the dark wood would have been far below effective threshold. The decision to render this subject in the lower-than-normal zones was based on my impression of a certain literalness of form and a desire to express a weathered effect. Highlights, of course, exceed Zone VII value.

LIGHT

While the photographer need not make an extensive study of the physics of light, he should nevertheless be acquainted with certain aspects of its behavior that are of importance because of their relation to his medium.

Incident and Reflected Light

When light (either direct from a light source or from a reflecting surface) falls upon an object, some of it is absorbed, and the remainder is reflected. The amount of light reflected depends upon the reflectance, the color, and the surface texture of the object, and also upon the angle at which the light strikes the surface. It is the light reflected from an object that we see, and which can be focused by a lens to form an image on a photographic negative.

My personal opinion is that the photographer should be more concerned with the quantity and quality of *reflected light* that is returned from the subject to the observer or to the camera—and with which a photograph is made—than with the *incident light* that illuminates the subject (see page 60).

Various subjects reflect varying amounts of light. The brighter an object appears, the more light it is reflecting to the observer. The more light an object absorbs, the less it reflects, and the darker it appears; a surface that appears deep black is reflecting only a very small proportion of the incident light. Reflectance of white surfaces approaches, but never attains, 100% of incident light intensity.

Diffuse and Specular Reflection

Matte surfaces, or surfaces having many minute irregularities, reflect only diffuse light; a chalk surface reflects all but a very low percentage of the incident light, and this reflected light is extremely diffuse in character. On the other hand, a mirrorlike metal surface projects chiefly regular or specular reflections.

A polished silver ball hanging in a black-draped enclosure reflects only the image of the light source, and the form of the ball is practically invisible, since there is little or no diffuse reflection (see Book 5, *Photography by Artificial Light*). Between these extremes of chalklike and highly polished surfaces there is an infinite variety of surfaces, affording widely differing proportions of diffuse and specular reflections. Some reflected light is polarized, and may be controlled by the use of Pola-Screens on the lens. The use of Pola-Screens will be described in Books 4 and 5 of this series.

Intensity

Theoretically, the exact determination of the intensities of either incident or reflected light is rather difficult, and a variety of standard units confuses the uninitiated.* The modern photographer, however, is spared direct computation, as his photocell meters are calibrated in terms of actual use of the camera, correlating units of brightness with emulsion speeds, lens apertures, and shutter

* For all practical purposes, the simpler units of measurement suffice. Intensity of incident light is usually measured in footcandles. The *footcandle* may be defined as equivalent to the light from 1 standard candle at a distance of 1 foot. Reflective surfaces reflect incident light as *foot-lamberts:* 100 foot-candles equal 100 foot-lamberts (from a 100% reflective surface). Foot-lamberts divided by pi equal *candles-per-square foot* (c/ft^2), the unit representing brightness on the Weston meter dial. No diffuse surface reflects more than 96% of the incident light; actual brightness depends upon the reflectivities of the subject.

1

speeds. Either the various brightnesses of light reflected from the subject are averaged by the meter at normal viewing distance, or the brightnesses of small parts of the subject can be accurately determined by careful close application of the meter (see page 61). We are chiefly concerned with the intensities of light reflected *from* the subject—that is, subject brightness—and with the basic formula:

Exposure = Intensity × Time.

As we shall see later, this formula, known as the Reciprocity Law, applies to all normal exposure values, thought it fails to hold true at very long or very short exposure times. It is actually a function of *exposure time;* a very long exposure time suggests a low-intensity *image.* A subject of low luminance value requiring a long exposure at a large lens stop or a subject of high luminance value photographed with a small lens stop and a strong neutral-density filter, requiring the *same exposure time* as the first example would show the same divergance from the Reciprocity Law. This divergence is termed *Reciprocity Departure,* or the *Reciprocity Effect.* (See page 13).

Since light radiates from a source in all directions, the intensity of light reaching an object—either from a point source or from a reflecting surface—decreases as the square of the distance from the source increases. If an object receives 16 units of illumination at a distance of 1 foot from a source, it receives only ¼ as much, or 4 units, if the distance is doubled to 2 feet; at 3 feet, it receives ⅑ as much; at 4 feet, ¹⁄₁₆ as much, or 1 unit; and so on. This *inverse square law* applies to all illumination except when the light is directed by special lenses, such as those in spotlights, or by reflectors of special focusing curvature.

From this one might ask: Why, then, do not objects appear to the eye to be of lower brightness as we move farther from them? A single ray of light from a light source is not diminished in intensity by traversing empty space (or, in a practical sense, in traversing empty air). The intensity of a single ray of light must not be confused with the *volume* or *amount* of light falling on an object, which of course follows the inverse-square law. A single ray of light from a source or a reflecting surface is of the same intensity at 1 foot or 100 feet distance, but the total amount of rays falling on a given area at 100 feet is 1/10,000 the amount at 1 foot. The *brightness* of a subject remains the same, and the brightness of its image also remains the same, regardless of viewing distance —except, of course, when the brightness of distant objects is reduced by atmospheric absorption. (The control of haze is discussed in Book 4.)

Measuring Light to Determine Exposure

The approach on which these books are based assumes that determinations of the required exposure are made on *light reflected from the subject.* (The student should not overlook the fact that some schools of thought favor the determination of exposure by measurement of light falling on the subject, and that some exposure meters are designed as incident-light evaluators.) My own philosophy of creative photography involves a direct relationship between the brightness of a given area of the subject and the density (opacity) in the corresponding portion of the negative—the objective, of course, being to obtain the desired tone value in the print. It must not be overlooked that the brightness range of the image—compared with the brightness range of the subject—is modified by lens flare (page 53) and by reflections within the camera.

Tone reproduction, sensitometrically speaking, is concerned with accurate proportional relationship between brightnesses in the subject and values in the

2

print. This is an estimable scientific objective, but creative photography, in which departures from reality are as important as in any other art, may require a non-literal approach—in other words, an emotional control of values that may be at variance with photometric standards. The use of incident-light meters may yield, generally, negatives that are quite satisfactory from a purely mechanistic point of view, but unless the dominant values of the subject are 1) visualized in terms of expressive values in the final print; 2) evaluated; and 3) presented in the print according to visualization, there is little chance for that emotional control of values so essential in art. I have no intention of belittling other philosophies of approach or—even by inference—depreciating other instruments for exposure determination. I am simply presenting a personal approach that has been proved effective, and I recommend the Weston Master Exposure Meter as the instrument that best helps me to carry out necessary computations quickly and easily (page 60). I recommend the S.E.I. meter (page 63) for precise work.

The variety of surfaces and colors in any ordinary subject results in a range of brightnesses that can be represented as a range of related opacities within the negative. If the darkest object in a given subject reflects 4% of the incident light and the brightest object reflects 80%, or 20 times as much, then the range of reflectivities (or brightness scale—Bs) is 1:20 and easily recorded on the standard films if the average exposure value is placed near the center of the characteristic curve of the film (page 9). If, though, the lighting is complicated by shadowed areas in the subject, the range of related brightnesses is increased. For example, consider an outdoor scene in which the illumination in the shadows is 1/15 that on the sunlit surfaces. The total range reflected here is 15 times as great as the range of reflectivities in uniform illumination. If the reflectivity range of the surfaces themselves is, say, 1:25, the total brightness range in the entire sunlit-and-shadowed subject is 1:375. An incident-light meter can only average these differences; it cannot determine the actual reflectance value of the various surfaces as can a reflected-light meter properly used. Of course, if the incident light falling upon various parts of the subject were separately evaluated, some approximation of the actual brightnesses of the subject could be obtained, but only by a rather roundabout procedure. The reflection factor of various surfaces must be known for accurate evaluation of the relationship between incident light and reflected light.*

Color and Orthochromatics

White light is the visual effect of the combination of all wavelengths (or colors) of the visible spectrum. When it falls on a white (unpigmented) surface, light of all wavelengths is reflected. A colored surface, though, absorbs all colors of light except its own. For instance, a "pure" red object appears red because it absorbs all blue, yellow, and green wavelengths from the white light falling upon it, reflecting only red.

* The approximate reflection factors of various substances and surfaces may be determined by an instrument such as the combined incident-reflected light meter made for industrial and engineering use by the General Electric Company, or by comparison with gray cards of known reflectivities. Of course, the element of color must not be overlooked; variations in the color response of various meters as well as the color sensitivity of various negative emulsions, and the psychological aspects of color and color combinations, will modify instrument combinations, will modify instrumental determinations.

Most of the light falling upon a brilliant white surface is reflected. If the surface is less brilliant, a part of the total light is absorbed, only the remaining portion of the incident light is reflected, and the surface appears gray. The greater the absorption, the deeper the gray. "Gray" is a relative, not a fixed, value. In creative photography we should be fully aware of the emotional value of black, grays, and whites, and their relationships. So long as the surface absorbs all wavelengths equally, the reflected light—no matter how little—is still *white;* there is no impression of color, and the surface appears neutral gray. If any particular wavelengths are absorbed more than any others, then the surface takes on the color of that light which is least absorbed, and the gray appears of a reddish or yellowish or bluish or greenish cast, depending on which light is most reflected. As the proportion of color increases, the impression of gray grows into the impression of a tone possessing a definite color value. For a rough example, consider a tweed cloth woven largely of gray threads, with a few flecks of bright blue added. It gives the impression of gray with a little blue superimposed; the blue is of low value. But if the greater part of the threads is blue, we are conscious of a strong blue color rather than just a blue tendency in the gray; then the blue is of high value. The more strongly a surface absorbs other colors, the higher the value of the blue—or red, or green, or whatever the unabsorbed color is. The reader is referred to standard works on color theory and should investigate the Munsell System of color determination.

Thus we see that we have whites and blacks, light to dark grays of neutral tone, and grays with color modifications progressing from the faintest suggestion of color to colors of high value. In nature one rarely finds objects of pure colors; only in the spectrum and with some specially prepared pigments and color filters does anything like a true monochromatic color exist. Rather, everything in nature reflects light of varying color proportion and value. This point is elaborated in Books 4 and 5 in sections on filters and color control. It is of great importance in all phases of photography, with either natural or artificial light.

Just how the photographer should relate the various grays in a print to the colors and brightnesses of a given subject is difficult to explain clearly. While standards of such relationships could be established, it is obvious that the most important relationship must be *subjective;* photometric equivalents have little to do with emotional interpretation. The classic example of the red apple and the green leaf may be evoked; a photometrically "balanced" black-and-white image would render both apple and leaf in about the same gray tonality. Emotionally, the apple should be felt as having a deeper tone than the leaf—or if further departure from reality be desired, the apple can be rendered much lighter than the leaf. Concept dictates procedure. And "concept" may be of either literal or imaginative character.

Since the beginnings of photography, rendition of color and brightnesses have been conventionalized by the limitations of the negative material. In early days, with the color-blind plates sensitive only to blue light, we became accustomed to white skies, dark lips, and very dark foliage. Later, with orthochromatic emulsions, responding to all parts of the spectrum except deep orange and red, foliage could be rendered more faithfully, but skies were still light and blank, lips still dark, and the rendition of clouds in landscape was considered a great feat. But with the appearance of the panchromatic emulsions, responding to the entire visible spectrum, we grew accustomed to dark skies (exaggerated

by the use of filters), light lips, and many other representations that have become as "conventional" as those of earlier times.

The modern photographer, however, has such a wide choice of negative materials, together with filters to modify their effects, that he need be bound by no conventions of expression. After learning—through experience *plus* logical experimentation—the basic differences between emulsion types, and the effects of various filters on tonal values and contrast, he has available a stimulating gamut of interpretive possibilities.

Emulsions and Filters

Visualization, based on experience as well as concept, is modified by the response of the emulsions used. It is one thing to be aware of the intensities and colors of a subject and to visualize a final print with the desired values, but quite another to choose an emulsion and a filter to render those tones as desired. For example, a magnificent early photograph by Paul Strand shows a dark jug and a platter of fruit on a white garden table, seen from above against a dark lawn. The design is exciting, chiefly because of its enhancement through "color-blind" rendition of lawn and fruit. The white table stands out vigorously against the dark background of the grass, and the fruit too is very dark, defined only by its outline against white and by sensitive recording of the highlights. The values are unrealistic, but the general effect is spectacular. Before the introduction of orthochromatic emulsions photographic plates were sensitive only to blue light, which gave a limited translation of subject values. Such values were necessarily accepted as conventional symbols of reality. But the same subject photographed with panchromatic or orthochromatic film might actually be far less interesting. The important point is this: had Strand approached the problem with panchromatic film, his treatment and arrangement presumably would have been entirely different.

The photographer has more control over the relationship between print values and subject colors than might at first be supposed. The modern photoelectric meters have a fairly consistent response to the dilute colors found in nature, making possible reasonably accurate evaluation of the brightnesses of colored surfaces. It is generally conceded that a Type B panchromatic film used in daylight with a Wratten K2 Filter gives results that some consider to be the visually "normal" representation of colors in terms of relative grays. Various interpretations may demand considerable divergence from this norm. Having evaluated the subject, and knowing the response of the negative, the photographer can use color filters to "correct" or adjust the effective color sensitivity of the emulsion (within the limits of its color response), and thereby create the desired color-value relationships in the black-and-white images. Color-filter control is augmented by exposure-development relationships (see Fig. 12).

In Figure 9, a-d, page 23, the photographer will see a comparative example of modification of subject color values by the use of filters. A more inclusive example is shown in Figure 3 on the next page.

The three principal types of photographic emulsions are:

Ordinary (color-blind; sensitive to blue light only)
Orthochromatic (sensitive to all but red light)
Panchromatic (sensitive to light of all colors)

The panchromatic emulsions are further divided into Type A (fairly obsolete—low red and high blue sensitivity), Type B (balanced sensitivity over entire spectrum with good green response), Type C (high red and low blue sensitivity). Among the many brands there are endless subtle variations of response to color, and in time the photographer may make selection of a film which exactly meets his requirements. At first, however, the Type B panchromatic emulsions will be the most practicable to use, and will offer a point of departure for use of other films of different color response. Figure 3 shows a number of colors photographed with orthochromatic and panchromatic film, using various filters.

A good general idea of relative color values and brightnesses in relation to panchromatic film can be had by viewing subjects through the Wratten No. 90 Viewing Filter. A near-monochromatic effect, of good visual intensity, is given by this filter, but the conventional blue viewing filter seriously depresses the brightness of the subject values.

Each of the three general types of emulsion—ordinary, orthochromatic, and panchromatic—has its own specific uses; there should be no prejudice against types other than panchromatic. The photographer can command his values with great flexibility and relative simplicity. But if he is familiar only with panchromatic films—as to color rendition and contrast—it is then necessary for him to discover the properties peculiar to other emulsions. Ordinary (color-blind) and orthochromatic films are generally capable of much greater contrast than most panchromatic emulsions.

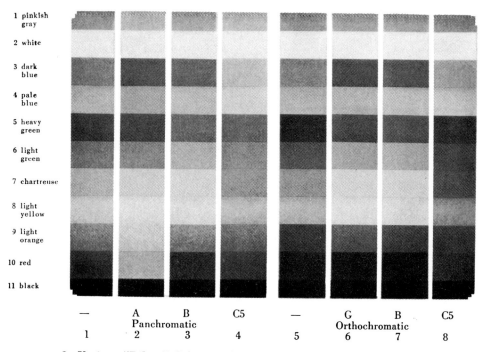

3. **Various "Dilute" Colors,** as found in nature, photographed with two films and several filters. (Tone values only approximated in halftone reproduction.)

The photometric equivalent of any tone, value, or color can be measured by a basic standard—but this standard should never be allowed to dominate emotional interpretation. For instance, we may assume that blue sky (as related to skin, snow, and cloud) is appropriately represented by "middle gray." Here photometric and emotional values more or less agree. But there are times when (for some valid emotional reason) the sky must appear very light—perhaps to convey the illusion of glare and sunlight—or perhaps very dark. In these cases photometric and emotional values do not coincide. It would be a fundamental error, though, to insist that the rendition of tones and values should be literal in the photometric sense.

As the response of panchromatic emulsions can be effectively modified by color filters, the color sensitivity of other emulsions can be approximated with panchromatic. This is true, with the exception that standard filters are not completely selective in their transmission of colors. Filters are effective only when properly related to the color sensitivity of the film used; for instance, orange and red filters cannot be used with orthochromatic film, because the film is not sensitive to red light. We must allow for residual transmission, just as we know that no pure colors exist in nature. Blue sky is predominantly blue, but not entirely so. Green foliage contains other colors as well. A gray-blue shade represents a low proportion of blue light with white light—and white light is composed of all colors, including blue. We might expect a natural red object photographed with orthochromatic film to appear black, but the chances are that it will print dark gray, because of the secondary colors in the red object to which the emulsion is sensitive.

Within practical limitations, the use of filters permits manipulation of panchromatic film to produce effects *approximating* the response of ordinary and orthochromatic emulsions. Suggested methods are:

1. *With panchromatic film.** To approximate ordinary (color-blind) film, use a blue C5 (or sharper-cutting C4) filter, which absorbs all red, yellow, and green light. (Images of subjects of these three colors will be dependent upon the residual blue light they reflect.) To approximate orthochromatic film, use a "minus-red" filter, Wratten No. 43, 44, or 44A. (A green filter such as Wratten 58, while withholding red light, also screens nearly all the blue light, and does not produce a true "ortho" effect.)

2. *With orthochromatic film.* To approximate ordinary (color-blind) film, use a C5 or C4 blue filter.

The use of filters is not limited to the above purposes nor to enhancing separation of subject values, such as sky and clouds (see Book 1, page 103). Some types of filters may be used with certain films exposed under illumination for which they were not designed. For example, Type B Kodachrome (balanced

* Type B Panchromatic has the best balance of the three basic panchromatic types. That is, its color sensitivity more closely matches that of the eye. Type C Panchromatic is hypersensitive to red, and the use of a correcting filter, such as the Wrattan XI with daylight (X2 with tungsten light) is advised for a higher response to green and a lower response to red light with this film. Type A Panchromatic is seldom used: it is more sensitive to blue light and less to red light than Type B. However, film designations are not consistent among manufacturers. The practical color response of various emulsions is a function not only of their color sensitivity, but also of the *degree* of that sensitivity. The filter-factor tables provided by the manufacturers suggest the relative color sensitivity of various films.

for tungsten light) may be used in daylight with a Wratten No. 85B filter. Other filters balance artificial light to precise spectral transmissions, compensate for the special spectra of vapor lamps, or modify daylight. The filters designed for such purposes—generally known as photometric or color-compensating filters— are chiefly for color photography, though possessing limited application in black-and-white work.

Filter exposure factors as given by the manufacturer are based on the response of the various emulsions to both standard daylight and tungsten illumination. They do not apply exactly if the light diverges from these standards. Furthermore, the photographer may prefer—in the interest of special emotional effects—not to apply these factors rigidly.

As shown in Book 4, exposure and development of the negative can be planned so as to modify filter effects considerably. Reducing the exposure factor for a K1 filter and giving *more* development will produce a result (in terms of image contrast) very similar to a K2 filter with normal exposure. Likewise, increasing the exposure factor of a G filter and giving *less* development will approximate a K2 filter under normal conditions. The color-transmission effects of filters are unchanged by variations in exposure and development of the negative, but the general contrast effects are considerably modified.

A good basic rule for the application of filters: Use filters conservatively, and only when you know what can be done with them. Much thoughtful experimentation is necessary for the intelligent use of filters.

Use of filters with natural and artificial light is discussed in Books 4 and 5. A table of filters will be found in Book 1, and the Photo-Lab-Index contains a comprehensive list of filter types and their properties. Refer also to *Wratten Light Filters*, Eastman Kodak Company.

Wave Length and Definition

Excepting x-ray, ultraviolet and infrared light, used in special work, all photography is done within the visible spectrum. The average good lens is adequately corrected, chromatically, for the visible wave lengths of light—that is, it brings the visible wave lengths to focus on one plane (see Book 1, *Camera & Lens*, page 40). However, enough of the extreme violet may be transmitted by lenses and filters to impair definition; more often when strong red filters are used, the extreme red light (proportionally emphasized) which comes to focus a slight distance behind the plane of visual focus, may adversely affect definition.

The eye, even with the aid of a magnifier, cannot detect variations of sharpness in the ground-glass image that are not within the color limitations of vision; nothing, therefore, can be done *visually* to detect or to correct for extravisible light. With panchromatic emulsions and highly color-corrected lenses, the difference between "visual" and "chemical" light (a bugaboo of earlier times) is minimized. (See Books 1 and 4 for discussions on infrared.)

Color Temperature

Another quality of light that is of importance to the photographer—chiefly to the color photographer—is color temperature, expressed in degrees Kelvin (°K). Considerations of color temperature are found in Book 5, and the approximate color temperatures of sunlight and skylight are discussed in Book 4, especially with reference to the use of filters with natural light.

THE EFFECT OF LIGHT ON THE NEGATIVE

What actually occurs when light strikes the sensitive emulsion of the photographic film is not fully known. We do know, however, that the silver halide is altered in such a way that it responds to the developer, being chemically reduced (by the developer) from its original combined form to uncombined metallic silver. Although before being altered by light the silver compound is in a relatively stable condition, on exposure to light it becomes a somewhat unstable transitional substance. The action of the developer favors completion of the change toward which the silver halide already tends; it ultimately becomes a visible and rather stable deposit of extremely fine silver particles suspended in the gelatin of the emulsion. The process will be discussed in detail in the section on Developers and Development.

The Characteristic Curve

In the early days of photography, exposure and processing of the sensitive emulsions were entirely empirical; through laborious trial and error, methods were evolved by which the apparently inconsistent reactions could be controlled. The growing importance of photography as a medium of communication of ideas and expression of spirit was obviously restricted by the uncertainties of the process, and not until 1890 were the physicochemical principles of the action of light on silver halide—the exposure-density relationship—revealed by the investigations of Hurter and Driffield. With great clarity and simplicity this relationship is expressed by what is known as the H & D Curve (the D-log E, or characteristic, curve; Fig. 4, below). This characteristic curve is the foundation of the science of sensitometry—on which are based the research on and the manufacture of modern negative and print emulsions.

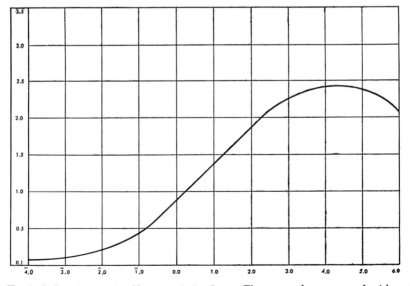

4. A Typical Sensitometric Characteristic Curve. The curve shows reversal with extreme exposure. The log exposure values (bottom line) are merely proportional. See Fig. 5, page 11.

While of utmost importance to the chemist, physicist, and manufacturer, sensitometry in its usual aspect does not concern the practicing photographer. But it is of real importance that the photographer be aware of the *practical* basis of sensitometry, and that he possess a concept of the relationship between exposure and density which will be of use to him in his work.

While the characteristic curve as described by the sensitometrist may tend to confuse the layman with its logarithms and other mathematical terms, the student and practical photographer can (and should) regard the curve as merely a *symbol* of the exposure-density relationship. As such, it is an illuminating and graphic clarification.

Logarithms need not, after all, be overwhelming. They are a sort of mathematical shorthand, a device whereby large numerical relationships can be expressed in small numbers. For instance, if the exposure range reproduced in Figure 5 were plotted on a continuous arithmetic scale it would require a page several feet long. On the other hand, an exposure range expressed in a logarithmic scale from 0.0 to 3.0 represents 1000 units of exposure; a scale of 3.0 to 3.0 represents 1,000,000 steps. (An arithmetic scale is composed of units in 1, 2, 3, 4, 5, 6, etc. sequence; a geometric scale of units in 2, 4, 8, 16, 32, etc. sequence.) *

Now consider the curve that represents a typical relationship between density and the amount of exposure (Fig. 5). (It should be pointed out that this is a generalized symbolic curve, for purposes of illustration—it is not intended to represent the characteristics of any particular emulsion.) The curve shows how the density produced in the emulsion—upon standard processing—increases with increased exposure. It must be emphasized that exposure here represents units of exposure (or the product Intensity \times Time) rather than any specific time or specific intensity. Here *Intensity* actually means subject *brightness*.

Studying the curve, we note that it can be roughly divided into three sections, which may be interpreted in the following manner:

1. In the foot or *toe* of the curve, the steepness (which indicates the rate at which density increases with greater exposure) is progressively greater as exposure is increased. This means that the very lowest intensities of light capable of causing changes in the emulsion are proportionately less effective than are the slightly greater intensities. Up to a certain point the light becomes increasingly effective, but not quite in proportion to the increase of exposure.

2. In the middle of the *straight-line* portion of the curve the *ratio* between increased exposure and increased density is uniform. But it must be recognized that doubling the exposure does not necessarily double the density; but the continued doubling of exposure in this region increases density by identical amounts. For this reason it is preferred in sensitometry to plot the curve against the logarithm of exposure, in which each doubling of exposure is expressed by a constant increase of .30. It is obvious that if equal increments of log exposure result in equal increases of density, the curve at this point becomes a straight line. This explains the preference in sensitometry for plotting density against log exposure rather than plotting opacity against exposure (arithmetic values).

* However, as the apertures of our lenses are marked in numbers of geometric progression—f/8, f/11, f/16, etc.—see Book 1, page 98) it will be more convenient to express exposure in *units* of geometric progression—1, 2, 4, 8, 16, 32, 64, 128. Hence when the symbolic curve or exposure scales are discussed in this book, exposure will be indicated in *units of exposure*, and negative density expressed as both density and its arithmetical equivalent, opacity.

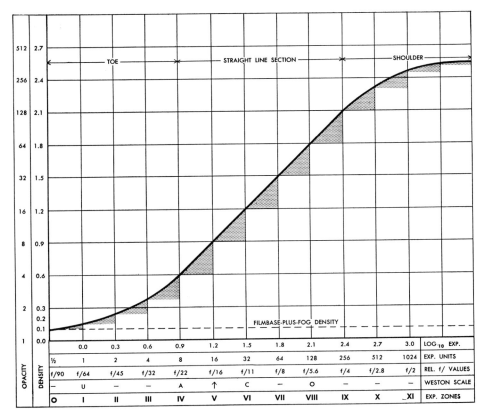

512	2.7													
256	2.4													
128	2.1													
64	1.8													
32	1.5													
16	1.2													
8	0.9													
4	0.6													
2	0.3													
	0.2													
	0.1													
1	0.0	0.0	0.3	0.6	0.9	1.2	1.5	1.8	2.1	2.4	2.7	3.0	LOG₁₀ EXP.	
		½	1	2	4	8	16	32	64	128	256	512	1024	EXP. UNITS
		f/90	f/64	f/45	f/32	f/22	f/16	f/11	f/8	f/5.6	f/4	f/2.8	f/2	REL. f/ VALUES
		–	U	–	–	A	↑	C	–	O	–	–	–	WESTON SCALE
OPACITY	DENSITY	O	I	II	III	IV	V	VI	VII	VIII	IX	X	XI	EXP. ZONES

5. A "Symbolic" Curve. Not related to any particular film curve. Suggests the exposure-density relationship, and shows the three divisions of the curve—toe, straight-line section, shoulder. The equivalent values of opacity and density are shown in the two left-hand columns (a fuller table will be found on page vii). Note that every time a log number increases by .3 the arithmetic values are doubled (a geometric progression). The opacity values are in round numbers. The Log₁₀ Exposure line is again divided into progressions of log increments of .3, signifying that each vertical line represents double the exposure value of the preceding line to the left. The second line—Exposure Units—indicates this progression in ordinary numbers. The third line gives the progression of lens stops (a geometric progression). The next line shows the scale on the Weston Master Meter, related directly to the sequence of Exposure Zones on the bottom line. The steepness of the curve is modified by development of the negative.

But the practical photographer is not necessarily a sensitometrist; he may employ curves which are based on arithmetic relationships and which are quite satisfactory to him as symbols of the exposure-opacity relationship. But he must not confuse the actual sensitometric curves with any symbols he selects for personal evaluations. I see no real reason for the practical photographer to plot curves except in preliminary studies and in some aspects of color photography.

At any event, the steepness of this straight-line section of the curve indicates the basic contrast of the negative; the steeper the line, the higher the contrast indicated. The contrast actually obtained depends largely upon the amount of development given the negative (see page 51).

3. At the top or *shoulder* of the curve, as the maximum possible density is approached, the steepness of the curve falls off—which means that increasing exposure here results in a diminishing increase of density.

11

While all characteristic curves have the same general features, their individual shapes and proportions differ. Depending on the qualities—and treatment—of the emulsions they represent, various curves show longer or shorter toes, steeper or less abrupt straight-line portions, broader or more acute shoulders. For example, the curve of a soft portrait film or of a fast "speed" film has a long toe and a relatively short straight-line section and shoulder, while that of a brilliant "commercial"-type film has a short toe and a long straight-line section. Process film, designed to give maximum contrast (when properly developed) has a very short toe and an exceptionally long and steep straight-line section. The serious student of photography must learn the significance of these variations and thereby recognize the broad limitations, or at least some of the basic properties, of any negative material by an inspection of its characteristic curve.

4. For reasons beyond the scope of this text, a sensitive emulsion does not respond to light of less than a certain intensity—this limit of response being one of the characteristics of the particular emulsion. We may define the *threshold* as the response to the minimum amount of light that must fall on the emulsion before the unexposed silver halide crystal is affected. This threshold value is related to the position of the point (shown here as density 0.1) where the characteristic curve becomes coincident with or parallel to the horizontal base axis. In practical terms the horizontal base axis of the curve does not represent density 0.0 as there is always a slight density due to film base plus fog (page 52).

The actual threshold may be considerably lower than the *effective threshold* —that is, the light required to produce the minimum density above film-base density that can be seen as a visible tone in the print. In broad general terms, the effective threshold density would be represented by an exposure of a given intensity placed on Zone 1 of the exposure scale (Fig. 12, page 32)—assuming, of course, that the exposure is based on the proper speed rating of the film and on normal development of the negative.

As exposures become greater, thereby falling on the shoulder of the curve rather than on the straight-line section, the separation of values is impaired; that is, there are only slight differences in density for fairly large differences in intensity. Here is an explanation of the "blocking" and flattening of highlight values in overexposed negatives—though blocking of highlights may also result from the scattering of light within the emulsion, or from diffusion of silver due to action of the developer (see page 98). In a true sensitometric curve (derived from measurements made on a film strip exposed on a sensitometer) the straight-line section is obviously extended beyond what we might suppose from practical photography in the field. The compaction of subject values, evidenced in the "blocking" mentioned above, creates an effective shoulder—a "false shoulder" sensitometrically speaking, but of great significance in actual work with the camera.

The Exposure Formula (The Reciprocity Law)

The amount of radiant energy falling on a sensitive emulsion determines the degree of chemical change brought about (with standard processing), and which, according to a direct relationship quantitatively expressed, gives the characteristic curve of that emulsion. Throughout the above discussion, the word

"exposure" has been used to denote the amount of light falling on any given portion of the photographic film, either as light of high intensity and short duration, or as light of low intensity and greater duration. The exposure formula, which applies to all practical work, is simply: Exposure = Intensity × Time.

The intensity (brightness of the image) depends upon the brilliancy of the reflections from the subject, and upon the settings and characteristics of the camera (lens transmission, lens aperture, bellows extension, etc.), and the time as controlled by the shutter. For the same subject brightness, 1 second at f/8 is equivalent to 8 seconds at f/22 or ½ second at f/5.6.

A practical demonstration of the exposure formula is as follows:

1. Take the meter readings of a variety of subjects under different lighting conditions. These subjects should be of minimum texture and continuous tonal value—such as blue sky, wooden panel, white smooth card, dark smooth card, cement surface—in both sunlight and full shade.

2. Note that the meter readings vary over a wide range for these subjects. Now, for each subject set the arrow of the Weston exposure dial opposite the brightness reading of that subject, and expose a film accordingly. (You may use the A, Arrow, or the C of the dial—or any other point thereon—but the same point must be used throughout this demonstration.)

3. When you have made all exposures—each exposure based on the indication obtained from setting the arrow (or other point of the dial) opposite the brightness of the subject photographed—develop *all* of the negatives together for precisely the same developing time.

4. All the negatives will have the *same density*, thereby demonstrating the validity of the formula: Exposure = Intensity × Time.

Failure of the Reciprocity Law (Reciprocity Departure)

The exposure-density relationship of a given emulsion (as indicated by the formula stated above) holds for all ordinary values of light falling on the negative; however, there are limits of extreme high or unusually low image brightnesses beyond which the densities produced in the negative are less than would normally be expected. The reciprocity departure is frequently of practical significance in black-and-white photography, and of great importance in color photography. More than meter-indicated exposure is required when the basic exposure is very long, either because of low subject luminance, or the use of small lens stops or heavy filters. *Reciprocity Departure*, as stated previously on Page 2, is a function of *exposure time**. Practically speaking, it is difficult to overexpose under such conditions. A simple practical test for determining the additional exposure required to overcome reciprocity departure will be found on page 59.

* Reciprocity departure due to long exposure times first appears in the lowest parts of the exposure scale. Then, as the image brightness further decreases (requiring more and more exposure), the middle, then the high, values are affected. This accounts for the sometimes surprising contrast produced by long exposures of apparently flat subjects; the high and middle values have responded normally, but the low values have suffered reciprocity departure, hence are represented by a lower opacity than would be obtained by normal exposure. When most, or all, of the exposure scale evidences reciprocity departure, the effect approximates that of extending the straight-line section of the curve. Therefore superior effects are obtained in copying by employing very low values of illumination, and long exposures. Also, good copying results result from using very short exposures with light of high intensity (speed lamps), as the reciprocity departure effect appears with both very low and very high values of image brightness.

The zone numbers have been added to this illustration of the Weston Meter dial.

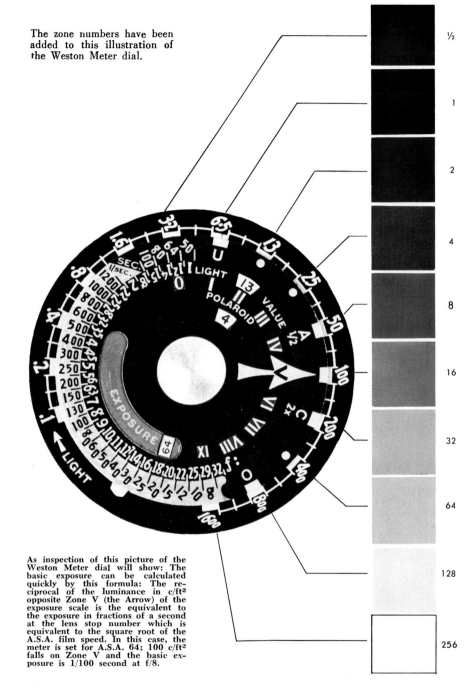

As inspection of this picture of the Weston Meter dial will show: The basic exposure can be calculated quickly by this formula: The reciprocal of the luminance in c/ft² opposite Zone V (the Arrow) of the exposure scale is the equivalent to the exposure in fractions of a second at the lens stop number which is equivalent to the square root of the A.S.A. film speed. In this case, the meter is set for A.S.A. 64; 100 c/ft² falls on Zone V and the basic exposure is 1/100 second at f/8.

	½
	1
	2
	4
	8
	16
	32
	64
	128
	256

6. The Gray Scale and the Weston Meter Dial. This illustration deserves considerable study. It contains some of the basic factors of the approach to exposure outlined in this book; the relationship of the exposure zones to the steps of the gray scale and the Weston dial. The gray scale relates to the values of the print; we do not directly compare it to subject values.

THE GRAY SCALE

A photographic print represents varying shades of gray, usually ranging all the way from a tone slightly lighter than black to a tone just perceptibly darker than the paper base; there may also be small areas of solid black and pure white. The actual range of reflectance (print brilliancy) possible in a print varies with the surface and the color of the paper base. For instance, in a glossy print on white paper the reflection from the lightest area may be 50 times as great as that from the darkest area; while the range may be only 1 to 20 or less in a print made on a rough, dead-matte surface. Thus we see that the print should not be considered as a literal representation of the brightnesses of the subject, for the actual range of light values in the subject may vary from 1 to 1600, or more —or very low, perhaps no more than 1 to 4 in some unusually uniform subject matter. But subjects of even the most extreme brightness range must be represented within the limits of the paper, being translated into varying shades of gray, usually with a note of solid black or white, or both, which serves to "key" the tonalities. Book 3 of this series is devoted to the problems of printing and enlarging, and the limitations of print scale are fully discussed therein.

It is important to recognize, first, the limits of the brightnesses that can be recorded in any one negative, assuming that the negative material is of normal properties and is to be given normal processing. If the exposure is correctly adjusted so that the darkest significant values in the subject are just recorded in the negative—and hence are printable as something lighter than pure black— then everything up to and including values that are 256 times (2^8) as great as this minimum value will also be recorded. Nothing lower than the minimum recordable value (the effective threshold) will affect the sensitive emulsion; anything brighter than 256 times the minimum value will, under normal development—that is, that which renders the low-middle values properly—produce such great opacity in the negative as to result in blank white in the print. But with normal processing each brightness value between these extremes will produce an appropriate density (opacity) value in the negative and a corresponding gray in the print. The range of opacities desired is influenced (as is shown later) by the type of printing paper to be used. Some papers are listed as having an exposure range of 1:100; most papers have much lower scales. Also the effective exposure scale of the paper is modified by the developer used (see Book 3).

Subject-brightness ranges considerably higher than 1 to 256 are frequently encountered and controlled by proper development procedure. No matter how large the subject-brightness range is, the respective opacities in the negative must be kept within a range that does not exceed the effective exposure range of the printing paper to be used.

Distinction must be made between the range of brightness of the subject and the brightness range of the lens image. Exposure meters measure the brightness of the subject; the brightness of the image cannot be measured directly except with highly sensitive electronic devices impractical for use in ordinary work. The brightness of the image is effectively determined for the lens in use through the tests described on page 39. The flare factor and the optical coating of lenses are mentioned on pages 53-54.

The photographer who wishes to work toward a predetermined result must visualize the tonalities in which he wants certain important parts of the subject

to be represented, and plan his exposure and subsequent treatment accordingly. Obviously, it would be most difficult for him to carry about a mental image of all the infinitely varied shades that may appear in a print, but he can learn to visualize a gray scale made up of a definite small number of steps and to think of a final print in terms of these tones.

A gray scale of 10 steps seems to be most convenient. With solid black and pure white as the extremes, there are 8 discrete shades of gray in between—not too many to visualize, and yet enough to symbolize various values in the subject. Moreover, the 8 intermediate steps of tone can be related to the 8 indications on the calculator dial on the Weston Master Exposure Meter (Fig. 6), covering a range of brightness from 1 to 128. The 10-step gray scale is reproduced (within the limitations of the halftone process) in Figures 6, 12, and 26, where it will be noted that the sixth step in the full progression from black to white has been designated "middle gray." This is not merely a compromise necessitated by the existence of an even number of steps, but a recognition of the relationship of tone progression to the characteristic curve of the average negative material.

The term "middle gray" as I use it is more an emotional value than a quantitative physical value. If we spin a disk surfaced with equal areas of black and white, we get a 50% gray tone which would not be "middle gray" at all, but a value lying between Zones VII and VIII of the exposure scale (page 14). A surface of average tonality—such as the middle step of tone of a full-scale glossy print—would have a reflectance of about 18% and relates to Zone V of the exposure scale. Of course, the *actual* brightness of this gray tone would depend on the intensity of the light falling upon it. But we are concerned here with proportionate values of tone. "Middle Gray" represents the *geometrical mean* of the extremes of useful values.

A careful study of a large number of good prints will show that any particular subject matter is usually rendered, within fairly narrow limits, in the same particular gray. For one example, the average tonal value of normal Caucasian skin in sunlight approximates the value of the Zone VI (one above middle gray) of the gray scale. Average skin has a reflectivity of about 30% to 40%. Likewise, most foliage is rendered as the gray in Zone III or Zone IV, while snow in full shade usually approximates the gray in Zone VIII. Of course there are variations—sometimes very wide—for special interpretative purposes in which the personal concept dominates (and rightly so); but most representations are fairly uniform, at least throughout the work of any one photographer.

It should be possible, then, for the individual to group subject values to correspond to the various steps of the gray scale according to his personal concept of the representation of values, and to devise a standard procedure for exposure and development that will give consistent negative quality. The ideal, it seems to me, is to be able to so plan exposure and development that practically all negatives will be suitably scaled for printing on normal paper.* (See Obtaining Optimum Opacity, page 39). Of course, it is of great importance that the student realize such visualization can only be approximate; too many variables exist to assure an exact determination of values. But it has been my experience

* Unfortunately, the manufacturers do not designate their various paper grades according to a uniform scale. A No. 1 contact printing paper from one manufacturer may have an exposure scale similar to a No. 2 enlarging paper from another manufacturer! I use the terms "No. 2" or "normal" to indicate a paper with an exposure scale somewhat less than that of "No. 1" or "soft" papers—roughly, an exposure scale of 1 to 50. See Book 3, *The Print*, for further explanation.

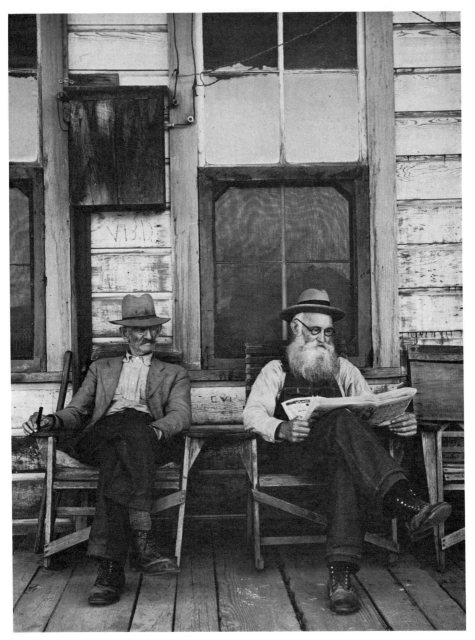

7. At Hornitos, California. This is an example of moderately low placement and expanded development (Zone V exposure "raised" to Density Value VI). The limitations of the reproduction process make it impossible to convey the subtle qualities of the original print. (This statement applies to all the halftones in this or any standard book printed in these times.) Actually, the impression in this picture is one of opalescent light, diffused but vibrant. The lowest values are about Print Value I; the highest values exceed Print Value VII. In the subject the luminance range was much less than the Print Value range suggests. But the *mood* of the scene would not permit literal treatment. So-called normal exposure and development would have failed to give the crisp vibrancy desired. Form is here revealed more by variation of tone than by light-and-shadow effects.

that in general work such broad visualizations of values give me far more positive results than do the usual empirical methods or the routine "average" methods which rely on the "latitude" of the film to absorb considerable variations of exposure. The chief advantage of this approach is that it provides for a concept and a realization of emotional and interpretative values—rather than mere mechanical tone reproduction. The procedures outlined in this book attempt to bridge the gap between sensitometry and applied photography. The problem suggests the relationship between Helmholtz and Beethoven—between the theory of sound and the production of expressive music.

How, you may ask, can consideration of a gray scale help you to make better photographs? Let us see how we can relate its tones to the things you wish to photograph, and what systematic procedures may be set up on the basis of this gray scale for planning exposure and development suitable to the desired interpretation.

Exposure Zones

This grouping, or arrangement in *exposure zones,* can follow a plan such as that presented on the opposite page. These zones can be related to the markings on the exposure dial of the Weston Master Exposure Meter, as suggested in Figure 6, page 14. If, for example, the value of the shadow detail desired in a landscape gives a Weston reading of 13 on Zone II, an important feature to be rendered as moderate gray gives a reading of 200 on Zone VI, and a very intense portion reads 800 on Zone VIII, then you may expect the recommended exposure and "normal" development to result in a suitably balanced negative, from which you can make a print rendering the important feature in the desired middle gray but still including detail in both low and high subject values. ("Normal" development is discussed later.)

Understanding of zone relationships makes it possible—through special manipulations—to record either or both light and dark extremes of a subject without seriously altering the middle-gray values (see Placement, page 31).

The Weston Master V meter employs a series of arbitrary numbers which represent c/ft^2 values as follows: $\#12 = 100$ c/ft^2, $\#14 = 400$ c/ft^2, $\#10 = 25$ c/ft^2, etc. (each ascending number represents 2x the value of the preceding number; each descending number ½x.)

The new Weston Ranger #9 employs a *different* series of numbers relating to c/ft^2 values, but in strict geometric sequence, starting with #10 (representing 1 c/ft^2) and progressing on the 2, 4, 8, 16, 32, etc. ascending series, and the ½, ¼, ⅛, and ⅟₁₆ c/ft^2 descending series. The c/ft^2 values appear in red on the dial. The range of the new Weston Ranger #9 is 1 : 1,000,000.

Some Typical Subject Brightnesses (Weston Master Meter Values)

Knowing some basic brightness values will aid in visualization problems and expedite meter readings. Some typical values are (in c/ft^2):

CLEAR BLUE SKY:	at sea level, about 400 :	in mountains, about 200.
CAUCASIAN SKIN:	in clear sun, 400-600 :	in open shade, 50-75.
SNOW:	in flat sun, 1600+ :	in open shade, 200+
MASS FOLIAGE:	in flat sun, 100-200+ :	in open shade, 13-25+
	OAK TREE BARK in open shade, 6.5-13.	

The grouping of subjects in the table below should serve merely as a basic guide; it should not be followed so rigidly as to thwart individual expression. Freedom of interpretation is all-important. The basic approach outlined in these books is valid only if it ensures a technique through which to express personal concepts.

Low Values

Zone 0.　　Complete lack of density in the negative image, other than film-base density plus fog. Total black in print.

Zone I.　　Effective threshold. First step above complete black in print. Slight tonality, but no texture.

Zone II.　　First suggestion of texture. Deep tonalities, representing the darkest part of the image in which some detail is required.

Zone III.　　Average dark materials. Low values showing adequate texture.

Middle Values

Zone IV.　　Average dark foliage. Dark stone. Landscape shadow. Recommended shadow value for portraits in sunlight.

Zone V.　　Clear north sky (panchromatic rendering). Dark skin. Gray stone. Average weathered wood. *Middle gray* (18% reflectance).

Zone VI.　　Average Caucasian skin value in sunlight or artificial light, and in diffuse skylight or very soft light. Light stone. Clear north sky (orthochromatic rendering). Shadows on snow in sunlit snowscapes.

High Values

Zone VII.　　Very light skin. Light-gray objects. Average snow with acute side lighting.

Zone VIII.　　Whites with textures and delicate values (not blank whites). Snow in full shade. Highlights on Caucasian skin.

Zone IX.　　Glaring white surfaces. Snow in flat sunlight. White without texture.

(The only subjects higher than Zone IX would be light sources, either actual or reflected; but they would obviously be rendered in the print as maximum white value of the paper surface.)

The above table of subjects in relation to zones should be considered only as a stimulant to individual concepts. It would be quite impossible to make a definitive relationship of a given subject value to a given exposure zone—for both practical and esthetic reasons. But we may *sense* certain relationships—such as dark trees against an overcast sky or black gloves against white velvet, which suggest a black-against-white mood; snow on dark rocks, bright metal against dark wood, etc., suggesting a white-against-black mood (and, of course, infinite combinations of white, gray, and black values)—without being concerned overmuch with their absolute values. We *feel* the whiteness and the darkness and the grayness of our subjects, and we visualize a print in which these values are expressed in an emotional relationship with one another.

As we shall see in the chapter on Visualization (page 21), all values are relative. The only absolute values in the final print are the pure white of the paper and the maximum black of the silver deposit. The unexposed edge of the negative represents minimum negative density (opacity), and in relation to the deepest value of the image will appear as maximum black in the print. Zone 0 represents this value (the "basement" of tone), and Zone IX represents maximum white (the "ceiling" of tone.)

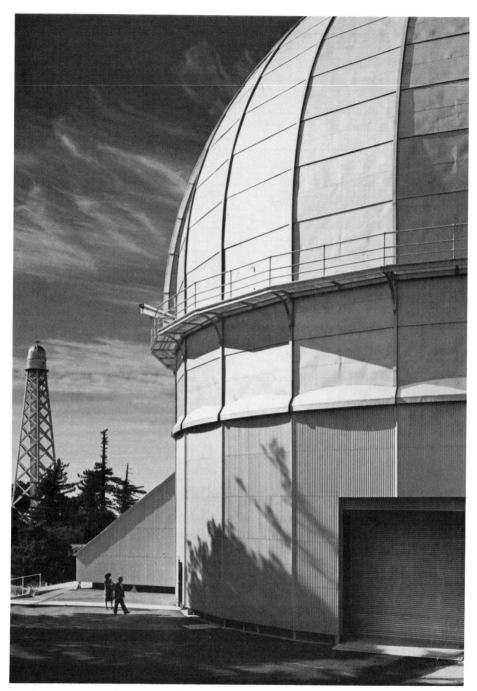

8. Mount Wilson Observatory, California. A subject of over-all high brightness; the mood is one of enveloping light and clarity. The range of brightnesses was rather severe, and a normal-minus development was indicated (page 47). Note that the shadow values are in logical relation to the glare.

VISUALIZATION

The concept of visualization, as set forth in this series, is extremely important; it is a subjective, creative approach and must not be confused with a photometric "tone-reproduction" approach, sensitometrically defined.

A photographic print is either the representation of a subject or a free interpretation of it ("reality" or "departure from reality").

In the first instance, the values in the print are related as closely as possible to the luminances (reflectances) of the subject; yet this is only a *suggestive* representation, since no print can successfully reproduce the brightnesses of the average subject. But if the values as rendered have a proportionate relation to those in the subject, the representation may be considered "literal."

If the photograph is to be a free interpretation, then values in the print may represent a definite departure from reality. Values are altered by expansion or diminution of contrast—through control of exposure and development—and further exaggerations are made possible by filters. However, except with extreme color correction or with the use of "color-blind" or infrared-sensitive emulsions, values retain their basic visual light-dark relationships. In other words, with normal procedures we cannot reverse the natural sequence of values: Caucasian skin is always lighter than most foliage, and sunlit clouds are always lighter than blue sky. Exaggerations of contrast, textural emphasis, and the subjective elements that the photographer may introduce assure a wide range of interpretative possibilities without deviating from a straightforward photographic technique. Limits are esthetic and subjective as well as physical and objective.

The first step in visualization—and hence in photographic interpretation—is to become aware of the world about us. We must examine and explore what lies before our eyes, not only for significance, substance, form, and texture, but for related brightnesses and tonalities as well.

Now what is meant by "visualizing the print"? Referring to page 15, we see that the maximum range of reflection density (brilliance) of a glossy print image is about 1:50. (Not to be confused with the exposure scale of the paper. See Book 3.) That means that the blackest part of the image reflects only 1/50 as much light as does the white paper base. Hence, no matter how great the intensity scale of the original subject may be, the visual scale of the final print is but 1:50. The important point to remember is that (with very few exceptions) the print should represent the full scale from black to white; the brilliancy limits of the scale are determined by the reflective capacity of the paper base and the maximum deposit of silver. The selection of tones between these limits is determined largely on a subjective basis. In other words, the tones between the pure black and the pure white need not be expressed in fixed relationships to the extremes. For example, in a portrait, if a part of the background be visualized as pure black and a part of the costume as pure white, then the tones of the skin may be represented as Zone IV or V or VI values as desired, although the extremes remain approximately unchanged. (Such control is discussed further in Placement, page 31). Therefore, understanding that all good prints possess one or both of the extremes of black and white, plus a wide range of middle tones, we may train ourselves to visualize—or see in the mind's eye—single or multiple values in terms of blacks, whites, and grays of the print.

We should begin by trying to visualize white, black, and middle gray, then

the more subtle divisions of the scale. When we feel satisfied that we can visualize simple areas of tone, we may think of specific components of photographic images in terms of tones. Studying prints helps in learning to recognize the various tones and separations of tone, and their relationship to subject values. Training in visualization of print values may be compared to a musician's training for recognition of pitch, or a painter's awareness of color values and relationships.

A suggested plan for practice in awareness and visualization is as follows:

1. Scan the subject for the darkest significant part. Take nothing for granted; at first glance a black cloth may appear to be the blackest area of the subject, but on more careful scrutiny deeper values and empty shadows may be perceived that are darker than the black cloth. In fact, many objects that appear black are only deeper shades of gray; school blackboards, black hats, black cats, are not truly black in the photographic sense, since they possess substance and tonal variation. At this point of the discussion, consider them as dark—not black— objects. They can be rendered black if you so desire, but you should be concerned at first only with literal values.

If we coat a card with lampblack we have a surface that is severely black. But consider an opening in a wall—a ventilator aperture, for example—that is totally unilluminated. If you compare the depths of the black hole with the surface of the black card, the latter appears merely a very dark gray. However, the card alone against lighter grays and whites might very well be accepted as entirely black, and treated as such in the final print.

2. Scan the subject for the lightest significant part. Again, take nothing for granted. The lightest object in the scene may be a piece of white paper, but the specular reflection of the light source from a polished metal surface has far greater intensity than the brightest diffuse light from this source reflected from the whitest paper.

3. Next, try to think of the brightest white and the deepest black in terms of print values. The specular reflections (highlights) from a polished silver spoon lying on white cloth are brighter (and should be rendered whiter) than the cloth. The highlight is properly rendered in the print as an area of pure white, and the white cloth as an area of very light gray. But remove the spoon; the cloth, now being the whitest object, may be rendered whiter than with the spoon lying on it; if the impression of substance is not desired, the cloth may be rendered as a pure white (without texture) in the print.

4. Having practiced observation of extreme values, and thinking of them in terms of the final print, you can practice observation and visualization of other values at the middle of the scale. Compare a middle-gray card with a white object, then with a black object, then with both together. It does not appear the same—either visually or emotionally—in these different comparisons. No value has been changed, but the various combinations have introduced subjective effects. Similar, but far more stimulating, effects may be observed when colors are combined. For example, place a green leaf on a red surface, then on a blue surface. The emotional effects vary to an impressive degree, although the colors themselves are not changed. Photographic control of color values is suggested in the comparative illustrations of Figures 9 a-d (page 23) and in Figure 3 (page 6).

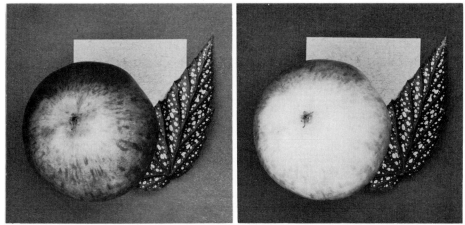

9a. Panchromatic film, no filter. 9b. Panchromatic film, A filter.

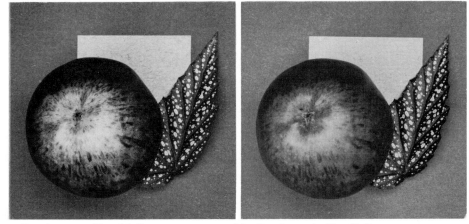

9c. Panchromatic film, C5 filter. 9d. Panchromatic film, B filter.

9. Apple, Leaf, Card—Comparison Group. A conventional apple, a yellow-speckled leaf, a blue-green card, and a neutral gray card. The prints are scaled so that the value of the neutral card is the same in each.

Thus it is clear that the emotional value of a certain tone may depend more on its relationship to other tones than on its intrinsic value. In your visualization, you must learn to recognize the importance of such relationships. A gray scale of 10 steps of tone, including black and white, is entirely adequate. More steps would be confusing. Besides, this scale of values, defined as *zones*, corresponds to the divisions of the Weston-meter scale. Middle gray is the sixth step, or Zone V (page 16). Also, both the sequence of zones and the sequence of the lens apertures are geometric; a difference of two zones can be expressed by a difference of two stops of the lens.

The beginner's problem is to become aware of tones; the accuracy of our perception increases with study and practice in visualizing print values. Some persons can visualize black, white, and middle gray with ease; others must work at first from either end of the scale, thinking of pure white, then a faint gray. then a slightly darker tone, and so on down to pure black or from black to white.

When a serviceable concept of the gray scale has been gained—it should not take more than a few days' intermittent practice—you can begin to relate subject values to print values, thereby attempting true photographic visualization.

As is shown on page 2, the values in the subject may be described as reflectances or brightnesses of reflection. In every subject there is a definite range of values from darkest to lightest—in a relative sense, from black to white. The actual brightnesses in a sunlit landscape may have a range in excess of 1 to 1600, while those of a low-contrast subject may lie within a range of 1 to 10 or less. For instance, shadowed dark wood may register 2 units of brightnesses in a sunlit landscape, while white stone in sunlight registers 1200 units. Black to white represents, here, a range of 1 to 600. Again, in a softly illuminated room the shadow in the recess of a cabinet may register 1 unit of brightness, a light gray wall 25 units, and a white paper on a desk 40 units. The scale from black to white then represents 40 units. In either case, a print may be made to *suggest* the entire range. If the print is on glossy paper and of full scale, its black-to-white range is approximately 1 to 50; within that range can be symbolized the 1-to-600 range of the landscape, the 1-to-40 range of the interior scene, or the very close range of an exceptionally low-contrast subject. Yet neither this compression nor this expansion of the range of brightnesses appears too unnatural to the eye, for in beholding any scene the eye accommodates itself to the average of the brightnesses in the subject; the perceived scale of brightness is independent of the actual brightness range in the subject. In the print—and therefore in the negative from which the print is to be made—it is not the actual brightnesses, but rather the relationships between them, that we wish to represent. In creative work we should think of *transcription* rather than *representation*.

Our problem, then, includes both concept and procedure. First, we are aware of the subject for its factual and emotional content. Second, we visualize the print through which we desire to express our concept of the subject, and perceive in our mind's eye certain print tonalities relating to important values in the subject. Third, we measure the dominant brightnesses in the subject (with the photoelectric exposure meter), determining their range and placing them on the exposure scale as described later (page 31). As placement on the exposure scale determines the degree of development needed to obtain a negative of the desired range of densities (opacities), the exposure and the development of the negative may be outlined before the shutter is actually released (see page 26).

Once visualization and plan of procedure are established, exposure and development of the negative become matters of purely mechanical control. The negative can be "designed" for a particular treatment of the positive—either contact printing or enlarging (with diffuser or with condenser).* Therefore

* A negative of less contrast (lower opacity range) is required for condenser-type enlargers, because light passing through the condensers is *collimated*—directed into straight lines. The higher opacities of the negative scatter collimated light to a much greater extent than diffuse light; hence the effective contrast of any negative is greater with condenser light than with diffuse light. This difference in contrast can be expressed as a mathematical constant, known as the Callier constant (for André Callier, who first observed the effect). See *Photographic Journal*, Vol. 49:200 (1909), London.

what is required in creative photography—apart from functional and esthetic factors—is the establishment of a "norm" in regard to negative opacity. The implications of such a norm are discussed throughout much of this book. In a "normal" negative the range of opacities is suitably adapted to the particular

printing paper to be used, and to the means of obtaining the print (contact printing or enlargment). Since various lenses and shutters differ in their efficiency and accuracy, and different negative materials and developers vary in their effects and results, every photographer must establish his own norm relating to his equipment and materials. Further, the norm is influenced not only by the practical considerations involved, but also by the photographer's own emotional and interpretative objectives.

For establishing the norm, some definite recognizable subject value that is usually rendered of consistent value in the print should be chosen as a reference or "control." I select normal Caucasian skin value (in 45° angle of sun, or in full shade) as a universally recognizable value. Such subjects as blue sky, gray wood, white stone, are too variable—but everyone will recognize normal Caucasian skin tones as lying within a reasonably narrow range of values. As is seen on page 97, skin tones belong on about Zone VI of the exposure scale. This value, lying a little above the middle gray of the scale. may be used as the basis of the tests for the norm (see page 39). The standard gray card (The Kodak Neutral Test Card), representing 18% reflectance, is now commonly used as the basic testing value.

Before proceeding farther, you should explore and become aware of the values in some good prints selected at random; then explore and become aware of the values in several aspects of the world about you; then make a very definite effort to visualize a print that *you* might make to express something in your immediate environment. You will find that within a short time your ability to visualize prints is sharpened. Above all, you will develop a much richer appreciation of the world about you and the photographic possibilities on every hand. *Awareness* is as essential to photography as to all other forms of art.

The photographer seeking to record or interpret any part of this world has little control—except through selection and point of view—over the myriad variations and qualities of any subject. Size, shape, color, position, brightness, surface, must all be rendered as two-dimensional shapes in varying shades of gray which. at the discretion of the photographer, are conceived as symbols of reality. Photography is a fairly flexible medium. Although it is impossible—because of shutter inaccuracies, variations in individual lenses, and lack of uniformity from one batch of film to another—to secure negatives of absolutely consistent physical qualities, still the "latitude" of negative emulsions permits some deviations without serious impairment of the final result. Moreover, moderate irregularities may be controlled through choice of printing papers and print developers. Shutters should be checked and their *actual speeds* determined.

Following this esthetic experience of visualizing the print, we then practice simple mechanical procedures of: a) measuring the brightnesses of the subject, b) placing the brightnesses on the exposure scale, and c) determining the degree of development required to give a negative of the desired opacity range. These points are more fully discussed in the following pages.

I beg you not to be discouraged by the apparent complexity of this approach. I suggest you read the book through, and then return to this chapter for clarification. The approach involves the application of several factors of thought at one time, and no matter which factor is presented first, a slight confusion is unavoidable until the other factors have been explained, separately and together. The confusion is quickly resolved when all the factors are understood.

THE EXPOSURE CHART

On the opposite page (Fig. 10) is reproduced the exposure chart [*Exposure Record*, Ansel Adams; Morgan and Morgan, Scarsdale, New York. Descriptive text and 100 record sheets] I have evolved and which has enabled me to make better use of my time, effort, and materials. The chart has two functions: It offers a new method of recording exposures, and—through the simple but complete record—provides a means of diagnosing the cause of most errors in the finished negative. Certain indications in the chart are obvious, requiring no discussion.

The first line, "Relative Lens Stops," merely indicates the progression of standard f-apertures; their effective transmission is indicated by the related numbers in line 3. For instance, an aperture of f/11 transmits 16 units of light, while one at f/22 transmits 4 units; or f/32 transmits 1/64 as much light as f/4.

The second line gives the relative exposures for the various zones in relation to Zone V; it is useful in computing placements of brightness values when meters other than the Weston are used (see page 62). It also may be used in conjunction with the top line for judging the relative values of the lens stops.

The third line, giving the relative exposures with Zone I as a reference, is valuable in determining units of exposure—of great importance when using artificial light or for synchro-sunlight photography (see Book 5).

The fourth line is the conventional Weston Master Exposure Meter scale, with the addition of a step below the U and a step above the O. It will be noted that the arrow corresponds to Zone V on the exposure scale, and represents the middle-gray tone (the sixth step in the entire progression of the gray scale). The lowest line gives the exposure zones, printed in Roman numerals to avoid confusion with exposure ratios and other numerical indications.

As shown in Figure 10, many values and operations can be indicated on the chart. The lowest value merely represents the lowest *important* value, not necessarily the actual lowest value of the scene. The highest texture values will usually fall in Zone VI or VII, and any values indicated in Zones VIII and IX represent the near-whites and pure whites of the image. If the development indications are "normal" ("normal" is used to signify optimum development determined by personal requirements and evaluated by practical test.) this signifies that the important values in the subject are placed in their approximate normal positions on the exposure scale. If the development instructions are other than normal, this usually means that the higher values are to appear in a higher or a lower tonality than their actual placement on the exposure scale would suggest. For example, suppose we wish to make a strong, vigorous portrait in sunlight. We will presume that skin value in sun normally belongs on Zone VI, but in order to intensify textures and achieve a more intense separation of tones, this essential value is placed on Zone V, one zone lower on the scale. The zone in which we desire to have this value appear in the print can be designated by running a short line from the recorded brightness to an X placed in the desired zone column. *More-than-normal* development is indicated for an expansion of values. (See pages 46-47.)

Conversely, if a compression of values is required (see page 47) the particular value in question is placed in a higher zone, and *less-than-normal* development is indicated. The X again is used to signify the lowered zone (tonality) desired in the print. Use of a color filter may raise or lower tonalities, supplementing the effect of exposure-development control. Deep-blue sky, registering about

EXPOSURE RECORD

Designed and Copyright by

ANSEL ADAMS

Morgan & Morgan, Publishers

SHEET NO.
FILM
SIZE
DATE LOADED

PLACEMENT OF SUBJECT INTENSITIES ON EXPOSURE SCALE

REL. LENS STOP F/	64	45	32	22	16	11	8	5.6	4	2.8
REL. EXP. FOR V	1/32	1/16	1/8	1/4	1/2	1	2	4	8	16
REL. EXP. FOR I	1/2	1	2	4	8	16	32	64	128	256
WESTON SCALE	–	U	I	–	A	→	C	–	O	–
ZONES	0	I	II	III	IV	V	VI	VII	VIII	IX

NO.	SUBJECT	0 (64)	I (45)	II (32)	III (22)	IV (16)	V (11)	VI (8)	VII (5.6)	VIII (4)	IX (2.8)	FILM TYPE OR SPEED	F.L.	EXT.	x	FILTER NO.	FILTER x	STOP	EXP.	DEVELOPMENT
1	Fig. 1, page ii, University Build		6.5	13				200			1600	50	5¾	––	–	––	–	32	1/5s	NORMAL
2	Fig. 2, page viii. Plaster Head		6.5				100		x·····	800		50	7	8	1.3	––	–	32	1/5s	NORMAL––
3	Fig. 7, page 17 At Hornitos, Cal.		1.6				····x 25		····x 100			50	5¾	––	–	––	–	16–	1/5s	NORMAL+
4	Fig.12, page 32 Longs Peak, Colo.		13	25	50	100	200				3000	50	12	––	–	K2	2	45–	1/2s	NORMAL
5	Fig.13, page 36 Portrait		35				600±··x		1600··x			80	12	14	1.4	––	–	22	1/100s	NORMAL+
6	Fig.19, page 57 Mendocino, Cal.	6.5							800··x			50	19	––	–	––	–	22	1/25s	NORMAL+
7	Fig.21, page 66 Old Faithful Gy.				25	50					1600	24	7	––	–	K2	2	8	1/25s	W.B.
8	Fig.23, page 82 Sulfur Barges, La.				50		200		800			100	7	––	–	K2	2	16	1/50s	NORMAL
9	ditto (average reading)						Av 200					100	7	––	–	K2	2	16	1/50s	NORMAL
10	Fig.24, page 87 Mesa Verde N.P.					13	Av 25	50				50	12	––	–	K2	2	64	3s	NORMAL++
11	Fig.31, page 105 Turbine-generator		.8				13			x···	200	50	7	––	–	––	–	45	4s	W.B.
12	Entry with meters other than Weston			1400		1/12 1400			1/100			50	SEE TEXT – PAGE 62					8 / 16	1/100s / 1/25s	NORMAL

DATE EXPOSED
PHOTOGRAPHER:
PLACE:
JOB:
REMARKS OVERLEAF

10. Exposure Record Chart. Refer to text for description and methods of use. Examples filled in should be studied with the illustrations in this book. In cases when the standard shutter speeds only approximate the calculated speed (1/5 vs. 1/6), a slight compensation is made with the aperture setting.

200 candles per square foot, is normally placed on Zone V (panchromatic rendering); but with a K2 filter, the effective placement of that sky is dropped to about Zone IV, though other parts of the scene are only moderately affected. It must be recognized that changes in effective placement which are brought about by use of a filter are not the same as those governed by development. Awareness of filter effects is gained largely by direct experience.

The outline of subject values as entered on this chart, together with notations of lens extension, filter used, etc., and with the indications of film speed, lens stop, exposure time, and desired developing procedure, gives a concise description of the negative, proving invaluable not only for exposure calculation but also for analytical evaluation and future reference.

It must be emphasized that unless all entries in this chart are *accurate*, the chart is worse than useless.

Moving from *left to right* the brightness value of each succeeding zone is exactly doubled; from *right to left* the value of each succeeding zone is halved. This parallels the progression of the lens apertures. Establishing a numerical value for any one zone demands that the values for all other zones be in proportionate relation. If a value of 50 is placed on Zone II, 800 can appear only on Zone VI and 25 only on Zone I. The complete technical data, including printing data that should accompany photographs, are discussed in Book 3. Rather than merely saying that such and such a photograph was "made at 1/25 at f/16"—such a statement having no meaning in itself—the technical data should include the dominant brightnesses of the subject and their placements on the exposure scale, together with the desired development of the negative and notes on the making of the print.

If a negative turns out disappointingly, the photographer should refer to the chart; usually he is able to determine from it what went wrong. He should first check through the calculations, noting whether placements were accurate, whether lens extension and filter factor were accounted for, and whether the computations for lens stop and shutter speed were correct. If he finds that his records are correct, then he should investigate such external causes as error in film speed, old film, faulty meter—or, more probably, faulty reading of the meter—inaccurate shutter operation, or exhausted developer or incorrect processing. As will be discussed on page 55 (procedure of testing), the flare factor of the camera and lens must be taken into account as well as the transmission of lens and shutter.

Unless we are certain of the brightness values of dominant parts of the subject, exposure and all other data are irrelevant. I therefore recommend the following outline for recording exposure and development data:

List brightness of lowest, middle, and highest values in the zonal placement columns, and set down the development instructions in the extreme right column. In separate columns note the speed rating of the film, lens data, filter data, stop used, and exposure time. Exposure time at any stop can be computed mentally in a moment.* However, in carrying out a full descriptive documentation of the

* Note that when a film of ASA 64 is used, whatever brightness figure lies opposite the arrow of the Weston meter indicates the fraction-of-a-second exposure opposite f/8. If the brightness figure is 400, then the exposure is 1/400 sec. at f/8 (or the equivalent). If ASA speed 125 is used, the exposure opposite f/11 is indicated by the brightness figure. If ASA speed 32 is used, the exposure opposite f/5.6 is indicated by the brightness figure.

photograph, all the data relating to exposure and development are necessary, plus data on the method of printing or enlarging, as well as the grade of paper and the kind of paper developer used. Such data are of exceptional value to other photographers, too, as the whole process is efficiently set forth; hence other workers are enabled to visualize the subject and its properties after analysis of the records.

We must never discount the value of experience. As we work with generalized subject material, we learn quickly some representative brightnesses under typical conditions, and therefore may not always have to refer to the exposure meter except as a check on brightness values under different lighting conditions. I know, for instance, that in the high mountains between the hours of 9 and 4 in summer, the sky just north of the zenith registers 200, meadow grass in flat light registers up to 200 and in cross light from 100 to 150, and that open shadow on it or on granite cliffs under similar lighting conditions registers about 25. If I visualize the open shadow as belonging on Zone III of the exposure scale, I know immediately that the indicated exposure is 1/100 second at f/8 for a negative of an ASA speed of 64. I know also that skin tones usually record from 400 to 600 in sunlight; they fall properly on Zone VI with the indicated exposure of 1/50 second at f/16 or f/16-22 on a negative of ASA speed 64. With such placements, normal development is usually indicated.

The value of all possible legitimate short cuts cannot be overemphasized. The less calculation between visualization and execution, the better. It is valuable exercise to study the various elements of one's environment, taking readings of their intensities at different times of day, and under different light conditions. Making up a reference chart from these readings and memorizing the more important values vastly facilitate work in the field; but it is important, too, to make a frequent check of values, for when one's judgment becomes inaccurate it is very difficult to regain a true concept of values without reference to actual readings. We must avoid the tendency toward careless omission of important steps of visualization, procedure, and notation.

It is sometimes helpful to take "average" readings with the meter, and to note the deviation between exposure based on this "average" and the exposure calculated from desired placement of the various subject values. The exposures generally differ, although occasionally they agree. But the two exposures will coincide more often with certain subjects and conditions than with other subjects and conditions: perhaps a key to an approximately correct exposure factor may be worked out for average readings of consistent subject matter. Average readings work best when the subject presents a balanced array of low, medium and high values. With flat, low-contrast subjects the average reading will be ½ or 1 full stop (or Zone) too low. (Refer to the indications of "average readings under Figs. 1, 11, and 23.) But dependence on "average" readings can never ensure precise exposure values; what is more important, the "average reading" procedure dulls acute appreciation of subject brightnesses and visualized print tonalities.

If the objective of photography were merely to obtain a physical image of the subject in which any expression and interpretation were only fortuitous, there would be little need for these books. However, once imagination and expressive interpretation are involved, *controls* become necessary. These controls must be precise and positive, so that the expressive intentions of the photographer may be fully realized.

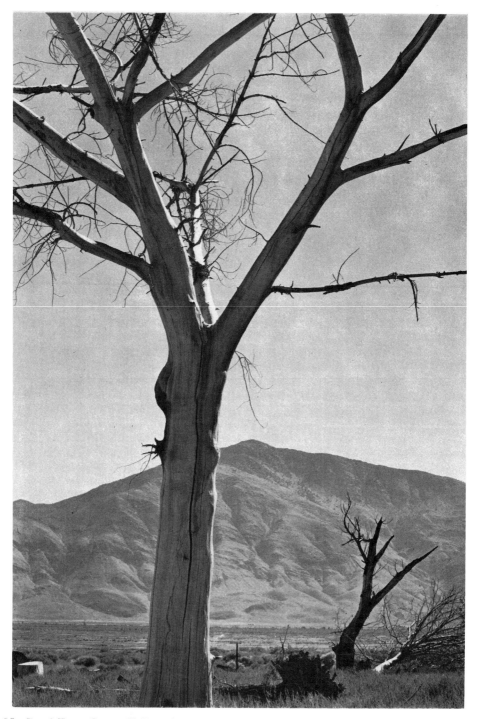

11. Dead Tree, Owens Valley, California. No filter used; atmospheric effects preserved. Average meter reading indicated too short exposure; bright areas of sky would have dominated.

PLACEMENT OF VALUES ON THE EXPOSURE SCALE

The procedures of visualization, exposure, and development are based on a series of generalized evaluations. Few subjects are of simple, bold tonalities; most are composed of a wide range of subtle variations of brightness, color, and texture.

However, not many subjects present a range of brightnesses greater than can be encompassed within the effective exposure scale of the negative; an exposure-meter reading that *averages* all the reflected brightnesses, or gives incident-light readings, usually permits both high and low values to fall within that scale. Recommended development times yield negatives of average opacity range that may be printed on contact or enlarging paper of standard grades of contrast. In addition, the negative can be reduced, intensified, or locally manipulated, and a certain amount of control can be exercised in making the print, to obtain a photographic print that may be adequate within ordinary standards. *If the photographer does not seek a higher degree and intensity of expression, he can rely on this simple average procedure with reasonable assurance of acceptable though perhaps uninspired results.*

However, if the photographic statement is to be acute and creatively expressive, then detailed visualization of the final print is essential (page 21). The perceptive artist is sensitive not only to the significance of the subject, to form, placement, and design, but also to the subtle relationships of tonalities and to the revelation of substance and the illusion of light. To express and reveal these qualities satisfactorily, he must make a careful study of the placement of various brightnesses of the subject on the exposure scale, of the optimum development corresponding to the placement, and of the printing processes employed. The term "optimum" is here used as a personal and arbitrary term—the placement of brightnesses on the exposure scale is imaginative as well as factual, and many personal factors are involved (see Fig. 12, page 32). Two photographers working with the same subject material could have an entirely different concept of values and would place the subject brightnesses on different parts of the exposure scale.

Visualization, exposure-meter readings, placement of values on the exposure zones, and certain manipulations in development of the negative and in making a print from it can all be applied toward the artist's own interpretation of a subject.

Let us see how we can use the readings made with the Weston Master Exposure Meter—and the relationships between them and the exposure zones that have already been pointed out (Fig. 6)—to determine the exposure necessary so that a certain subject may be represented by the desired tonalities in the final print.

Suppose that in a landscape there is some important feature we wish to represent in the print as middle gray, and that it gives a meter reading of 200. We place the arrow of the exposure calculator opposite the 200, since the arrow corresponds to Zone V, or middle gray. If we are using film with an ASA speed rating of 64, and have adjusted the calculator accordingly, then when we set the arrow on the dial opposite 200 we read from the lower scale that the required exposure is 1/100 at f/11—or 1/200 at f/8, or 1/50 at f/16, and so on. Now let us see whether or not other values in the subject will fall within

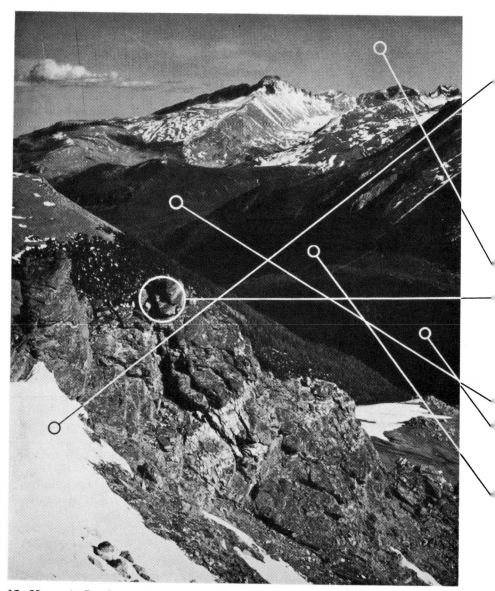

12. Mountain Landscape (Longs Peak, Colorado) and gray scale. This is a typical problem of outdoor photography. Visualization was based on a somewhat normal interpretation of values, although the shadows have been a little deepened by the use of a yellow filter. Within the limitations of the halftone process, we can see how the values of the subject were related to the gray scale. The first step in visualization was to define the limits of the scale. The glaring white snow in the foreground was obviously at the top of the scale—practically a pure white (Zone IX). If this were placed on Zone VIII, the effect would be rather depressing, as so much of the image lies in deeper registers of tone. The areas that represent Zone 0 are negligibly small; the lowest value (deep shadow in forest) was visualized as being of Zone I value. Hence, the lightest and darkest brightnesses of the subject fall on their normal positions on the scale. The other values also fall on the appropriate zones. As a light-yellow filter was used, I placed the shadow values about one-half a zone higher on the scale, knowing that the filter would deepen their values. The sky fell on Zone V without the filter; with the K2 filter, it was recorded as about Zone IV value.

GRAY SCALE	EXP. ZONES	WESTON SCALE	EXP. UNITS	
	IX	—	256	Representing glaring white snow.
	VIII	O	128	Had there been more variation in the other tonalities of the picture, the snow recorded as Zone IX above would have been placed on Zone VIII—for textural and tonal effects.
	VII	—	64	No important brightness of the subject relates to this zone (VII).
	VI	C	32	No important brightness of the subject relates to this zone (VI).
	V	↑	16	Average brightness of rocks in sun and shadow would fall on this zone (actually checked by meter reading on the subject).
	IV	A	8	The sky usually is of Zone V value (higher near the horizon). The K2 filter reduced it to about Zone IV. If the sky were of Zone V value here, it would lessen impact of higher values.
	III	—	4	Dark foliage in sunlight falls appropriately on this zone (III).
	II	—	2	Dark foliage in half-light falls appropriately on this zone (II).
	I	U	1	Deep shadow falls on this zone (I).
	O	—	½	No important brightness of the subject relates to this zone (0).

Refer to line 4 of Exposure Record (page 27) for exposure data and method of recording.
The halftone engraving process can only suggest the correct progression of values from I to VIII.

the desired zones when the negative is given normal development. A reading on the most deeply shadowed portion of the scene may extend from 13 to 25; these correspond to Zone I—the U on the dial—and Zone II, so we know that even the darkest area of the print should show some value, not merely undifferentiated black. Important values fall above the threshold of exposure. Next we consider the higher values. There may be light objects reading from 400 to 800, corresponding to Zones VI and VII. If we are satisfied to have them placed on these zones, then the indicated exposure and the usual "normal" development procedure will produce a negative basically suitable to the desired interpretation. (The foregoing is of course based on the assumption that we use a paper whose exposure scale closely approximates the opacity range of the negative. If the paper scale is too long, the print will be "flat"—if too short, the print will be harsh.)

Note that determination of the placement of any one value on the exposure scale automatically determines placement of the other values. Each successive exposure zone, from the lowest to the highest, corresponds to a brightness which is exactly double that of the preceding zone. If we decide to interpret as middle gray a value that reads 50 on the Weston meter, then the Zone I value is 3.2 and 400 falls on Zone VIII (see Fig. 6, page 14). This inflexible relationship may frequently require changes in development procedure. For example, if a reading of 3.2 is placed on Zone I, then values of 800 or more (falling on Zone IX) will be rendered—under normal development and printing—as dead white, lacking substance and texture. Fortunately, however, we can effect considerable control through the development process. Increasing the time of development expands the opacity range of the negative; decreasing it compacts the range. For example, the placement desired for a low value may cause a certain high value to fall on Zone VII when we wish to render it as Zone VIII (textured white). The range of brightnesses in the subject is less than the exposure scale of the negative and with normal development the resulting opacity range of the negative may be too short, so that in a print made from it by usual procedures the high values are not high enough in relation to the deeper tones. To obtain a Zone VIII density (opacity) with Zone VII placement (for normal paper), it is necessary to give more than normal development and so achieve the required higher opacity range (contrast) in the negative, or to resort to a printing paper of shorter exposure scale. I feel that it is advantageous to concentrate on a paper of one grade and type, and therefore recommend increased development of the negative as the better solution (see page 98).

Special procedures in development are explained in detail later in this book. We may recapitulate here: The usual exposure-development-printing procedures may be modified, according to personal concepts (departure from reality), by a) alteration of exposure and development processes, b) selecting paper of a different exposure scale from that ordinarily used, c) controlling the quality of the printing or enlarging light and the time of exposure, d) varying the print-developing time or altering the composition of the print-developing solution. While we may draw upon numerous controls, it is my personal opinion that the most important control lies in exposure and development of the negative, and the use of but one contrast grade of paper, which vastly simplifies darkroom procedure, and assures a more positive fulfillment of the original visualization.

We must not overlook the fact that the color sensitivity of different emulsions

used will cause subject colors to be rendered in different values. For example, red will not be recorded on ortho film (see page 5), and green will be recorded somewhat darker on pan film than on ortho film. Accordingly, let us begin with a Type B panchromatic film, which most nearly approximates the eye in color sensitivity. It will require some experience before we can visualize how various colors will be represented in gray values, but the use of the Type B panchromatic film will minimize this difficulty. When the photographer feels secure in his ability to visualize with this film, he can then explore the effects of "ordinary" (color-blind) and ortho films. The Wratten #90 Viewing Filter minimizes subject color differences and shows about how the unfiltered Type B panchromatic film will interpret the scene.

In Figure 12 and the accompanying gray scale we can observe a problem of placement. When we look at the symbolic gray scale we observe first the limits of the scale, the lowest and highest brightnesses to be represented by the blacks and whites of the print. In the illustration, the first values perceived are the intensely black shadows on the distant trees and the white snow in bright sun.

It is probable that everyone would place the black shadows at the bottom of the scale and the glaring white snow at the top. With the shadows placed on Zone I, the brightnesses of the snow fall on Zone IX or higher, and optimum development would be that amount of developer action required to produce a sufficient opacity range in the negative for the snow to print as a pure white and yet render the shadows properly as intense black. Were the negative given less than optimum development, there would not be enough difference—enough contrast—between the negative opacities corresponding to the shadows and the snow. If the printing time were sufficient to bring the blacks to their proper depth, the densities of the image representing the snow would print as a gray-white; or if the printing time were short enough to retain the pure whites, the expected blacks would be only dark, inadequate gray. To be sure, the use of higher-contrast paper would help—but, as previously stated in this book, printing procedures are based on the use of normal-contrast paper, and negative development should be carried out accordingly. (See Book 3.)

We have used an approach based on the old maxim "Expose for the shadows and develop for the highlights." Let it not be thought that this procedure can be *exact*—it can, however, become very dependable. In ordinary practice the highest values of the subject should not be considered at first; we should begin by visualizing the important shadow or low values and placing them in the desired positions on the exposure scale. The essential high value—*not* the pure white—is then measured, and its placement on the exposure scale is established by its ratio to the shadow value. The key is to determine in every case the most important shadow value in which detail must be preserved, to place that value in its appropriate exposure zone, then to find the placements thereby determined for the other values, and finally to adjust the degree of development to obtain the desired high-value opacities in the negative. Development must be increased if the essential high value falls below the zone representing the desired tone in the print; it must be decreased if the high value falls above the desired zone. In other words, "Expose for the shadows and develop for the high values."* (Before proceeding, reread the above until it is clear.)

* I think of "highlights" as sharp, brilliant reflections without texture—quite different in quality from "high values," in which texture is preserved.

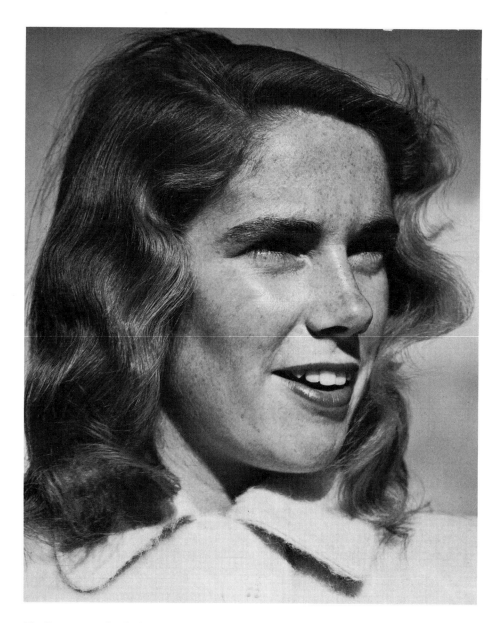

13. Portrait in Sunlight. As the shadows indicate, the lighting was rather flat. Taken in late afternoon, against sky, no filter. Skin values placed on Zone V, development normal-plus. The original print shows more subtle detail throughout the image than reproduction can hold. The object of the low placement and more-than-normal development was to get an image of textural clarity and brilliance. In a way it is an intentional exaggeration of the subject (not many subjects are willing to be interpreted with such textural exaggeration). The tonal scale runs from the teeth (Zone VIII plus) down to the shadow in the hair (Zone I in the print). Zone 0 is represented by the total black in the mouth. The coat is about Zone VIII. It is an interesting observation that the entire range of the picture is encompassed by the teeth and the intense black behind them. Cover the mouth with a finger tip: a general impression of tonal weakness over the entire print will be apparent. The need for definite white or black (or both) accents is quite obvious.

If we begin by planning our print—say a portrait—by visualizing and determining the limits of the tonal scale, then the next step is to visualize the desired tone of an important key value—in this case, skin. Approximately normal placement of average Caucasian skin value is on Zone VI—although conditions and personal preferences may suggest departure from this norm. We place the intensity of the skin on Zone VI, and if we give the negative optimum development for our particular purposes, we find that a print on normal paper reveals skin value at the required tone and at the same time shows the unexposed edge of the film as a total black (represented by Zone 0). If on achieving the desired tone for the skin we find that the film margin is not rendered pure black, the reason may be found in one or more of the following:

1. The negative was not developed to the optimum degree to achieve the required opacity for skin value. *Remedy:* Check potency of developer solution, temperature, agitation, and timing. If all are satisfactory, then check exposure meter and shutter. Errors are frequently the result of sheer carelessness in calculation of exposure, or in exposure procedures. Do not blame equipment or materials until a careful check has shown no errors in procedure! Refer to page 44 for suggestions in taking accurate meter readings.

2. The film may have deteriorated through exposure to moisture, heat, chemical fumes, or age. Or the film may be fogged (see page 52).

3. The paper used has too long a scale. *Remedy:* Use paper of shorter scale. These factors are described in detail elsewhere in this book and in Book 3.

We need not concern ourselves if we find that the metered values of the *pure* whites of the subject fall higher than Zone IX on the scale; in this case we may want them to show as a pure-white value in the print, and any opacity above Zone IX will print as pure white. But if these whites should fall below Zone IX, then we must increase the development in order to expand the total opacity range of the negative; while all values increase in opacity, the lowest values show minimum opacity increase. As a result, the skin value may have a higher opacity in the negative than is normally desired, but the opacities in shadow areas are but slightly increased, and we can "print down" (print a bit deeper than usual), intentionally sacrificing some separation in the lowest tones. A common question is: When you have achieved the desired relationships between the opacities of Zone I or II and Zone VI, how do you know what the values of Zone VIII will be? It has been my experience that the controls required to produce the desired opacities for Zone VI values usually assure the proper opacities for Zones VII and VIII. We must remember that, even with one contrast grade of printing paper, we have considerable control in print exposure and print development. These controls are quite fully discussed in Book 3. In any event, even if we fail to achieve a "perfect" negative, we have recognized three general values in the scene—dark, middle, and light—and in placing these values (with a certain elasticity) at appropriate positions on the exposure scale, we can achieve a negative that is much closer to a controlled ideal than that which an approximate average meter reading could give us. Everything depends on adequate visualization of the ultimate print.

The table on page 18 lists approximate brightnesses of ordinary subject matter. These of course vary with seasonal conditions and the time of day, but the figures given offer a fairly good guide. It is important to recognize that although the reflected brightnesses of a subject vary with the intensity of the light source, the relationships between the elements of that subject are retained. For example, a rock under noonday sunlight may show a brightness of 200 candles per square foot and be related logically to Zone V of the gray scale. The same rock on an overcast day may have a brightness of only 25 candles per square foot and may still correspond to Zone V for the purposes of the desired interpretation. Let us assume that a deep-toned tree trunk is to be shown darker than the rock, and light-colored blossoms are to be rendered higher in value. These interrelationships are not affected by the change in intensity of illumination. The values by which objects are represented *in the print* may be independent of their actual brightness in the original subject. But only with special control, such as the use of monochromatic filters, infrared, etc., may subject values be actually inverted in the print; for example, a red object may visually appear darker than its blue background, but with a strong red filter it will be rendered lighter.

The photographer can literally command his values. As an example, for some special effect he may want skin value to appear on Zone IV (or on Zone VII). It is only necessary to place the brightness of this skin value—as measured by his exposure meter—on Zone IV (or Zone VII) and give the negative normal development exactly as if he had placed the skin value on Zone VI.

However, he may soon discover that placing a subject value upon any desired opacity in the negative for that particular value may produce unsatisfactory tones for other subject values. Suppose that in the above example the skin value reads 100 and the subject's dark dress reads 6.5; if skin value receives (normal) Zone VI placement, the dark dress then falls on Zone II. Normal development produces a negative from which both skin and dress can be printed in acceptable tones. But placing skin value on Zone IV (for special effects) lowers the dress value to Zone 0, and no matter how development may be modified, the negative shows no density in that part of the image, for the dress value has been placed below the effective threshold. An exception might occur if a developer giving exaggerated emulsion speed were used or the film hypersensitized before exposure. To achieve Zone IV tonality for the skin and yet retain texture in the dress, the photographer can place the dress value on Zone II (which brings skin to Zone VI) and then lessen the development time considerably. With this procedure he obtains a negative that represents skin value by a much lower opacity than normal. Of course the dress value is also lowered by the reduced development, but to much less extent, and therefore retains sufficient opacity in the negative to suggest substance and texture in the print.

It is important to remember that *increased* development results in *higher* effective placement of *all* values, but that the low values are changed far less than the high values; *decreased* development results in *lower* effective placement of values, with the lowest tones being least affected.

The matter of emulsion "latitude" may well be discussed here. Presuming that the straight-line section of the negative curve had an effective latitude of 1:64, a subject intensity range of 1:16 (as in the above example) could be placed anywhere on the straight-line portion of the exposure scale and given 1, 2, 3, or 4 times minimum effective exposure without theoretically altering the

relationships of tone in the image. While this is true in sensitometric theory (and, to a limited extent, in practice), we must realize that when values are placed higher on the exposure scale there is a consequent loss of the finest textural qualities and the most subtle tones of the high brightnesses resulting from certain effects due to scattering of light within the emulsion, diffusion of silver grains in development, etc., while with longer exposures lens and camera flare may alter the crispness of the lower values. (With a short exposure, lens and camera flare may be so weak as to fall below the effective threshold of the negative emulsion; with longer exposures they may produce a definite printable density.) In addition, with higher densities in the negative, the Callier Effect (page 24) becomes increasingly apparent, especially with condenser enlargers; lens and camera flare in the enlargers and reciprocity departure in paper emulsions further contribute to the total result. Hence, it is my strong personal belief that both exposure and development of the negative should be held at the practicable minimum consistent with detailed shadow values and translucent high values.

OBTAINING OPTIMUM OPACITY

It is impossible to formulate any valid specific rules—"An exposure of x seconds at aperture y is required when the average reading is z on a certain subject on January 19 at 2 P.M." Such rules are not applicable, for not only does every photographer have his own personal concept of the desired results, but there can be no assurance that his equipment is exactly the same as another man's. Exposure-meter readings, transmission by the lens, lens and camera flare, shutter speeds—all may be variable. Nor do even the most efficient developers give consistent results with various films.

The only thing a photographer can do is to make careful practical tests in which he accounts for all practical variables, thus establishing the "norms" by which he can achieve the desired opacity range in his negatives. They need not be tests of a highly technical nature; such tests made by a trained sensitometrist with complicated equipment would have little significance in ordinary practice. But the photographer should understand the characteristics—within broad limits —of his equipment and materials in relation to the work he intends to do. The variables of the process all have a definite effect on the values and contrasts in the negative, while the printing or projection method used requires negatives of specific contrast range. The tests to be made should be planned not only with the lens and the camera to be used in actual work, but also for each type of film and developer employed. At first glance these tests may seem rather arduous and time-consuming, but once a precise determination has been made for any given film and developer, other tests are relatively easy to carry out.

Figure 14, page 40, indicates how opacity may be affected by development times. We have seen how the relation between exposure and density (opacity) is represented in the characteristic curve for a given negative emulsion (Fig. 4), and we are familiar with the 10 steps of the gray scale and their relation to an actual photograph (Fig. 12). The schematic graph (symbolic rather than sensitometrically exact) of Figure 14, page 40, suggests the optimum contrast achieved (with various exposures) through variations of development time. We should note the following points as we study the different curves and their relationships:

1. This exposure scale is geometric (related to the lens aperture and Weston exposure-scale sequences), laid out on a 1, 2, 4, 8, 16, 32, etc., scale, with the exposure zones in large Roman numerals below. See Fig. 5, page 11.

2. The vertical scale is given in both logarithmic and arithmetic terms; the corresponding values are density and opacity, respectively.

3. Five curves are shown. The central curve represents the norm—the density or opacity range achieved by "normal" development.* Note again, please, that these curves are symbolic rather than actual sensitometric curves, and that we are concerned here with the optimum opacity for Zone VI exposure value.

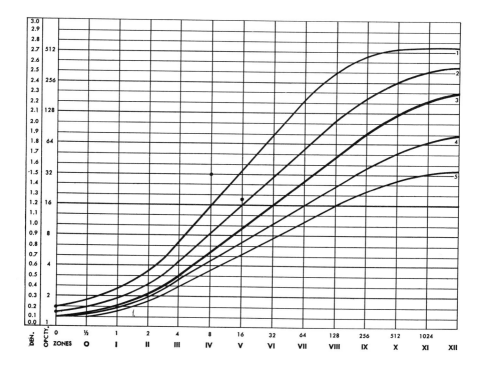

14. Group of Curves, suggesting effects of different times of development in relation to different exposures. The heavy horizontal line represents a density of 1.20—actually a density of 1.10 (opacity 12.5) above film-base plus fog density (0.10). The heavy curve symbolizes the exposure-density relationship of the negative when a Zone VI exposure is developed to a density of 1.20 (1.10 above film-base plus fog). It shows a Zone I density of 0.10 above film-base plus fog, and a Zone IX density of 1.80. The density range—from Zones 0 to IX—is 1.70, or an opacity range of 1 to 50, (approximating the exposure scale of a normal printing paper. Curves 1 and 2, representing long development times, may show a higher film-base plus fog density than 0.10; in which case the optimum density for Zone VI should be 1.10 plus whatever this film-base plus fog density happens to be.

* "Normal" development is an arbitrary value depending on a) personal concepts of values b) transmission factors of lens and shutter, c) character of the negative emulsion, d) character of the developer, e) method of printing—contact, or enlarging with diffuse or condenser (collimated) light, f) type of printing or enlarging paper to be used. All these values are integrated in a general routine procedure, based on tests and experience and controlled by the expressive objectives of the photographer. I am very anxious to convey my conviction that photography is a fluid procedure, not a rigid and mechanically limited craft.

4. The heavy horizontal line intersects the normal curve at the Zone VI vertical, and at a height above the base line representing a density of 1.20. However, at the base of the chart, we see that the film-base and fog density is arbitrarily assumed to be 0.1, so that the actual density represented by the heavy line is only 1.10—a density of 1.10 (or opacity of 12.5) above the film-base and fog. This I consider the optimum density representing Zone VI values in a negative that is to be used in contact printing or for projection with a diffusion enlarger.* It is achieved by Zone VI placement and "normal" development. Or to put it another way, that development is "normal" which produces a density of 1.10 (opacity 12.5) above the film base to represent subject brightness that has been given Zone VI exposure placement.

5. The curves rising more steeply than the norm intersect the horizontal line on the Zone V and Zone IV verticals. These curves represent what may be designated as normal-plus and normal-plus-plus development, respectively. Their significance lies in the fact that exposing a given subject intensity on Zone V and then developing it *more than normal* will yield the same (optimum) opacity or density as would be produced by Zone VI placement and *normal* development. Similarly, the same subject brightness can be given Zone IV placement and much greater development and still produce the optimum opacity for representing Zone VI brightness. Thus we see that, in terms of comparative scale:

Zone VI exposure with normal development represents 32 units of exposure as 12.5 units of opacity. Zone V exposure with normal-plus development represents 16 units of exposure as 12.5 units of opacity. Zone IV exposure with normal-plus-plus development (some films are normally incapable of such exaggeration of exposure-opacity values) represents 8 units of exposure as 12.5 units of opacity.

Since in each case Zone I values are but slightly increased, the separation of values—and hence contrast—is increased with lower placement and greater development. (Values below Zone I are not brought out by increased development, for they are below the effective threshold and are not recorded on the film.) As development is prolonged there will be a slight increase in fog density with low-energy developers; high—perhaps harmful—increase in fog with high-energy developers (see page 52).

6. Curves that rise less steeply than the norm intersect the horizontal line on Zone VII and Zone VIII verticals, and represent normal-minus and normal-minus-minus development. Exposure of a given brightness on Zone VII and decreased development can, here, result in an optimum opacity for that brightness identical with that obtained through Zone VI placement of the same brightness and normal development. Again we can make the comparison:

Zone VI exposure with normal development represents 32 units of exposure as 12.5 units of opacity. Zone VII exposure with normal-minus development represents 64 units of exposure as 12.5 units of opacity. Zone VIII exposure with normal-minus-minus development represents 128 units of exposure as 12.5 units of opacity.

* In the first edition of my *Exposure Record* I suggested working for a density of 1.4 (1.3 above film-base fog) for Zone VI values for contact printing. In the light of subsequent experience I have reduced that suggested value to 1.20 (1.10 above film base) for contact printing. (See 2nd edition, *Exposure Record*, Morgan & Morgan, Publishers.) The photographer is free to select any value he desires, within broad limits. If he were working with a straight condenser enlarger, his value for Zone VI exposure might well be density 1.00 or less.

ment and decreased development.

7. Reviewing 5 and 6 above, we see that a given subject brightness may be placed on any of 5 zones (IV, V, VI, VII, or VIII) and, by appropriate development, be represented in each negative by the same opacity.

Values are compacted by high placement with decreased development, or expanded by low placement with increased development.

The principle of expansion or compaction of values has been demonstrated with reference to only one desired opacity—that representing Zone VI brightnesses—but it is applicable to other placements as well. Subsequent text and illustrations indicate use of the principle in practical examples.

A purely mechanistic approach to photography does not favor control of mood, or of the illusions of light and of substance. For example, let us think of a forest scene: an environment of cool green light and mood, accented with brilliant fragments of sunlight and deep shadow. While the mood (the feeling or the experience of the scene) is one of smooth and rich environmental light, the actual brightnesses of the scene are rather extreme—perhaps 1 to 500—and a photo-

The separation of values—and hence the contrast—is decreased with higher place-

metrically appropriate image would certainly not be, in my opinion, expressively appropriate. A painter does not *match* the colors of his subject in his canvas; he modifies them—often to an extreme degree—to convey the deeper and more personal concepts and impressions of the world about him. In truth, art is the enlargement of experience. The general approach to photography fails in the sense that the elements of *experience* and *communication* of the deeper and more intangible aspects of the world and of people are made secondary to mechanistic-craft elements.

Assuming that a No. 2 paper is to be used—that is, a paper having a total effective exposure scale of approximately 1 to 50—the negative should have an opacity range of 1 to 50 (excluding those opacities which are to appear as pure white or solid black in the print). In other words, a range of brightnesses running from Zone I to Zone VIII of the exposure scale should appear in the negative as an opacity range of from 1 to about 50. Of course the actual range can be somewhat greater or smaller, as the process of printing is subject to some modification. The very subtle values of the blacks and the whites are difficult to explain in practical terms. It is more practical, and more convenient, to consider the key opacity as corresponding to Zone VI values on the gray scale. If Zone VI value is established in proper relation to complete black, it will be found in most cases that the higher values are adequately rendered. If Zone VI value is represented by a density of 1.10 above the density of the film base itself (or an opacity of about 12.5) in a negative that is to be used in contact printing or for projection with a diffusion enlarger, then for projection with a condenser enlarger the density should be about .90 or 1.00 above the film base (opacity about 8 or 10), depending on the character of the enlarging light. The Callier effect—the scattering of light by the particles within the emulsion—increases the effective contrast of the negative. This effect is least apparent when diffused light is used. See Book 3. These values have been established with regard to my own concept of tonal values; it must be thoroughly understood that they are by no means fixed values, and that each photographer should determine which opacity range is best suited to negatives for his own technical and expressive purposes.

When very precise evaluation is necessary, densities are determined by use of a densitometer, a device that measures the densities of the negative on a logarithmic scale.* Few photographers are expected to possess the most accurate and expensive instruments, but a relatively low-cost Kodak Densitometer is available. The Kodak Densiguide was formerly available, and may be found occasionally in stores. It is adequate for ordinary work† and should be checked against a good standard densitometer, and calibrated properly if there are differences between the densitometer readings and the indications on the Densiguide scale. Most engraving firms and color-photography laboratories have fine densitometers, which might be made available for testing purposes under special arrangement with the owners.‡ Although most densitometers are expensive, the Weston Analyzer, which is both a densitometer and a photometer, is moderately priced and is a very satisfactory instrument. (Photocell readings of density are more dependable than visual readings.) Not only is the Weston Analyzer accurate, but it is very simple and rapid to use. The S.E.I. meter (page 63) may be used as a densitometer for either transmission or reflection density measurements.

The photographer should review the demonstration of the formula described on page 12: **Exposure = Intensity × Time.**

Opacity Tests With Portraits

If the photographer accepts Zone VI value as normal skin value, he should start these tests by making a number of identically exposed portraits, placing the brightness of the skin—excluding highlights and shadowed areas when taking the exposure-meter readings—on Zone VI of the exposure scale and developing the different negatives for different lengths of time. The negative that yields the most satisfactory print therefore suggests the normal development time; more precise determination can be made in further tests. The value of any tone in the print is established in relation either to the pure whites of the paper base, or to the maximum black represented by the "print" of the unexposed edge of the film. I think the latter relationship is most understandable and also more closely associated with the negative opacity range; any print tone represents an opacity value on or above 1 in the negative. Obviously, the clear edge of the negative would be represented by the maximum black of the print (Zone 0 of the gray scale). This will be more fully discussed in Book 3, and page 53 of this volume.

At first reading, the procedure suggested for these tests may *seem* empirical and therefore contradictory to the recommendation that tests and controls be as precise as possible. Actually their end result is the assurance that the photographer will have a command of values based on his own emotional concepts, through application of methods established by careful experiment.

* Density is a logarithmic term; it is the logarithm of the opacity. Thus, for example, as working approximations, an opacity of 1 would be a density of 0.00, an opacity of 2 would be a density of 0.30, an opacity of 10 would be a density of 1.00, an opacity of 20 would be a density of 1.30, and so on. Refer to table on page vii.

† It is a small negative gray scale; any one of the densities of the scale can be brought into a small aperture in the card and directly compared (by juxtaposition) with the film to be measured. But only the edges of a film can be measured; the area of the image cannot be explored except by trimming it down to the parts to be measured. This is suitable when a test film is used, but obviously impossible with a valuable negative.

‡ A calibrated negative density scale is available from the Eastman Kodak Company on special order. It is of great accuracy, but represents a sequence of determined values, whereas a regular densitometer measures a continuous scale of density values.

The photographer has the choice of three ways of approaching the tests: 1) by simple trial-and-error methods (definitely limited); 2) by taking my recommendations on required optimum opacities, making tests of the exposure and development required to obtain those opacities, and then applying them to his own work, modifying where necessary; 3) by making an approximation of the development time required to achieve optimum opacity through actual portrait (or other subject) tests followed by tests with the gray card.

In making the portrait tests, most careful reading of the meter to determine skin value is required.* Reading should be taken from the side of the face, inclined so that it is about at a 45° angle to the direction of the light. The most positive readings are obtained in sunlight, between 9 and 11 A.M. or between 2 and 4 P.M., with the subject facing the south (in northern latitudes).

When the development time for the desired Zone VI opacity for skin value has been determined, the tests should be continued—make a number of identical exposures of a gray card (the exposures determined by placing the brightness of the card on Zone VI and not forgetting any lens-extension factor) and develop for varying lengths of time until an opacity is obtained which renders the same gray in a print as was considered the most satisfactory tone in the portrait test. Comparison is not hard if the flat area of the face (the cheek) is considered.

When the normal development time for Zone VI values has been established, it is advisable to test for the threshold, simply to see whether there is any chance of some basic miscalculation of film speed or some defect in the meter or the shutter. I choose for my threshold value—that is, the value of Zone I exposure placement—a density of 0.1 above film-base density. Film-base density varies, but may be read easily enough by developing an unexposed film for the normal time, thereby obtaining the degree of fog due to development in addition to the

* There appears to be some confusion on just how to make a correct reading of skin value. The following should be observed:
1. The angle of view of the Weston exposure meter (roughly 30°) is too wide to evaluate accurately an area such as the side of the face without intruding the shadow of the meter itself. Accordingly, a small extension tube should be made of firm black cardboard and fitted to the front of the meter. The length of this tube determines the effective angle of view and the multiplying factor (see Book 1, page 64). Very accurate readings of small areas of the face can be made with the S.E.I. meter (page 63).
2. The direct illumination on the face—sunlight or artificial light—should fall on it at an angle of about 45°. If the light is at a very low angle, the skin will reflect considerable glare; if the light angle is very high, the indicated value of the reflected light will be deceptively low.
3. The reading should be made with the meter axis perpendicular to the plane of the side of the face. If an extension tube is used, its multiplying factor must not be overlooked.
4. When a reading is obtained as in 3) above, the basic skin value can be considered as related to Zone VI. Variations of value of the illuminated skin surfaces will not vary to any serious extent in average work.
5. The brightness of the shadowed areas of the subject should be measured exactly as on the directly illuminated areas. Care must be taken not to allow the angle of view of the meter to include areas of higher brightness, such as bright areas of the face or background.
Important Suggestion: Once the photographer has established a typical skin-value concept and evaluation, he may procure a piece of cardboard approximating the color, texture, and reflective value of skin, and use this card as a basic brightness reference. It is worth the trouble to have this card prepared by a painter. The reverse side can be a pure, matte white —the uses of which will be described in Books 4 and 5. This card should be fully protected and kept clean. A card 18 inches square is adequate; 24 inches square is advisable. As the reflectivity of normal skin is about 35%, the card should have this same reflectivity on one side, and the highest possible reflectivity on the other (white) side. The Kodak Neutral Test Card shows 18% reflectance on one side and 90% on the reverse side.

basic density of the gelatin emulsion and the film base. With high-sulfite non-staining developers, average film-base plus fog density approaches 0.1, and the density (or opacity) range should be figured as above this density. If the threshold test indicates a density of, say, 0.15 above film density (0.25 including film base-fog density), it is almost certain that the film-speed setting for that particular film and meter is too low, or that the shutter timing is faulty. If this occurs, retest for Zone VI with the next higher film-speed value set on the calculating dial. The normal developing time may now be slightly longer. Test again for both Zone VI and threshold values. If the threshold values are now satisfactory, that meter setting is right for the film in question. [For Ansco Isopan in daylight, I use a film speed of 64 for a coated lens, a speed of 50 for an uncoated Dagor or Protar lens (4 air-glass surfaces), and a speed of 40 for an uncoated 6- or 8-air-glass-surface lens. See page 53.] If the threshold test indicates a density of 0.07 or less above film base-fog density we may suppose that the film-speed setting of the meter is too high, or that something is wrong with the lens-and-shutter system. Actually, the difference between a density of 0.10 and 0.07 is very slight; the corresponding opacities are 1.259 and 1.175, which would make the total opacity scales—in relation to Zone VI—(1.20) about 1 to 10 and 1 to 10.7. (See Speed Ratings of Films, page 58.)

15. Leaves, Glacier National Park, Montana. Low placement; normal-plus development; flat, dawn light.

| WESTON SCALE | – | U | – | – | A | ↓ | C | – | D | – | FILM TYPE OR SPEED | LENS | | | STOP | EXP. | DEVELOPMENT |
ZONES	0	I	II	III	IV	V	VI	VII	VIII	IX		F. L.	EXT.	x			
Opacity test							6.5				40	7	14	4	8	2 sec	NORMAL
Expansion						6.5					"	"	"	"	8	1 sec	NORMAL +
Expansion					6.5						"	"	"	"	11	1 sec	NORMAL ++
Compaction								6.5			"	"	"	"	8	4 sec	NORMAL –
Compaction									6.5		"	"	"	"	8	8 sec	NORMAL – –

16. Exposure Chart (section). Showing method of recording data for optimum opacity tests (see text). Brightness values can be as high as 25 or 50 if desired.

After normal developing time is established for Zone VI placement, proceed with the following contrast-control tests:

1. Set up a gray card and illuminate evenly. Extend the lens as far as possible, for better coverage of the negative area, and remember to compute the increase in exposure required by the extension. (See Book 1.) Select the proper film speed for the illumination used. Daylight may be used, but only if of assured constant quality and intensity, as in high, clear sections of the country. Controlled tungsten light is best for general purposes (do not fail to use the *tungsten-light* speed rating for the film). Its intensity can be regulated by varying the distance of the light source from the card. The brightness value of the card should read not less than 6.5 (Weston), and the readings should be made with great care, avoiding the shadow of the meter and of the hand on the card. The Weston meter with an extension tube or the S.E.I. meter will give more precise readings and show variation of illumination over the entire card.

2. Place the metered-light value on Zone VI of the exposure scale (see line 1 of the chart, Fig. 16), and make 4 identical exposures as indicated. Develop one negative in the selected developer for the time the manufacturer recommends for this developer, or for the time suggested by personal experience (see page 44). If the opacity (density) is too low, develop the second film for a longer time; if the density of the first film is too great, develop the second film for a shorter time. It may require several trial developments to establish the proper density (or opacity) for the printing process and the paper to be used. When the proper density value is obtained, consider the developing time used for this negative as *normal* for that particular film and that particular developer. Be certain that the developer is used at consistent strength and temperature throughout the tests and that agitation is consistent in interval and degree (see page 74). I favor the term *density* here in its specific sense.

3. Next, place the metered-light value on Zone V (see line 2 of the sample chart), and expose 4 negatives accordingly. Develop one negative for about *1.5 × normal time*, and compare the density with that of the normal negative. Develop the other 3 negatives more, or less, striving to match the density of the normal negative. Thus is established the development factor for Zone VI subject value placed on Zone V of the exposure scale, which placement would result in an expansion of the values in the image in relation to the brightness scale of the subject; that is, in more contrast and textural exaggeration. Examples on pages 17, 36, and 45.

4. Place the metered-light value on Zone IV (see line 3 of the sample

chart), and expose 4 negatives accordingly. Develop o. e negative for *2.5 × normal time*, and compare with the normal negative. Again, develop the other negatives more, or less, until one matches the density of the normal negative. Thus is established the development factor for Zone VI subject value placed on Zone IV of the exposure scale, which placement would result in greatly expanded image values in relation to the brightness scale of the subject; that is, in much greater contrast and textural exaggeration. Some negative materials will not yield a Zone VI opacity with a Zone IV exposure with ordinary developers. If the desired opacity cannot be obtained for a Zone IV exposure, the use of a shorter-scale printing paper will be necessary. Examples of Zone IV exposure-Zone VI development on pages 87, 101, and 110.

5. Place the metered-light value on Zone VII (see line *4* of the sample chart), and expose 4 negatives accordingly. Develop one negative for about ³⁄₄ × *normal time*, and compare with the normal negative. Develop the other negatives more, or less, until one is obtained that matches the density of the normal negative, thereby establishing the development factor for Zone VI subject value placed on Zone VII of the exposure scale, which placement would result in compressed values in the image in relation to the brightness scale of the subject; that is, in less contrast and milder textural effects. Example on page 20.

6. Place Zone VI values on Zone VIII and expose 4 test negatives, and again determine the development time required to match the density of the normal negative. It will be from ¹⁄₂ to ²⁄₃ *normal time* of development. As the time of development approaches ¹⁄₂ normal, it is better to use the alternate water-bath process, as the lower values in the image are otherwise depressed in contrast and of weak emotional impact (see page 104). Such high placement and reduced development result in considerable compaction of values in the subject. Examples will be found on pages viii, 50, 103, 105, and 110.

It may seem that a simpler method of obtaining a series of test strips would be merely to produce a scale on the same film by progressive cumulative exposures—withdrawing the film-holder slide a small distance for each exposure. However, such procedure involves the *intermittency effect*. Especially in the higher density range, 10 exposures of 1 second each may not produce the same density as 1 exposure of 10 seconds' duration. Also, the brightness of the image decreases from the center of the negative to the edge (see Book 1, page 12), thereby suggesting that only the center of the field should be used for accurate density determinations. (The greater the extension of the lens, the more even the brightness of the image.)

It is essential that all tests be made under carefully controlled conditions. Meter readings must be very accurate, lens extensions computed carefully; developer should be fresh and used at an exact temperature; and agitation must be followed on a schedule precise as to interval and degree. Needless to say, in practical work also the procedures must be unvarying; otherwise the tests will not be valid. (See Agitation, page 74.)

You may well ask why anyone should go to such pains to produce negatives of consistent opacity range when papers are available in several contrast grades, adaptable to a wide range of negative opacities. It is perfectly true that both overcontrasty and overflat negatives may be accommodated by the use of various grades of paper, and of print developers of greater or less activity. I have

selected the average No. 2 paper (a rough designation for papers of medium contrast range) for the simple reason that it is fairly easy to secure negatives of an appropriate opacity range for this paper, and because the subtleties in the lightest and heaviest tones of the print may be better controlled with the use of normal contrast paper. With papers of higher contrast it becomes increasingly difficult to control the refinements of the higher and lower tonalities. An ideal arrangement would provide negatives of rather extensive opacity range and print only on the longest-scale papers, but many of the fast modern films do not favor this procedure. Ansco Versapan is ideal for long-scale results. It supplants (and improves upon) the old Isopan film.

Again, should you obtain a negative that is not suited to No. 2 paper, you may resort to No. 1 paper if the negative is too harsh, or to No. 3 paper if the negative is too soft. The chief reason for obtaining negatives of consistent opacity scale is not merely to restrict ourselves to any one grade of paper or to any one routine of procedure. It is rather to establish *a routine of visualization and execution,* thereby assuring a positive discipline of awareness and intention. Should you desire to work with more massive negatives (such as would be produced with commercial films) and print on papers of long scale (such as No. 1 soft bromide), you need make no change in this basic approach, but merely secure a higher opacity range in your negatives. Of course on testing for this higher opacity you would find that normal developing time would be longer than for the average negative, and that developing factors for lower zonal placements of the same subject value would be higher than for negatives suited to No. 2 paper. Conversely, if you are limited to a very brilliant condenser enlarger with a carefully focused collimated beam, you will find that you must have very much softer negatives. Normal developing time will consequently be much less, and the developing factors for lower zonal placements will be reduced. *Remember:* With longer than normal developing time, the film more closely approaches its maximum opacity, and its response to additional development is consequently lessened.

The ideal degree of printing (presupposing an ideally scaled negative) would produce a total black in the print from the clear borders of the negative, and render every opacity value above that as an appropriate gray tone in the print. However, owing to tolerances in exposure and development, variations in film quality, lens flare, and possible inaccuracies in equipment—and to subjective factors governing the tonal concepts in the print—some control of printing is often required. Frequently shadow values that appear in the negative with appreciable opacity and texture will be "printed down" (given longer printing exposure) and thus rendered as approaching total black in the print. (See Book 3 for further discussion.)

We should remember that unless *all essential* values are recorded in the negative, we can never achieve adequate tonal control in our prints. We cannot modify the expression of a certain feature in the print unless that feature is suitably represented in the negative. We cannot create the illusion of substance, texture, or value from a badly underexposed part of the negative, nor can we produce translucent high values from severely overexposed areas of the negative. But given a negative that makes at least a reasonable approach to the ideal, we may indulge in a rather wide range of effects through printing control, thus achieving the visualized image to a satisfactory degree.

Printing down is an interpretative factor in the process of printing. It is strongly advised that everyone experiment with the ordinary "printing-out" papers (see Book 3). The ideal negative for this printing medium would, of course, have a very long scale. Commercial orthochromatic or commercial panchromatic film with vigorous development for average subjects will provide ideal negatives for this process with average subject material.

In creative problems, the procedures worked out in tests should be followed carefully, and results should be studied thoughtfully for agreement with the factual and emotional requirements. If any modifications are needed, they will soon be apparent. The process must always remain sufficiently fluid to be readily adapted to the individual's purposes.

The photographer must not hesitate to make tests—many times, if necessary. If his work means anything to him, it is worthy of constant investigation and evaluation. The curse of contemporary photography is the frantic effort of the manufacturer to make it "simple." It is no simpler than any other art— nor is it more complicated. Ultimate achievement taxes the capacity of the artist, whatever his medium may be. However, the photographer can be more certain of his results, and therefore make better use of his energies, if he establishes reliable procedures for achieving the desired expression.

Units of Exposure

Photographic exposures are ordinarily related to conventional lens stops, progressing in geometric ratio (1, 2, 4, 8), f/8, f/11, f/16, f/22 ... (see Book I). Shutters are usually calibrated in somewhat the same ratio, although here the progression is not constant (1, 1/2, 1/5, 1/10, 1/25, 1/50, 1/100 ...). This irregularity is more a matter of habit than a necessity; the shutters could be made to operate at speeds progressing by a regular factor. In any case, it is quite possible to work with lens-stop and shutter-speed relationships of 2x or 1/2x, and our concept is best maintained in that geometric scale.*

In comparing exposures—either between two negatives or between different sections of the same image—it is convenient to think in terms of *units* of exposure. No matter what the actual lens stops or shutter speeds may be, the geometric ratios can be expressed accurately in units. If we think of Zone I on the exposure scale as representing 1 unit of exposure, then Zone II would represent 2 units; Zone III, 4 units; Zone VI, 32 units; and so on. It is convenient and straightforward to compute the *effective range of exposure* in terms of units; merely divide the greater number of units by the smaller. Thus the range from Zone II (2 units) to Zone VIII (128 units) is simply 1 to 64.

Referring to the Exposure Record chart (page 27), we see in line 3 the relative exposure values in reference to Zone I; the figures in this line represent the actual number of units of exposure required for each zone (or for the series of f-stops).

* The *effective* transmission of a lens at a given aperture will vary from the theoretical transmission, due to inherent physical properties of the lens; flare, transmission, etc. While it is possible to adjust the size of the apertures to give transmissions equal to the theoretical values, it must be remembered that unless the aperture is of the correct ratio to the focal length of the lens (regardless of its *transmission* values) the optical properties such as depth of field will be inaccurate. Hence, adjustments of the actual transmission values should be compensated for by application of an exposure factor, or by adjustment of the film-speed ratings, rather than by physically altering the diameter of the lens apertures.

The understanding of units is of special value in planning exposures with artificial light or in balancing synchro-sunlight effects (see Book 5, *Photography in Artificial Light*) or in pre-exposure (page 109 this book).

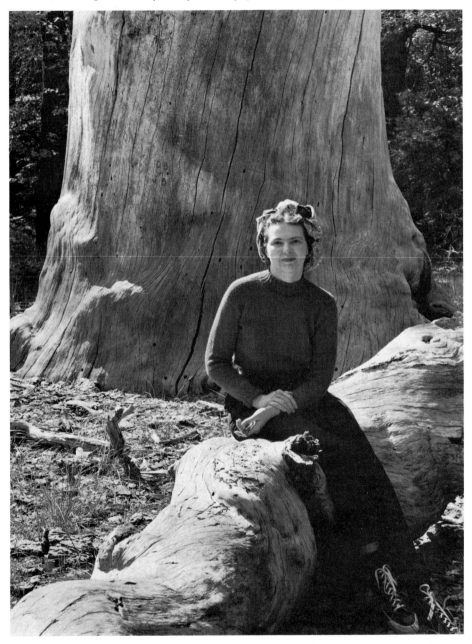

17. Outdoor Portrait. An application of the water-bath development process (page 104). The actual brightness range was severe, but the mood was one of soft enveloping light. The water-bath development favored the low and middle tones and modified the glaring high values.

GAMMA

In sensitometry, the characteristic curve reveals to the trained eye many qualities of the emulsion. One of these qualities deals with contrast in the image, which is controlled by varying times of development. A quantitative expression for this quality is derived by measuring the steepness (or angle with reference to the horizontal base) of the straight-line section of the curve. This quantitative expression is known as *gamma*. In truth, "gamma" is a term of interest and significance only to the research scientist and the manufacturer. But photographers persist in using it, not so much in relation to its true meaning, but rather as a symbol of the degree of practical contrast in their negatives. Development "to gamma 0.7" or "gamma 1.0" is really, in their usage, synonymous with "a certain number of minutes in a given developer at so many degrees temperature"—which procedure, empirically, yields the desired results.

The concept of gamma is difficult to apply, for the following reasons:

1. As a considerable proportion of the negative values may lie on the toe or on the shoulder sections of the curve as well as on the straight-line section, gamma has little actual meaning in regard to the full scale of values in the negatives. Gamma is determined by the angle of the straight-line section of the curve to the base; at 45° angle we have gamma 1.

2. Since for lenses of different construction the brightness range of the image from the lens will vary in relation to the range of the brightnesses of the subject, an arbitrary constant gamma is obviously difficult to realize. Considering the contrast of a fully coated lens as 1, an uncoated 8-surface lens may yield an image of 1/3 to 1/5 contrast of the coated lens. Of course, in practical work this contrast factor depends on the proportion of high to low brightnesses of the subject.

3. As the subjective values of perception and visualization of the final print involve a flexible control of exposure and development, gamma is a limited attempt at a utilitarian expression of values and relationships in the image.

Hence, is it not more logical to leave gamma to the sensitometrist and manufacturer, and to think of negative development in terms of a simpler symbol? X minutes at Y degrees temperature would represent "normal" with consideration for the photographer's concept, lens, film, film developer, methods of printing and enlarging, and the paper used.

"7 minutes at 68°F in Ansco 47 for Isopan" represents "normal" to me. I have no idea what the actual effective gamma is, nor do I care. I could consider this degree of development as yielding Gamma = 1.0 or being Development No. 9 or Operation H, or any other symbol I choose. But why should I inject an unnecessary and confusing symbol for a perfectly simple statement of procedure? "Isopan/Ansco 47/68°F/7 minutes" is definite and easily expressed and understood as the means of obtaining *my* "normal" negative. With a condenser enlarger your "normal" may be Isopan/Ansco 47/68°F/6 minutes—or any other set of values that gives the balance of tones *you* desire.

There is nothing more destructive to a creative approach than the domination of "the perfect negative" or "the standard negative"—unless such standard be determined by the individual in relation to his own concept. The time-gamma charts have a definite *comparative* value in relation to my approach, chiefly in regard to temperature variations of the developer (see the PHOTO-LAB-INDEX).

FOG

The term "fog" is often misused and poorly defined. Briefly, ordinary fog is an allover deposit of reduced silver halide on a negative or a print. The causes are complex, the types numerous, and the effects varied.

Fog may be produced by exposure to heat, by dampness, by age, by incorrectly compounded developers or too prolonged development, or by exposure to penetrating radiations, such as x-rays. Severe lens or camera flare may produce a veiling of the image frequently interpreted as fog. But true fog is apparent in the unexposed edges of the film; if the edges are clear and fog appears in the negative image, the causes lie in the camera-lens system.

Fog streaks may be traced by placing the film in its original position in the camera, emulsion side toward the lens, image inverted. The direction of the streak will usually indicate its source. Leaks in the light trap of the film holder produce fog streaks from the edge of the film. Streaks from poor contact between holder and camera back, being shielded by the edges of the holder, strike the film away from its edges. Holders or camera back may be warped, or a label pasted on the holder may press it out far enough to admit light. Cracked holder slides, pinholes in bellows, insecure lens flanges or lens boards, can produce disastrous effects. See Book I, page 113, for checking for equipment defects.

Irrespective of the cause, negative fog is not so serious as fog in the print; whereas print fog depreciates the visual image values, fog in the negative, if evenly distributed throughout the film, may merely raise the over-all opacity and shorten the density (opacity) scale. A fog density of 0.20 will appreciably affect only the lower zones of opacity. (See Pre-exposure, page 109.) Within reasonable limits, fog can be counteracted by choosing printing paper appropriate to the *effective* opacity scale of the fogged negative.

A slight fog, such as that resulting from moderately prolonged development, does no apparent harm. Greatly prolonged development, however, may bring the heavy parts of the negative image to maximum opacity while continuing to increase the fog level. This results in a definite shortening of the scale of the image, thereby defeating the aim of prolonged development, which is to achieve increased contrast. A typical effect may be represented as follows (assuming the use of a soft-acting developer such as D-23):

		Film-Base Plus Fog Density	High-Value Density	High-Value Opacity	Density Range	Opacity Range
Normal development	15 min.	0.10	1.8	63	1.70	1 to 50
Twice normal	30 min.	0.13	2.0	100	1.87	1 to 74
Four times normal	60 min.	0.16	2.3	200	2.14	1 to 138
"Gamma-infinity"	5 hrs.	0.36	2.4	250	2.04	1 to 110

The contrast (opacity range) increases up through 4 times normal development, but then may be actually reduced with gamma-infinity development. The effect varies with different films and different developers; a straight Metol-sulfite formula, with greatly prolonged development, gives much less fog than a standard Metol-hydroquinone developer, for example.

If the fog is uneven, there is little that can be done. General fog may be reduced by subtractive or cutting reduction (see page 111).

LENS FLARE AND IMAGE CONTRAST

Every air-glass surface in a lens reflects a certain small proportion (between 4% and 5%) of the incident light. In lenses of several air-glass surfaces, the effect of this reflection is not only a loss of light transmission but also a diffusion of random light over the entire negative. This random light is known as *flare*.

In simple lenses the flare effect is immaterial. But as the number of air-glass surfaces increases, the cumulative effect of all the internal reflections is sufficient to reduce image contrast rather seriously. Flare therefore has a definite effect on the quality of the images produced by any uncoated lens. The difference between the theoretical image contrast and the contrast actually obtained is called the *flare factor;* it can be expressed as a ratio, $\dfrac{Bs}{Bi}$ —the brightness range of the subject divided by the brightness range of the image. In severe cases a centralized "ghost image" or flare spot is observed, but in general there is only an allover diffusion of light resulting from the reflections and counterreflections from the air-glass surfaces of the lens. For this reason exposure tests should be made with the lenses used in one's practical work.

Two negatives, one made with a lens of 6 or 8 uncoated air-glass surfaces, the second made with the lens coated (which practically eliminates reflection), will require differing amounts of exposure and development. For example, the exposure and development for a negative made with an uncoated Cooke Triple Convertible Lens is not the same as that for another negative (of the same subject) made with a coated Kodak Ektar Lens. In the latter case the brightness scale of the image approaches the brightness scale of the subject more closely.

18. Opacity: glasses and negative between light and printing paper. From left to right: 1st space, paper exposed direct to light; 2nd space, 1 sheet of glass over paper; 3rd space, 2 sheets of glass over paper; 4th space, 2 sheets of glass and negative; 5th space printed for image, the film edge is too weak; 6th space, printed for maximum black of film edge, image too deep. In this case it would be necessary to resort to a paper of shorter exposure scale to get proper quality. The negative was not sufficiently developed for the printing paper used.

Actually, flare may sometimes be used advantageously. There is no question in my mind that coated and uncoated lenses yield different image qualities. If an "uncoated" effect is desired with a coated lens, a neutral-density filter,* or a piece (or pieces) of optically plane glass may be placed before the lens. The uncoated surfaces of these glasses will produce reflection and scattering of light, and therefore slightly reduce the contrast of the image. Of course, it must be thoroughly understood that the addition of such elements to the optical system will reduce definition. In large-size images ($3\frac{1}{4}$ x $4\frac{1}{4}$ inches and up) the loss of definition is negligible except when great enlargement of the negative is considered, but with smaller images the loss of definition may be very serious.

It has been my experience that placing filters behind the lens (in larger cameras) has the advantage of minimizing reflections from external light, but also has the disadvantage of throwing the image out of focus. This must be compensated for by focusing backward about $\frac{2}{3}$ the thickness of the glass. Obviously, ground-glass examination of the image with a focusing magnifier (see Book 1) is advised when filters or glasses are used behind any lens. The reader is reminded that, for minimum impairment of definition, gelatin filters are always to be preferred. (Wratten gelatin filters are now lacquered.)

The whole question of flare is subject to discussion and needs clarification. In practical work, two types of flare are encountered: lens flare and camera flare.

Camera flare is of far greater importance than is usually recognized. In a recent practical test, I found that with an 8-inch coated lens on a 5x7 camera, the flare amounted to a density of .14 above film-base and fog density. With the same lens on an 8x10 camera the flare was only about .05 above film-base and fog density. Obviously, the larger bellows reflected less light to the film. If the bellows were entirely shielded from the light from the lens, camera flare would be reduced to practically zero. Therefore, it is of the greatest importance that the interior of the camera be treated to minimize reflections; the bellows should be of the darkest and least reflective materials, and all wood and metal parts should be treated with a "dead" (nonreflective) black paint. If the reader has any doubt of the amount of reflected light within the camera he is urged to open the lens and point it to a light surface, remove the camera back, and simply *look* at the bellows and flat wooden parts. The negative itself reflects a considerable amount of light (at least 10% reflectance) and this, of course, will be scattered throughout the interior of the camera, producing a considerable amount of flare.

Lens flare has been investigated in the optical laboratories and the flare factors of different lenses have been determined. In actual practice, however, it is very difficult, if not impossible, to determine accurately the amount of flare a lens will give (in terms of image values) because of the infinite variety of subject material, variations in exposure, etc. This we know: A coated lens minimizes lens flare under all conditions, gives an image of greater apparent brilliance, and assures greater purity of color in color photography. More light is transmitted at any aperture setting. Now, what is the effect on the values of the image? And how can we adjust our exposure-development procedures to the flare-free image—or to the flare-modified image?

* A neutral-density filter is designed to reduce transmission of light without altering color value. These filters are obtainable in a variety of "powers," and require appropriate increase of exposure.

Let us set up two identical cameras equipped with the same lenses—one coated and the other uncoated. Let us assume that for a given aperture and exposure time the coated lens transmits 90% of the light, and the uncoated lens 60%. Hence, the coated lens transmits 50% more light than the uncoated lens. Obviously, every part of the exposure scale is thus increased by 50%. That does not mean that the *densities* (opacities) will be increased by 50% (see page 9); but all opacities of the negative will respond just as if 50% greater exposure was given with the uncoated lens—*with the following important exception:* the low values of the image from the uncoated lens will show less contrast and generally higher opacity than in the image from the coated lens. In other words, while the opacities of the high values will show but little increase, the low values will be modified by flare—softened as it were.

Now, let us adjust the lenses of both cameras so that the actual transmission of light is equal in both lenses. We can reduce the aperture of the coated lens, or lessen the exposure time to equal the 60% transmission of the uncoated lens. We will now see that the opacities of the high values of both negatives are practically identical. But there are considerable differences in the opacities of the lowest values (lessening as we go up the scale). What are these differences?

1. With the coated lens, the shadows (low values) will be represented as lower opacities, but their relative contrasts will be retained.

2. With the uncoated lens, the shadows will be represented as higher opacities than in 1, but their relative contrasts will be much less. Why? Flare light from the uncoated lens has scattered over the entire image and has added a small amount of opacity to all parts. But, of course, this addition of opacity is apparent only in the lower opacities; it is too small to make an apparent increase in the higher opacities. Let us illustrate this on the Zonal scale:

We will first list the exposure units represented in Zones 0 to VIII:

0	I	II	III	IV	V	VI	VII	VIII
½*	1	2	4	8	16	32	64	128

* Practically subthreshold—no effective opacity.

Suppose that lens flare superimposes approximately 2 units of exposure over the entire negative. We have then:

0	I	II	III	IV	V	VI	VII	VIII	
½	1	2	4	8	16	32	64	128	Image units
2	2	2	2	2	2	2	2	2	Flare units
2½	3	4	6	10	18	34	66	130	Total units

From Zone V up the effect is so slight as to be practically negligible. Considering shadow values as representing Zones 0 to III, we see that the contrast ranges given by the coated and uncoated lenses *within these zones* are:

Coated lens: 1 to 8
Uncoated lens: 1 to 2.4

Obviously, the shadows will be "snappier" with the coated lens.

Now, we have shown the contrast differences in the shadow area of the scale; what are the differences in contrast over the entire scale—from Zone 0 to Zone VIII? They are:

Coated lens: 1 to 256
Uncoated lens: 1 to 50 (approx.)

Of course, the degree of development would control the opacity scale of the negative; we are discussing the contrast scale of the image from the lens.

Hence, irrespective of the contrasts within the lower values, the image from the coated lens will always be more brilliant—that is, have a greater contrast range—than the image from an uncoated lens.

It will be obvious that with an uncoated lens we may obtain "false" opacities for the lowest image values—mistaking opacity from flare as opacity from actual exposure. With a coated lens used with the same subject and same exposure these low values would appear quite underexposed. If we had determined, by test or by empirical experience, that such values would fall within the exposure scale (with our uncoated lens) we would then be obliged to increase exposure with the coated lens and adjust development accordingly (see page 44). It is not a simple matter for a photographer who has had long experience with uncoated lenses to change to coated lenses and achieve fully controlled results.

To make an approximate determination of the maximum flare caused by lens and interior surfaces of the camera, photograph a large white card in the center of which is a hole an inch or so in diameter, back of which is a box painted a dead black. Place the brightness value of the card on Zone VIII of the exposure scale, set the lens at a fairly large aperture and expose accordingly. The brightness of the hole will be so low as to fall far below the threshold of the negative emulsion, and will have no effect on the film whatever.

Were there no internal reflections in the lens or camera, the image of the black opening would have no greater density than the unexposed edges of the film (usually about 0.10). Actually, it will have considerable density. While the actual brightness of the image could be determined by direct measurement with very sensitive meters, we can achieve a fairly satisfactory approximation of the flare factor by comparing the densities of negatives developed normally. *Normal* development is specified, since greater development increases contrast, and the flare factor would appear to be reduced in a more strongly developed negative—in which high values are increased in density proportionately more than are the low values. This flare seriously modifies the density range in ordinary negatives. An image showing a low density of 0.10 and a high density of 2.60 (range = 2.50; opacity range = 1 to 316) when no flare effect exists may be modified by flare so that its low density becomes 0.30, and its range is reduced to 2.30—or a 1-to-200 opacity range. The test suggested above will indicate maximum flare. The appreciable flare factor is less with more normal subjects, approaching minimum with subjects of very narrow brightness range (Fig. 24, page 87).

Dust and finger marks on lens surfaces increase flare, but some kinds of "tarnish" actually reduce flare and increase transmission.

19. At Mendocino, California. Picture made on a hazy day; half-sun and misty sky of great brightness. Exposure intentionally short; low placement and normal-plus development given for maximum separation of values. Illusion of light preserved. Made with coated Cooke Convertible Lens, 19″ component. General flare from the sky would reduce sharpness of the telephone and power wires unless a coated lens were used. General tone of gray prevented use of contrast filter to augment separation of shadow and high values. No regular filter would have any appreciable effect. The contrast was increased entirely by low placement and expanded development. The sky (800 on the Weston dial) was placed on Zone VII and the negative developed to raise this value to Zone VIII (page 46). The exposure could have been less (with greatly expanded development) and more print brilliancy gained. However, as the shadows under the eaves (meter reading 6.5) fell on Zone 0 (with the sky on Zone VII) any further reduction of exposure would have depressed other low subject values down to, or near, threshold value. *Brilliancy* is not equivalent to *contrast* in the esthetic sense.

SPEED RATINGS OF FILMS

When we say that a certain film has a Weston rating of 50, or an ASA rating of 64, or perhaps a Kodak rating of 400 or a Scheiner-27 rating, just what is meant?

We cannot compare the various film-speed indications with any degree of accuracy, as their origin is based on data referring to different sections of the characteristic curve of the film. It is not necessary to investigate the methods for determining or describing them sensitometrically, because we are in no position to apply such calculations. We can assume that the Weston speeds are of sufficient accuracy to be applicable to all ordinary emulsions. These speeds result from an arbitrary density produced by an exposure well up on the characteristic curve. The Scheiner rating is based on threshold values, Kodak and ASA speeds are based on a minimum gradient value, and so on. They are not directly comparable.

Moreover, with different emulsions experience will indicate certain modifications. For example, one film rated Weston 50 may have a longer toe to its curve than another film with an equal rating of 50. The film having the longer toe will give better shadow detail, because it will respond more effectively to values lower on the scale. For this reason I advise a threshold test, if only to discover what the film's response is to the lower intensities of the scale.

Once again I must emphasize that lens flare may make a sharp alteration of threshold values. See page 53 for discussion of lens flare. But lens and camera flare are quite inconsequential when an average subject brightness is exposed below Zone IV or V.

In order to compensate the various film characteristics as well as individual lens and shutter irregularities, Weston advises the use of group numbers. That is, for a film rating of 50, the photographer is advised to make exposures based on ratings of 32, 40, 50, and 64, and determine from the threshold densities that film speed which is best for his purpose. (I have added a lower number to the conventional three-number group as I have found by experience that such a low number is frequently correct with complex uncoated-lens systems.) The rating giving the best result should thereafter be used for that particular film under similar conditions—lens, shutter, developer, and printing processes, not to mention the photographer's personal concepts of print quality.

My personal method of determining practical film speeds is:

1. I expose (at the published speed rating) for the effective threshold (in most cases, a Zone I placement of a single luminance value) and develop according to the manufacturers' instructions. If the negative-density value is about 0.1 above filmbase-fog density I can assume the ASA speed rating is right for my equipment and procedures.

2. I then expose (at this same speed rating) on Zone V or VI and develop for the desired density values. It will require several tests to establish my "normal" development time. Although the low density from the Zone I exposure responds to increases or decreases of development, the differences are slight. In this way a practicable, personally satisfactory film-speed rating is achieved. While not satisfying the exacting standards of sensitometry, this method is well within the tolerance of practical work. If threshold density is *within* the limits of 0.07 and 0.15 above film-base density, the resulting opacity ranges are easily

accommodated by ordinary printing procedures. For example, on the basis of a Zone VI value of density 1.10 above film-base plus fog density:

Threshold Density (above filmbase and fog)	Zone VI Density (above filmbase and fog)	Density Range Zones I to VI	Opacity Range Zones I to VI
0.07	1.10	1.03	10.7
0.10	1.10	1.00	10.0
0.15	1.10	.95	8.9

(Zones VII, VIII, and IX of course have greater opacities than Zone VI, and the total range of the negative would then be greater than indicated above for the Zones I to VI range. (See page 9.)

There is no doubt that films of various brands, described as having the same film-speed ratings, may show marked differences of "speed" at different points on their curves. It is of great importance that the photographer bear in mind that films of the same brand may not have similar "speeds," due to age, storage conditions, and the inevitable variations in manufacture. However, I have found that once development procedures are established for a certain brand of film, it is then only necessary to test this film for Zone VI opacity; the ratio between Zone VI and the other zones seem to retain an approximate proportional value. Of course, fresh tests are necessary with all "new" or "improved" films.

Finally, I urge the reader not to be discouraged by the apparent discrepancies in film-speed ratings. No indicated speed number should be thought of as more than a guide. Practically all meters are now calibrated for ASA speed values.

Test for Reciprocity Departure

This practical test will demonstrate reciprocity departure due to long exposure times. It will require a good densitometer to measure accurately the density values of the test negatives.

1. Prepare 3 cards, about 11x14 inches and of matte surface, with a brightness ratio of 1, 4, and 16. Check these values in strong light with the Weston meter. The lightest card can be a sheet of unexposed but fixed photographic paper; the other cards exposed, developed and fixed paper of the proper values.

2. Set up cards and illuminate with an even, diffused light at an angle to prevent glare.

3. Place the value of the lightest card on Zone V. The cards will then represent Zones I, III and V. I suggest the light be adjusted to give luminance value of 40 c/ft^2 on the lightest card. For a film speed of ASA 64 the first exposure would be 1/40 second at f/8 or 1/10 at f/16. The lights should be daylight type (bluish) and if any lens extension factor is involved do not fail to adjust for it. (Without any lens-extension factor).

4. Make 1 exposure (a) based on the meter indication (placement of the value of the lightest card on Zone V, at f/16 with 1/10 sec. exposure). Then place the light at increasing distances from the cards, and expose accordingly:

 b. with the light at 2x the original distance, give 4x the original exposure.

c.	4x	16x
d.	6x	36x
e.	8x	64x
f.	16x	256x

At the "d" distance, the exposure would be about 3¼ seconds at f/16.

5. Develop all together for "normal" time with agitation in a standard developer.

6. According to the Reciprocity Law (page 12) the six sets of images should have identical densities. However, in the negatives given long exposure, reciprocity departure will appear — it will be recognized by progressively lower densities, first in the image of the darkest card, then of the middle card, then of the brightest card. A simple calculation will show when reciprocity departure first appears in terms of exposure values. It will appear first in Zone I, then — with longer exposure — in zone II, etc. Corrections are usually made by using the same exposure time and employing larger lens stops. The Eastman Kodak Company provides a fine information sheet on the reciprocity characteristics of their sensitive materials (including suggestions for adjusted development times).

EXPOSURE METERS

Exposure meters may be classified in two main groups: (1) those registering incident light (that falling upon the subject), and (2) meters registering the light reflected from the surface of the subject.

Incident-light meters will not be discussed in this series. Not that I consider them unsuitable, but much experience is required of the photographer in translating the values of incident light into values of light reflected *from* the subject in terms of personal tonal concepts. It is difficult to get an accurate idea of reflection values of the subject with such meters. Of course when the range of values is fairly close and when subtle placements of tonality are not considered, the incident-light method works quite well, but the personal philosophy of exposure and development outlined in this book requires a much more precise appraisal of the brightnesses of light reflected *from* the subject.

The second type of meter, such as the Weston Master Exposure Meter, measures all light reflected from the subject within a viewing angle of about 30° (with closed baffle). It is selective only in that it averages the light intensities within this angle of view. In other words, it cannot indicate in a single reading the *range* of values or the extremes of intensities within its field of view; it can only indicate their *average*. A simple demonstration will clarify this important point. Place a large sheet of white paper under a constant light and measure the brightness of its surface. Measure similarly the brightness of a large sheet of black paper. Then place the black sheet overlapping a part of the white sheet and hold the meter opposite the line of intersection; the reading on the meter should then average the two values. For example, if the light paper registered 400 and the black paper 50, the average would be 225. A slight inclination of the meter toward the white or toward the dark areas will alter the reading. Next cut the papers into small squares and arrange them in a checkerboard pattern; if the field of view contains equal numbers of light and dark squares, the reading will again average 225. But suppose you increase the proportion of the light squares—the reading will be higher. Similarly, increase the proportion of dark squares and the reading will be lower. If you place only a few white squares in a black field, no accurate indication of the reflection value of the white squares is possible, nor could a few isolated dark areas in a white field be read for their actual brightnesses. Only *average* reflective values would be indicated. (The Weston Master Meter dial is calibrated in *candles per square foot*.)

If the reflectances of the different areas of the subject scanned by the meter were known we could compute their actual brightness and place them as desired on the exposure scale. Such a calculation would be both time-consuming and inefficient; it would be more practical merely to place the average opposite the arrow of the meter and trust to the latitude of the film (if the intensities were equally balanced). But if the white paper registered 800, and the black paper 40, and only a few black areas were scattered over the larger white area (giving an average reading of, say, 600), then, if 600 were placed on the arrow the dark areas would fall on Zone I and the white areas on Zone V-VI. The resulting density range of the negative would be quite low; a paper of quite short scale would be required to retain the values from black to white in the print.

So we see that in a normal scene, a small bright area in a much larger dark area (or a small dark area in the midst of a large bright area) will be merged

into the average reading. This average reading is valid only if the light and dark tonalities are fairly well distributed. Even so, the placement of these *individual* tonalities on the gray scale for the desired emotional effect is not achieved.

Some method, then, must be found for reading the values of small areas. A simple method is to construct an extension tube to fit snugly over the cell of the meter. The length of this tube can be adjusted to give one-half, or one-quarter, or some other simple fraction, of the normal reading. The correct length is determined by making readings on a large, smooth surface with no tube in place, and then with tubes of varying length until the length is found for the desired ratio. The tube must be matte-black inside, and so fitted that no light enters at the point of contact with the cell aperture. Let us see how the tube is used in actual practice. Suppose we want a reading on the side of a face; if an unshielded meter is held far enough away so that its own shadow does not fall on the face, its normal 30° angle of view may include eye sockets, a part of the hair, or other elements that lower the meter readings. But by using the extension tube on the meter, and thus effectively decreasing its angle of view, we limit the reading to that area in which we are chiefly interested. If, for instance, we have a tube giving a ratio of $1/4:1$, and the tube-shielded reading obtained is 50, then the actual value of the area being measured is 4 times as great, or 200, and the exposure is then based on this latter figure.

If we use the *average-light* method, we place the arrow of the computing disk opposite the average reading of the meter. For instance, if pointing the meter at a subject shows a reading of 200 (signifying 200 candles per square foot), then placing the arrow of the disk opposite 200 indicates that every part of the subject reflecting between 13 and 1600 candles per square foot will be recorded on the negative. [Of course, brightnesses higher than 1600 will also be recorded on the negative, but will lie beyond the useful exposure scale of the negative in reference to normal development.] With normal development of the negative (producing the correct opacity range), these values *can* be represented in the print—though with no assurance of either literal truth or emotional validity. The average-light reading is somewhat refined by the use of the "A" and "C" positions on the meter dial. For flat, low-contrast subjects, the "A" position is advised, and for contrasty subjects the "C" position is advised. This procedure, nevertheless, does not achieve positive results.

Another method consists in placing the U of the disk opposite the reading from the darkest essential part of the subject. Every subject intensity falling between the U and the O will be recorded—but, again, without control over the placement on the gray scale of the more significant portions of the subject.

Whenever a more selective interpretation is desired, it becomes necessary to evaluate both the darkest and the lightest values in regard to their respective placements on the gray scale. It must be remembered that values under Zone I, being of subthreshold brightness, will have no practical negative or print value. It is obvious that for security the first problem of placement concerns the low values of the subject. Once these low values are established within the limits of the exposure scale, the placement of the high values is thereby rigidly determined. But the proper range of opacity in the negative is achieved by the character and the amount of development.

It is of utmost importance that all readings be taken with the meter pointing along the lens-to-subject axis, because different angles of view may involve

reflections and brightnesses different from those seen from the point of view of the lens. With certain objects of nonspecular surfaces, the meter-viewing angle makes little difference, but it is of real importance in photographing metals, smoothly painted surfaces, skin, and other subjects capable of brilliant reflection. I cannot too strongly emphasize that the shadow of the meter or the hand or the body of the photographer must not fall on the subject while readings are being made; otherwise a false reading is obtained. At times it is difficult to avoid this shadow, especially when working with axis (or near-axis) illumination. In such cases the reading should be taken slightly from the side, and if there is a noticeable difference of reflective value to the eye, some compensation should be made. Light sources should not be included in the field of view of the meter. The extension tube mentioned on pages 44 and 61 is helpful under such conditions.

Meters Other Than the Weston Exposure Meter

Many available photoelectric meters are excellent in construction and are of a high order of accuracy. Dial calibrations can be made for other meters besides the Weston.

The manufacturers of film and exposure meters do not use the same criteria for determining film speeds. It is not necessary here to explain the various methods but I must emphasize the fact that no matter what "speed" has been assigned to any film, the photographer will probably be forced to modify it because of the variables of his equipment and procedures.

The sensitometrist and the manufacturer assume average conditions and average subject matter in their design and manufacture of materials and equipment. Indeed, they cannot do otherwise, but when the photographer is confronted with problems that are not "average," or when he desires results that are "departures from reality," he must make adjustments and changes in accepted procedure. Personally, I would think of the speed of any film I use in relation to given opacity for Zone I exposure. I am perfectly aware that the opacities of higher zones may vary with different films in relation to consistent Zone I opacity, but I can bring Zone VI or Zone VIII to the desired opacities by varying the time of development.

Although the Exposure Record (page 26) has been designed for use with the Weston meter, and its markings correlated with the dial on that meter, it can also be used with other meters. The procedure is not so direct, but is by no means difficult. An example is given in line *12* of the sample *Exposure Record* (page 27) and the procedure outlined as follows:

First, set the film-speed indicator appropriately, and establish the *actual exposures* required for the lowest important value (brightness) and the highest important brightness of the scene, just as though they were both placed on Zone V of the exposure scale. (Select for this purpose any lens stop.) Enter both exposures in the square under Zone V, with that for the low value at the top of the square and that for the high value at the bottom of the square. These are the respective exposures that would render the low and high brightnesses as the same density in similarly processed negatives. In the illustration the exposure for the low values is 1/12 second, and for the high values, 1/400 second.

The next step is to give the low value the desired placement on the scale,

halving the exposure for each step to the *left* until the entry has been made in the zone in which you wish the low value to appear. (In the example it went from Zone V to Zone II with relative exposures of 1/12, 1/25, 1/50, to 1/100 seconds.) A 1/100-second exposure of the *low* brightness at the selected lens stop will render that brightness as a Zone II value in a normally processed negative.

Once the low placement is established, the placement of the high value is determined similarly, *doubling* the high-value exposure, zone by zone, to the *right,* until the exposure equals that determined for the low placement (in the example, through 1/200 to 1/100 in Zone VII). A 1/100 second exposure of the high brightness at the selected lens stop will render that brightness as a Zone VII value in a normally processed negative.

It is possible, of course, to use any stop desired, provided the exposures are adjusted in relation to it.

The procedure is valid only if the meter used is correctly calibrated to the Weston meter for Zone V readings. In other words, a reading on a large smooth surface should be taken with the Weston meter, the value placed opposite the arrow (on Zone V), and the indicated exposure noted. Then the other meter is read under the same conditions. If the second meter indicates a different actual exposure, it is necessary to adjust the film-speed setting on that meter until the exposure indication is the same as that given by the Weston meter. The Weston meter is stressed here because it directly relates to my *Exposure Record.*

While the above procedure may appear complicated at first reading, it is surprising how rapidly one becomes familiar with the method of computation; a few days' intermittent practice will assure both facility and accuracy. The principal step involves the exposure required to place separately *both* low and high values on Zone V of the exposure scale (implying, with similar development, that both negative densities will be equal). Placement on other zones is then a simple matter of multiplying or dividing the exposures by the proper geometric number.

The S. E. I. Exposure Photometer (Salford Electrical Instruments, Ltd.)

This excellent device accurately evaluates small areas of the subject (an angle of 1°) over a 1 to 1,000,000 luminance range. The instruction book accompanying the meter does not give data which adequately explains the full potentials of the device. It is well adapted to the Zone System approach. Evaluations are made of distant subjects from the camera position; a baffle tube is available which reduces flare and enables the meter to be pointed directly into a strong light without distorting the readings. It will evaluate dark objects against light backgrounds and vice-versa, bright clouds near the sun, extremely dark interiors, etc. I use it as a *photometer,* translating the exposure indications to c/ft^2 and calculating the exposure mentally after placing the luminance values on the desired zones.

In order to correlate the S.E.I. meter with my exposure-zone system I have interpolated certain values and methods of calculation, which in no way contradict the principles of the meter and its operation. The meter is calibrated to read direct exposure values over a wide range of lens apertures and film speeds. The Black Index relates to the low shadow values, and the White Index relates to values 100 times the intensity of the Black Index values. By direct comparison with the Weston-meter readings on smooth, continuous surfaces the minimum shadow values will be found equivalent to Zone II placement; in fact, any brightness value correlated with the Black Index will indicate a Zone II exposure for that value. If the White Index is used, the placement will be 2/3 of a zone above Zone VIII. (A progression of three numbers on the film-speed scale represents a difference of 1 zone. Zone II to Zone VIII represents a range of 1 to 64; the Black to White Index range is 100.)

Once Zone II placement is known (exposure for Zone II) for any subject brightness, it is a matter of simple calculation to obtain any other zonal placement on the exposure scale. While such calculation is simple in principle, several methods are presented so that the photographer may select the method that solves his exposure problems with a minimum of effort. Some suggestions follow:

When the Black Index is set to the proper ASA film speed, the indicated exposure is equivalent to a Zone II placement on the exposure scale (see exposure record chart, page 27). Other zonal placements for any subject brightness value may be obtained by the following methods:

1. Changing the film-speed setting for different zones. (The following applies to all film speeds, but for an example we shall use here a speed of ASA 64.)

For Zone 0 increase speed by	4x (64 to 250)	or multiply exposure by	$\frac{1}{4}$
I	2x (64 to 125)		$\frac{1}{2}$
III reduce speed by	$\frac{1}{2}$ (64 to 32)		2
IV	$\frac{1}{4}$ (64 to 16)		4
V	$\frac{1}{8}$ (64 to 8)		8
VI	1/16 (64 to 4)		16
VII	1/32 (64 to 2)		32
VIII	1/64 (64 to 1)		64

2. Multiplying the indicated Zone II exposure value by the factor for other zones (see right-hand column above). This calculation can be expedited by referring to the line "Rel. Exp. for I" on the *Exposure Record*, page 27.

3. Using the film-speed number for Zone V ($\frac{1}{8}$ of Zone II speed) and proceeding as with any meter lacking the exposure scale on its dial (see page 62). I prefer this method because it is the simplest; with a little practice the entire exposure calculation can be done mentally. It allows both low and high values to be placed on Zone V at first—then by proper factoring the low value may be placed on the desired zone and the placement of the high value may be automatically determined. An example follows:

Using Black Index, select one lens stop for both low and high exposure readings, with film speed set at $\frac{1}{8}$ ASA speed of film used. With the Black Dot on ASA 8, the exposure value opposite $f/8$ is the reciprocal of the c/ft^2 value. We then take readings of various parts of the subject; if a deep shadow read 1 sec (at f/8) it would represent 1 c/ft^2 and if a high value 1/125 sec (at f/8) it would represent 125 c/ft^2.

Example:

 a. Exposure for lowest important value on Zone V—1 sec.

b. Exposure for highest important value on Zone V—1/125 sec.

c. If low value is placed on Zone I, the exposure will be 1/16 sec.
 Demonstration:

Zone	I	II	III	IV	V
	1	$\frac{1}{2}$	$\frac{1}{4}$	$\frac{1}{8}$	1/16

d. High value must then fall on Zone VIII:
 Demonstration:

Zone	V	VI	VII	VIII
	1/125	1/64	1/32	1/16
or:	1/16	1/32	1/64	1/125

e. (Combining c and d, as the calculation would appear on the chart:

I	II	III	IV	V	VI	VII	VIII
1/16	$\frac{1}{8}$	$\frac{1}{4}$	$\frac{1}{2}$	1	—(low value)		

 (high value)—1/125 1/64 1/32 1/16

f. If the high value falls on the appropriate zone, development will be normal (page 39).

WESTON SCALE	—	U	—	—	A	↓	C	—	□	—			
ZONES	0	I	II	III	IV	V	VI	VII	VIII	IX	STOP	EXP.	DEVELOPMENT
Normal		$\frac{1}{16}$	$\frac{1}{8}$	$\frac{1}{4}$	$\frac{1}{2}$	1/125	$\frac{1}{64}$	$\frac{1}{32}$	$\frac{1}{16}$		8/32	1/16 / 1	*NORMAL*
Expansion			$\frac{1}{8}$	$\frac{1}{4}$	$\frac{1}{2}$	1 / $\frac{1}{8}$					8/16	1/8 / 1/2	*NORMAL ++*
Contraction					$\frac{1}{25}$	1/10 / 1/200	$\frac{1}{100}$	$\frac{1}{50}$	$\frac{1}{25}$		8/32-45	1/25 / 1	*NORMAL −−*

20. Exposure Chart (section). Showing method of recording brightness readings and exposure with meters other than the Weston. (Instead of brightness units, enter exposure values for highest and lowest important brightnesses for Zone V placement.) Compute other zones from Zone V. These examples are arbitrary and exposure values "rounded off."

As we know that whatever brightness value (in c/ft^2) falling opposite the Arrow of the Weston Dial (Zone V) represents a reciprocal value in fractions of a second exposure as noted opposite f/8 with ASA 64 speed (or f/11 with ASA 125 speed, etc.), we can calculate desired placements and resulting exposure quite rapidly with the S.E.I. Meter by applying the following method:—We first place the black dot opposite ASA 8 on the outer scale of the meter. When the reading of any area has been made we observe the exposure indicated (in the proper range scale) opposite f/8. The reciprocal of this exposure value represents the candles-per-square-foot brightness. (1/25 sec. represents 25 c/ft^2). Placing this as desired on the exposure scale, we can then determine the relative brightness opposite Zone V: placing 25 c/ft^2 on Zone III would show a related brightness value of 100 c/ft^2 on Zone V. The exposure (with ASA 64 film) would then be 1/100 sec. at f/8; at ASA 250 film, 1/100 at f/16, etc.

The Honeywell Pentax 3°/21° Exposure Meter

This is an excellent direct-reading cadmium sulfide cell meter with a viewing field of 21° and a measuring field of 3°. It can be used the same way as the S.E.I. Exposure Photometer; the luminance scale is in arbitrary numbers like the Weston V scale (but not of the same luminance values). #11 on my Pentax seems to coincide with #9 on my Weston V. When the ASA film speed dial is properly adjusted, accurate c/ft^2 values can be interpolated.

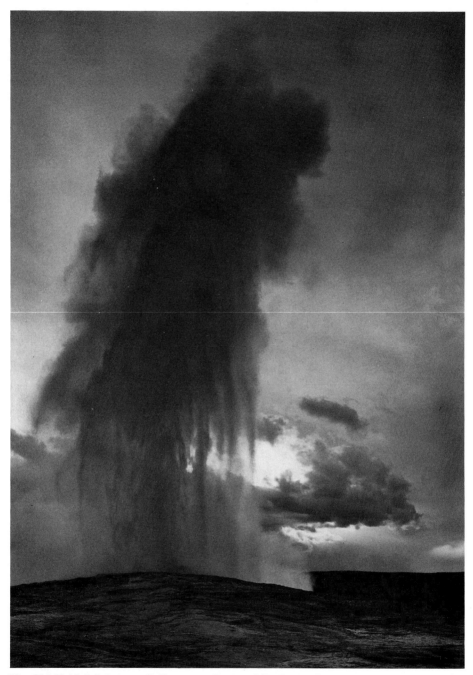

21. Old Faithful Geyser, Yellowstone National Park. A subject such as this is impossible to evaluate by "average" meter readings. The bright sun would dominate the meter readings, and the indicated exposures would be far too short. In this problem, the values of the foreground were placed on Zones III-IV. The intense clouds near the sun fell on Zone IX and above. Hence the negative was given water-bath development, not only to hold the total range under control, but to favor the separations of the lower values. The mood is maintained.

DEVELOPERS AND DEVELOPMENT

Perhaps no art, science, or craft has evolved by such an extraordinary combination of pure science, pure witchcraft, and wishful thinking as that which constitutes the popularly accepted procedures in photography. In the development processes above all others, weird mumbo jumbo persists and flourishes.

A complete discussion of the practical and theoretical aspects of development would require a volume of impressive size. Moreover, such a discussion could not possibly be carried on in terms intelligible to the layman. Here I prefer to present only enough of the general aspects to assist the creative photographer to understand the *effects* of the essential processes.

Developer Action

Essentially, the action of the developer reduces silver chemically. By "chemical reduction" is meant a change from its original combined form—a fairly complex mixture of silver halides incorporated in the gelatin emulsion—to uncombined, metallic silver, in particles so small that the total deposit appears black. This reduction can be expected to take place only in portions of the original relatively stable silver compound that have been exposed to light. The exposure determines the amount of silver compound that can be reduced by the developing agent, and therefore determines also the density of the black, metallic-silver deposit comprising the negative image. For the relationship between exposure and density see The Characteristic Curve, page 9. In all parts of the film not exposed to light, the silver compound is normally unaffected by the developing solution, and is subsequently dissolved out in the fixing bath and washed away.

A number of factors—some of the greatest complexity—modify the process. A study of such factors could easily occupy a lifetime. For the artist to spend his time and energy in an exhaustive investigation of such matters would be ridiculous. The phases that concern him are only indirectly related to those occupying the chemist or the sensitometrist.

The artist's interest in variations of the fundamental process should concern their possible applications rather than their nature. Any experimentation undertaken should be based on the results of established scientific investigation, and should be directed toward refining and clarifying his own basic concept.

Of course the creative photographic worker should understand such things as the differences between basic developing agents, the effects of acidity or alkalinity (pH) and temperature on the development process, and other controls that may be exercised by slight variations of procedure. He should know why bromide inhibits developer action, thereby effectively reducing the emulsion speed, and that sulfite not only preserves the developer solution and affects the pH, but also acts as a silver solvent in large concentrations, favoring fine grain. He will acquire through study and experience a multitude of interesting bits of information, some definitely useful, some only entertaining, others highly impractical.

Reduction of silver halides to metallic silver may seem straightforward enough, but there are many modifying factors deserving consideration. The degree of reduction, the size and dispersion of the reduced silver grains, and the color of the developed image—all these combine to produce a profound and complex effect in relation to the ultimate creative statement.

Since so many factors modify the final result of the development process, the photographer has almost unlimited control over the effects produced, through use of various developing agents and procedures.

Choice of Developer

There are countless books and articles about photography, and anyone consulting them is impressed by the great number of developer formulas, together with their variations. Doubts must inevitably arise as to whether or not one is using the best developer for one's purpose. Actually, only slight practical differences exist between standard formulas designed for normal work. A few formulas for specific purposes are appreciably different in composition and application.

It has been said that Metol-hydroquinone, in various combinations and concentrations, can duplicate the effect of practically any other developer. A pyro man will object strenuously to this statement, an Amidol man will protest, and a "Migrain 967" man will smile knowingly. The truth is that any standard formula will give satisfactory results if properly used in relation to the problem at hand.

It must be remembered that the *effective* speed rating of the film is what concerns the photographer, not necessarily the published speed rating. The effective rating is influenced by the light transmission of the photographer's lens and shutter, the condition of the negative material, and his concept of the values of the scene in relation to the visualized print. The type of developer used also has a profound effect on the speed value of the film. If, for example, a film processed in an Elon-hydroquinone-borax developer such as Kodak D-76 can be rated as 100 ASA, its effective speed rating is then reduced to 50 by the Kodak D-25 developer, and the Sease No. 1 formula, which is paraphenylene-diamine and sulfite, gives a relative speed of 20 or 25. The ordinary fine-grain developers give only about half the normal emulsion speed, and unless this is understood underexposure will frequently result. The addition of potassium bromide to a developer further reduces effective emulsion speed, but this reduction relates principally to the lower part of the characteristic curve of the film. Technically, the addition of bromide is said to "depress the inertia"; effectively, it reduces film speed, raises the threshold, and increases the image contrast. The addition of bromide favors fine-grain images due to the lowered gamma for any given developing time.

Remember that developer is not a magic brew that, when applied to a piece of exposed film, reveals a work of art. Rather it is a chemical solution of known properties and action, the function of which is to reduce exposed silver halide to metallic silver. Variations between developers are, in truth, so small that with certain adaptations of exposure and use, almost any developing formula can be used with almost any negative material. Rather than begin with a multitude of subtly differing formulas, it is much better to start with one formula, explore it to the limit, then investigate others.

Very few photographers take the trouble to explore the potentialities of developers. Or, achieving satisfactory results with one developer, an unimaginative worker will continue to use it to the exclusion of all others, championing it belligerently while depreciating other formulas. He should, instead, approach the problem objectively, make selection of a formula on the basis of the work

at hand, and then fully investigate the capacities and limitations of the formula. Such an investigation will show that a number of equally useful developers may exist for a given type of work.

Frequently a manufacturer will withdraw a formula from his data sheets because sensitometric tests indicate another formula appears to be superior. But sensitometric and practical results apparently do not always agree! A case in point is the recent republication of the Ansco-12 developer formula. It was superseded by the Ansco-17 formula several years ago, but now it is found to yield, for some photographers, a negative of certain favorable characteristics not considered in the laboratory tests. I am not implying that anything "mysterious" is involved in the composition and function of developers, but I am quite confident that many effects in practical photography do not enter into laboratory and sensitometric investigations.

The photographer, obliged to choose from the many types of developers, will wisely concentrate at first on normal developers for his film.

If he is using small cameras, fine-grain developers will be required. High-energy and other special developers should be used only where a specific need exists, and then not until he has a working knowledge of normal developers.

Developing formulas may be grouped broadly as follows:

High-Energy Developers. For "process" work, extreme contrast, and rapid processing. *Examples:* Kodak D-11, Ansco 70, and the Ansco Rapid Processing Procedure.

Standard Developers. For general use in tank or tray with roll, pack, and sheet film. *Examples:* Ansco 47, Kodak DK-60a, Kodak D-23, DK60-A, Kodak D-23, Edwal FG7.

Fine-Grain Developers. For miniature film or any negative intended for considerable enlargement. *Examples:* Extreme fine-grain, DuPont ND-3, Edwal 20, Kodak D-25, Microdol; semi-fine-grain: Ansco 17, Kodak D-76, D-23, Edwal Super 20, Minicol, and FG7, diluted 1 to 15 with water or 9% sodium sulfite.

Special Developers. Designed for reproduction processes, x-ray, tropical, autopositive, metallurgical, and other special fields. Examples may be found in any photographic formulary.

Probably the most complete formulary in existence, the PHOTO-LAB-INDEX, [Published by Morgan & Morgan, Inc., Hastings-on-Hudson, N. Y.] lists almost every practical developer formula. Also an excellent list of developers may be found in *What You Want to Know about Developers* by Edmund W. Lowe. Of course any standard technical work on photography offers numerous formulas.

Manufacturers specifically recommend certain developers for their products. These recommended formulas are designed to balance various factors, such as emulsion characteristics, efficient processing time, reasonably fine grain, and the characteristics of standard printing papers. (Also, economy, stability in solution, and efficient action are considered.) Obviously, no manufacturer can cope with the enormous variations in individual concepts. He can only work toward a norm —as no other course is open.

The photographer should endeavor at first to achieve a norm, and later make such deviations as are required. I know a man living in the Southwest whose only available water was excessively alkaline. None of the standard formulas could be used according to directions, owing to the high alkaline con-

tent, which he compensated for by mixing the formula as given and reducing the developing time; but the result was not so satisfactory as if less alkali had been used in the formula. Usually shorter developing time with abnormally high alkaline content does not give such satisfactory separation in the lower values without blocking highlights as does longer developing time with a smaller amount of alkali. A more satisfactory and more logical procedure would have included tests with progressively less alkali in the developer until the developing time approximated that recommended. Such difficulties and disappointments are easily avoided by an open mind and a definite testing procedure. At the beginning the rule should be: Use the developer recommended by the manufacturer, explore it to the utmost, deviate from the formula only when necessary.

Most standard developers as recommended normally yield greater high-value opacities than I personally prefer. I favor developers that raise the shadow and lower middle tones to a higher opacity (in comparison to the high values) than the average developer is capable of doing. For this purpose, a developer of the semicompensating type, such as Kodak D-23, using Metol alone as a reducing agent in a solution of relatively low pH or alkalinity, will produce admirable results (see page 107). Prolonged development in developers of this type will yield vigorous high-value opacity; hence these developers can be used for a variety of effects and controls (providing relatively long development times are not impractical from an operating point of view.)

Developers containing hydroquinone, or those with Metol alone operating at higher pH values, do not have this valuable compensating action. I find that with the average Metol-hydroquinone developer, by the time the required shadow opacities are reached, the high-value opacities may be too severe; on the other hand, development to the desired high-value opacity may produce insufficient shadow contrast. This difference is not clarified by the usual concept of "gamma," owing to the fact that the restraining action of released bromide in a compensating developer is local and does not operate over the entire negative; its effect is plainly seen in a depression of the higher opacities. The effect of this is not, therefore, the same as development to a lower contrast; rather it combines the properties of low-contrast development in high-value areas and higher contrast development in the shadows. This aids in bringing out subtle differences in tones and values in shadowed, dark, or poorly illuminated areas of the subject that the eye can perceive but which are normally beyond the capacity of the film to separate with the usual development procedures. This is not peculiarly a property of low pH developers, as will be discussed later (page 102); the Metol semicompensating developer, however, is the most convenient means of producing the desired "compensating" effect.

Pyro developers (pyrogallol, also called pyrogallic acid) as a rule produce a "stained" image, which augments the printing contrast of the negative. Also, pyro with less than normal alkali produces fine translucent high opacities. It is an excellent developer—perhaps the finest in many ways—but its action is not always consistent; the amount of stain produced depends chiefly on the degree of oxidation of the solution. This oxidation varies with the concentrations of pyro, sulfite, and alkali in the solution, and the time over which the solution has been used and exposed to air. Yet many workers feel that the results from pyro outweigh its inconsistencies—not the least of which is the unpredictable amount of stain, further modified by the printing- or enlarging-light color.

Pyrocatechin, once a popular developing agent, shows promise of renewed prominence in the future. It, too, is a "staining" developer. Some specialized uses are described on page 107.

A fact worthy of repeated emphasis is that the artist's creative concept is of vastly greater importance than the tools and methods of his craft. In the Alta Mira Caves, early man created magnificent images of animals with the most primitive implements, and utterly without "sophistication." Under the most "impossible" conditions, Hill and Adamson produced photographs in 1844 that remain among the highest expressions of the art.

Do not permit yourself to become a slave to equipment, materials, or methods, but learn to control and apply them to advantage.

Developer Ingredients

Whatever the developing formula chosen for a particular piece of work, it contains chemical compounds of several types, each included for a specific purpose. The amounts vary, and there may be a fairly wide choice of chemicals for any of the given purposes, but the developer always contains a developing agent and usually an activator, a preservative, a restrainer, and occasionally other substances added as modifiers.

The *developing agent* is an organic compound that has the power to reduce exposed silver halide to metallic silver. Metol, hydroquinone, Amidol, pyrogallol (pyro), and glycin are the most common. Proprietary chemicals are capitalized; standard chemical names are in lower case.

The *preservative* is added to prevent undue oxidation of the developer solution, thereby prolonging its life as well as preventing stained negatives and prints. Sodium sulfite is usually included for this purpose. (It is also a silver solvent.) In large quantities, as in D-23, it produces a mild alkalinity.

The accelerator (alkali) supplies the alkaline environment required by most developing agents (except Amidol, which can be used without alkali in a sulfite solution. Metol also functions in a fairly concentrated sulfite solution which is hydrolyzed sufficiently to make the solution slightly alkaline.) Most developers require a fairly high pH (alkalinity). Sodium carbonate and sodium hydroxide are most commonly used as alkalizers; borax or Kodalk (a proprietary chemical) and sodium metaborate are used to produce a mild buffered alkalinity. A buffer is a chemical salt which releases only part of its available acid at any one time. As this is used up an additional part is released, so tending to maintain a constant pH or degree of alkalinity (or acidity) during the course of solution exhaustion. The amount and strength of the alkali used have a decisive effect on the developer action and the resulting quality of the negative.

The *restrainer*, usually potassium bromide, prevents fog (unwanted reduction of unexposed silver halide). It also reduces emulsion speed and increases contrast by inhibiting the reduction of lightly exposed grains, thereby producing lower opacities in the shadow areas of the negative image. The addition of potassium bromide, owing to its restraining action which lowers the gamma of the negative, favors finer grain. The amount of bromide in a negative developer must be measured carefully, especially with developing agents of low reduction potential (resistance to the effect of bromide in solution).

Acids, or rather compounds with a mildly acid reaction, such as sodium bisulfite or potassium metabisulfite, are used as preservatives—in stock solution

A of the ABC pyro formulas, for example, or to lower the alkalinity and buffer the solution, as in the Ansco 47 formula.

Other compounds, including alcohol, sodium sulfate, potassium thiocyanate, etc., are used in special formulas for specific purposes. The addition of strange and exotic substances—often included in odd formulas invented by bathroom chemists—should be avoided.

Replenishers

As a developer is used, its strength diminishes; the developing agent is weakened in its reduction of the exposed silver halide. Further, during development certain chemical substances—chiefly soluble bromides—are released from the emulsion and accumulate in the developing solution. The presence of such residuals alters the character of the developer and profoundly affects negative quality, first reducing the effective emulsion speed, lowering fog, producing lower gamma, and later seriously inhibiting the action of the developer. Adding properly balanced replenisher solutions to the original developer re-establishes the normal activity of the developing agent, and partially counteracts the weakening action of the residuals. Such replenishers can be used to good advantage until the concentration of the residuals becomes so great that the replenisher can no longer overcome their harmful effects. Then discard the developer.

Manufacturers list the proper replenishers for their developers, which should be used exactly according to directions. Merely adding more of the original developer does not restore the developer to its original strength.

Inspection of the developing solution or estimation of its decrease in volume cannot really indicate the need for replenishment, nor should one delay until a change in the quality of the developed negatives becomes apparent, for by that time some negatives will have been underdeveloped. It is best to add replenisher in relation to the amount of film (area in square inches) developed in a given volume of solution. For replenishing Kodak D-23 Developer I add 22cc replenisher for every 80 square inches of film developed, using 4 liters of solution.

It has been my experience that a developing solution should be discarded before its theoretical limit of usefulness has been reached; continued replenishment is dangerous—usually resulting in loss of shadow detail. In fact, it is more economical (in terms of dependable results) to use fresh developer at all times than to attempt to prolong the life of a developer by continued replenishment: beyond, say, 1000cc of replenisher added to the original 4 liters of developer.

Quantity of Developer Solution

A good rule is always to develop with the greatest practicable volume of solution; for 4x5 films—when no more than 12 are to be developed in a tank at one time—at least a gallon is advisable. With a smaller volume the developer may become weakened *during development*, resulting in a slight underdevelopment. For tray development, also, it is preferable to have ready at all times 1 gallon of solution, fresh or properly replenished, so that twelve 4x5 negatives, six 5x7s, or three 8x10s can be safely processed at one time. In this way, developer action is consistent, within practical limits, throughout the period of development.

If the reader holds any doubts, I suggest he make 12 identical exposures, then develop one film in a 1-litre (32-oz.) tank of fresh solution for a measured

time. Then, in the same tank, develop the remaining 11 films for the same time and with the same interval and degree of agitation (see page 74). The difference in density in the second batch will be quite apparent. Since the total energy of a developing solution depends on the amount of work it does—that is, the amount of silver halide it reduces—and since no two negatives contain the same amount of reducible silver halide, it is not feasible to establish a development-time increase factor for a number of films developed at one time in a small quantity of developer. It is far better to work with a generous volume of solution, thereby securing consistent results.

Prepared Developers

Most standard developers are now available in precisely weighed packages, and only require to be dissolved in given volumes of water. Of course in dissolving prepared developers pure water is a necessity, as with other photographic solutions; containers and mixing vessels must be clean; the proper sequence in dissolving and mixing the various chemicals is to be followed; measures, funnels, stirring rods, and stoppers must be uncontaminated; materials must be stored under favorable conditions. Occasionally, packaged chemicals deteriorate if faulty containers result in exposure to air or moisture; if any doubt exists, discard them. Most chemicals are fairly cheap, and spoiled negatives (or prints) make the use of questionable materials an expensive economy.

Developers, replenishers, fixing baths, intensifiers, reducers, toners, and other special formulas are available, all designated by formula number—such as Kodak D-72, Ansco 17, Kodak F-6, and Defender 6-D.

There is no doubt that the standard developing and fixing formulas are cheaper in prepared form; especially so, considering the time required for weighing, measuring, and mixing.

Effect of Temperature on Development

Developing times published in manuals or recommended by manufacturers always specify a working temperature, usually 68°F. The action of a developer solution—just as with any chemical reaction—is affected by temperature, so that lower temperatures result in longer developing times, conversely a shorter time is needed at higher temperatures. Time-gamma-temperature graphs are available for most developers (see Photo-Lab-Index); they indicate how much development is necessary to produce the desired contrast values in terms of gamma (see page 51).

It is not an easy matter for the practical photographer to reckon time-temperature factors for the various developers. And of course developers behave differently with different films. The published charts are the simplest way to determine developing time at any temperature. When the photographer has established his personal normal developing time at a given temperature, he may refer to the charts for the proportional developing times required at other temperatures.

The response of various developing agents to temperature change is by no means equal. Metol, for instance, has a fairly consistent response to increase or decrease of temperature over a wide range—that is, the increase or decrease of necessary developing time is proportional to the temperature difference, be it 1° or 8° or 15°. There are other developers, however, for which change of activity is not a simple function of temperature; not only does the change in developing

time vary with temperature difference, but the *character* of the development is altered. For example, hydroquinone is thought to lose much of its activity below 55°F (the well-established "fact" of reduced activity of hydroquinone at low temperatures is open to question, especially when hydroquinone is functioning with other developer agents), although Metol remains quite active at lower temperatures. Developing solutions containing more than one reducing agent will yield different effects at various working temperatures.

For uniform and constant developer temperatures it is best to adjust the darkroom temperature well in advance, so that all temperatures are equalized when work is started. If such adjustment is not possible, the temperature of a tank or tray may be kept reasonably constant by placing it within a much larger container filled with water of the desired temperature. This "water-jacket" system is the simplest and most satisfactory method for maintaining constant temperatures. See Book 1 for further comment on temperature controls.

Agitation

Development requires an even infusion of the developing solution throughout the exposed light-sensitive emulsion. Gelatin absorbs a limited amount of the solution, so that the effectiveness of the absorbed solution depends on the potency of the developing agent, the character and the amount of associated ingredients (alkali, preservative, restrainer, etc.), as well as on dilution of the solution. As development proceeds, the developing agent originally available to any particular area of the film is exhausted, so that a fresh supply of developer at that point is necessary for continuation of the process. Moreover, certain by-products of the development process—known as "residuals"—tend to inhibit further reduction, and must be removed from the emulsion. Replacing used solution with fresh developer is best done by keeping either film or developer in motion, thus ensuring a constant supply of fresh solution to the emulsion.

The qualities of the developed negatives are considerably modified by the extent and method of agitation of the solution (or the film) during development.

Suppose that a negative is placed in a developing solution, allowed to remain only long enough to become saturated, then is placed in a tray of water or suspended in the air. The developing solution in the emulsion will continue to reduce exposed silver halide until it is exhausted. But, since a certain volume of the solution reduces only a definitely related amount of exposed silver halide, it is clear that the less strongly exposed areas of the image must receive proportionately greater development than the highlights, which, being denser, quickly use up all the available developing agent. The result is a lessening of the possible contrast in the negative. (This scaling-down of high opacities is the principle of water-bath development, in which such limitation of the developer action is intentionally imposed to reduce the density of the high values (see page 104).

If, however, the negative is allowed to remain without agitation in a tray or tank of developer, there will be *some* exchange of fresh and used developer between the solution and that in the emulsion, so that restriction of development is not so great as when the film is removed from the solution. Even so, there is still a proportionately greater development in the shadow and middle tones than in the higher values; the densest areas are not developed to the maximum possible extent, so that the range of opacities in the image (its contrast) is less than with normal development.

74

A negative processed without agitation in a tray of solution may be unequally developed—since local exchange between emulsion and solution may be more effective in some areas than in others—also, a film suspended vertically in a tank in which both the film and the solution are motionless will show a definite "bromiding effect" or streaking, as well as a probable allover greater density in the areas of the negative immersed most deeply in the solution. With the water-bath process (page 104) uneven development is not unusual.

To assure even development, then, and to attain optimum contrast in the image, it is necessary to provide a more or less continuous replacement of the developing solution within the gelatin. Developer action becomes most effective with continuous agitation.

Agitation is not merely giving the film a few jiggles or so during development. It should follow a definite plan (see page 77), consistently applied, but not in a way as to produce directional currents and nonturbulent flow. Such currents must be avoided in order to prevent streaks and uneven spots in uniform areas, such as the sky.

In *tray development,* the film itself should be kept in constant motion, or else have a constant flow of the developer over it (as is effected by rocking the tray). When several negatives are being developed together in a tray, they must be kept in constant motion; otherwise lines and streaks and areas of uneven development will inevitably appear.

In the beginning, only one film should be developed at one time; with practice, a dozen or more films may be handled. A constant change of position can be accomplished in a small tray by repeatedly shifting films from the bottom to the top of the pile, and with a large tray by continuously moving the films, one by one, from one pile to another; or two small trays may be used, so that piles of films can be moved, a film at a time, from one tray to the other. But care is necessary to avoid scratching, finger marks, air bells, and bubble marks. (See page 72 for minimum quantity of developer solution required.)

Air bells or bubbles are to be guarded against in tray development; unless the negatives are constantly moved bubbles will form between the films and leave damaging effects, revealed in the finished negative as circles or streaks of lesser opacity. In the stop bath as well as in the fixing bath, too, there is danger of air-bell formation, which results in an area of greater opacity as the action of the developer continues in areas isolated by air bells. Presoaking in water or in a solution of a wetting agent (such as Kodak Photo-Flo) assures a more even absorption of developer by the emulsion. The films should be immersed and agitated, as in the developing solution, until they are fully saturated. Desensitizing baths also accomplish this very well (see page 111). Of course presoaking prolongs the developing time slightly, as it delays saturation of the emulsion with the developing solution, hence presoaking (or desensitizing) must be allowed for in timing the development. A wetting agent added directly to the developer and the fixing bath, while of doubtful utility, can in most cases cause no harm.

The solution in a tray must be of ample depth to submerge the negatives completely. It is preferable to use a tray considerably larger than the negatives, tipping the far edge up so that films and solution gravitate to the near side. In immersing a negative in the tray, slide it under the surface of the solution rather quickly and agitate vigorously to remove any possible air bells, but *do not rub* the fingers over the surface of the film. In immersing each subsequent film, it

22a. Half Dome, Yosemite Valley. Example of development with intermittent agitation.

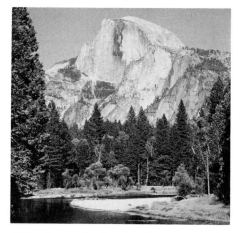

22b. Same. Developed with constant agitation. Opacity and contrast increased.

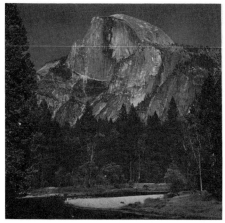

22c. Same. Developed without agitation. Opacity and contrast decreased. Uneven sky values.

These three images represent identical exposures, developed as indicated. Then all three were printed together on one sheet of paper—given the same exposure and developed in a normal print developer.

The striking differences in negative quality that derive from intermittent, constant, and no agitation of the negative in the developer will impress the reader with the need for adequate and consistent agitation.

However, the reader should know that if each negative were printed separately on a paper of appropriate exposure scale, reasonably good prints could be made from 22b and 22c, with the exception that in 22c some unevenness in the sky, due to "stagnant" development, would appear. No. 22a would yield the best print (on normal paper), as the negative development was appropriate to the exposure.

is important not to dig its corners or edges into the surface of the film below it; aligning the edges of the films against the edges of the tray may be helpful.

Agitation of a number of films in a single tray is best accomplished by removing the film on the bottom and placing it carefully on top of the pile, then pressing down *gently* to assure flow of solution over it. (Once films are saturated with developer, slight pressure with the balls of the fingers is not harmful, unless the developing solution is overwarm.) With two trays, either the bottom or the top film in one tray is moved to the second tray, where the pile is completed, each film then being pressed gently under the solution with the balls of the fingers or thumb. (Pressure should be applied at the edges of the film.)

If the developer in use—pyro, for example—produces stain on exposure to air, the negatives should not be lifted clear of the solution. That is, they must not be piled on one another unless it is possible to shift them under the surface

of the developer. For tray development a high-sulfite developer should be chosen, so that little fog will result from exposure to air during development.

Since tray development demands constant agitation, developing time for any solution is shorter than with intermittent agitation in a tank unless the number of films is so great that an appreciable interval exists between each handling of any one negative, in which case such a process would be considered as intermittent agitation, the interval of which is the time required for a complete shifting of the pile. Development times must be adjusted to the frequency of agitation.

Refer to Figure 22 a-c for examples of no agitation, intermittent agitation, and continuous agitation.

In *tank development*, the negative holders must be moved vigorously, not merely joggled. They should be lifted clear of the solution, tipped to one side, immersed, then lifted clear and tipped to the opposite side; or if the tank is large enough, be given a considerable degree of circular motion. (If the developing solution in use tends to oxidize and stain on exposure to air—pyro, for example—agitation should be done without exposing the films to air. This implies a side motion as well as an up-and-down motion). Another way is to move the holders slowly broadside across the tank (assuming a tank of considerable length and volume), thereby setting up currents and eddies that favor good circulation in the solution. Caution is necessary; if films are moved too rapidly they will be forced from the holders and probably damaged.

Large professional developing tanks, especially for color processing, may be equipped with efficient automatic agitators that are designed to avoid "flow channels" on the negative and fixed currents in the solution. For the small roll- and sheet-film tanks, automatic agitators may or may not be efficient. Personally I would rather carry out intermittent agitation (say at 1-minute intervals) and occasionally invert the tank (if the top is watertight) or invert the reel within the tank. Violent agitation of the tank may cause frothing of the developer and serious air-bell and bubble markings on the film.

It must be emphasized that the actual degree of agitation is not so important as adherence to a consistent plan with regard to interval, extent, and total time of agitation once developing times have been established with that plan in use. A plan should be adopted when the optimum opacity tests (see page 44) are made, and should always be followed closely if consistent results are expected. I suggest to the following plan:

1. For development up to 5 minutes:
 constant agitation
2. For development of 5 to 10 minutes:
 during first minute, constant agitation
 every minute thereafter, agitation for 15 seconds
3. For development of 10 to 15 minutes:
 during first minute, constant agitation
 every 2 minutes thereafter, agitation for 30 seconds
4. For development of more than 15 minutes:
 during first minute, constant agitation
 every 2 minutes up to 20 minutes, 30 seconds' agitation
 every 5 minutes up to 60 minutes, 60 seconds' agitation
 every 10 minutes thereafter, 60 seconds' agitation

This, of course, is only a suggestion allowing many variations. It is advisable to work out a plan easy to remember. For a developer such as D-23, which usually requires from 14 to 17 minutes for normal development, and may extend to 60 minutes or more, plans 3 and 4 would apply even though an 8-minute developing time were used for soft ("normal-minus" or "normal-minus-minus") development. See page 41.

Remember that constant agitation results in a negative of proportionally greater high value opacity due to a marked increase in development contrast. Intermittent agitation is usually better for moderate or long developing times. If there are too many films in a small tank, agitation will not be efficient.

Handling Negatives during Processing

Tank or tray? The question must be answered by every individual for himself, the answer depending on the nature and the amount of the work at hand as well as on individual skill and preference. Most people consider tank development ideal. There is no doubt that the method allows more precise control and can be done with less muss, less finger-staining; also lighttight tank covers allow use of darkroom lights between agitation periods. Yet there are photographers who prefer to develop in a tray, and who hold that careful and experienced hands are less likely to damage negatives than are film hangers.

Whatever method is chosen, the photographer should work out and adhere to a definite procedure for handling films and equipment, from loading the holders to drying and storing the finished negatives. An hour or so of study, with thoughtful attention to each step, to find the easiest and most efficient procedures *in his own darkroom* may save the photographer many hours of work, as well as assuring better results and greater satisfaction. A profitable continuation of this study would be actual practice in darkroom procedure without lights, and with discarded film, executing each step of the development process with the express purpose of improving facility.

Darkroom Hints

1. Take nothing for granted; check safelights, solution temperatures, etc., before every operation.
2. Do not be impatient; wait sufficient time for the thermometer to register correctly. Some thermometers require several minutes' immersion for accurate readings.
3. Do not use towels over too long a period of time; they accumulate chemicals.
4. Never drain hypo from negatives or prints on the floor or on sink edges. Rinse thoroughly after removing from hypo before examination.
5. Don't forget to list the number of films processed in the developer and fixing solutions. If a variety of sizes are used, it is better to list the number of square inches of film processed. This will give you a good check on the need for replenishment.
6. Be certain to use clean swabbing material for every batch of films. If a rubber windshield wiper is used, see that it is rinsed before applying it to films.
7. Inspect films frequently after hanging to dry to be certain no water drops have gathered on the front or back surfaces. The use of Kodak Photo Flo is advised.

The general outline of a processing system (assuming tank development) may be as follows:

1. *Prepare work space and materials.*

 Lay out the required number of film hangers, right side up and grippers open. Place the rack for the loaded hangers in a convenient position. Prepare developer, stop bath, and fixing bath, and arrange the washing tank.

 Check safelights and switches.

 Set the tank cover in a convenient place.

 Check temperature of the developer and determine the required development time; adjust timer.

 If negatives are to be developed for different times, stack the film holders in proper sequence so that the topmost negative is that requiring the longest (or shortest) development time. Note down the developing times required.

2. *Load exposed film in developing hangers.*

 Turn out all lights.

 Remove each film from its holder, dust with a soft camel's-hair brush, insert it in the hanger, close gripper, and place the hanger on the rack. Have all films facing the same direction, and make sure that the proper sequence of hangers is retained (corresponding to the numbered film holders or special groupings).

3. *Place films in the developer.*

 Lift all hangers together and place in the developer.

 Set timer.

 Agitate all films according to plan (see pages 74 and 77).

4. *Complete the processing.*

 When development is complete, place the negatives (in the hangers) in the stop bath and agitate for from 30 seconds to 1 minute. Then place the negatives in the fixing bath and agitate constantly for 1 minute, and thereafter every 1 or 2 minutes. Do not allow them to remain in the fixing bath overlong (see page 83).

 Rinse the negatives in water, then transfer them to the washing tank— or to a full "storage" tank (with a small flow of water)—in which all films are accumulated until the entire batch is ready for washing. Before washing, swab each side of the negatives with a soft chamois or cotton to remove any possible scum or chemical deposit.

5. Ideal tank washing is accomplished with a device that distributes water evenly, and with sufficient force to reach every part. In one such device a pipe drilled with numerous small holes is placed on the tank bottom. Small vents in the tank sides—both top and bottom—allow the water

to flow freely from the tank. Water input pressure must be sufficient to maintain adequate circulation and a full tank at all times; if the water level falls so that the negatives in their holders are only partially submerged, serious damage is likely.

6. *Hang the negatives to dry.*

After sufficient washing, remove negatives from the hangers—drying in the developing hangers may result in watermarks or adhesion to the edges of the hangers—swab and rinse, apply a wetting agent if desired, then hang up the negatives by the corners to dry. Swab both sides of the negative to remove any possible scum or chemical deposit. Remove excess water with an automobile windshield wiper. Check to be sure no water drops remain. (See Book 1 for a discussion of storage of negatives.)

7. *Clean the darkroom.*

As soon as the negatives have been set to washing, begin to put the darkroom in order, returning used apparatus to its place.

Discard solutions that are not to be used again, return to storage containers any solutions kept in them, and finally replace the containers on the shelves. (Funnels, measuring and mixing vessels, outsides of storage containers, etc., should all be hosed off to avoid contaminating the storage shelves.)

Cover the stop-bath and fixing-bath tanks. Also cover the developer tank if the developing solution is to be used again. (A floating lid of hard rubber or plastic, which minimizes exposure to air, helps to prevent oxidation.) This lid must have raised edges to provide proper displacement. Wood is not advised as it absorbs chemicals.

Wash out thoroughly the emptied tanks and trays (see page 81, footnote). Wash off working surfaces on the "wet" side of the darkroom.

Dust film holders, and reload them if they are to be used immediately, or else partially insert the slides with the "exposed" side out, and store the holders.

It is conventional to have the black side of the slide flange of the holder face outward if the holder is empty or contains exposed film, and to have the white side face outward if the holder contains unexposed film. Raised dots or ridges are stamped on the white side of the slide flanges for identification in the dark.

Special tanks may call for special loading procedures (as directed by the manufacturer), but subsequent procedures are essentially the same as above.

If the developing tanks are overlarge, and the hangers are easily placed askew in them, there is danger of the hangers' falling off the sides of the tanks and dropping into the solution, possibly scratching and ruining other negatives. Many a film has been scratched by careless handling of the developing hangers.

In tray development, the underlying principles are unchanged, but problems of handling are different. How to achieve sufficient agitation without damaging the delicate emulsion is described in the section on Agitation (page 74).

THE STOP BATH

Since developing solutions are predominantly alkaline—the developing agents require alkaline environment for activity—their action can be arrested by immersing the film (or print) in an acid stop bath. The bath's function is twofold: 1) it instantly stops the action of the developer, thereby arresting development of the negative (or print), and 2) it neutralizes the alkalinity of the carried-over developer so that the fixing bath will remain acid. Most negative developers are less alkaline than print developers, and do not require such a strong stop bath as is necessary for prints.

To many workers, the stop bath is merely a splash of acid in a vague amount of water. It should be compounded as directed. With too little acid, it is easily neutralized by the alkaline developer in the emulsion—and development may then continue. Too much acid may generate gas bubbles within the emulsion, producing small blisters or "pinholes." Chrome-alum stop baths not only neutralize alkalinity but also harden the emulsion, and are therefore advised for miniature work—some think them best for all types of negatives. However, the ordinary acetic-acid formula is economical and perfectly satisfactory for most purposes; see page 115.

As in all solutions, agitation in the stop bath is important. Throughout the film the developer action must be stopped instantly; partially arresting developer action may result in streaks and differences of density in the image, most clearly visible in the sky or other area of continuous tone. Such unequal densities are practically impossible to correct by retouching, or dodging or burning in printing.

There are various methods for testing the acidity of the stop bath that are practicable only when very large volumes of solution are used (as in motion-picture and photomural work). The average photographer uses much smaller amounts of solution, so that it is better to make a fresh stop bath (of correct proportions) for each batch of work, discarding the solution when finished.*

Subjecting the negative to sudden and extreme changes of temperature may result in reticulation, or other damage. At certain temperatures the gelatin emulsion tends to swell beyond its tolerance of adhesion to the base, so that blisters or reticulation may occur, or considerable areas of emulsion may be detached from the base. For this reason it is important to control the temperature of the stop bath and the fixing bath as well as the developing solution.

Remember that the developer is alkaline. Not only will hypo contaminate it, but the acid stop bath can also destroy its effectiveness. Therefore fingers or tongs contaminated with either of these solutions must not be returned to the developing solution without having been rinsed thoroughly in frequently renewed warm, neutral water.

If through error a negative is transferred from the developer to the stop bath before reaching optimum development, it can yet be saved; it should be washed for at least 5 minutes, then placed in a 1% solution of a mild alkali such as Kodalk for 5 minutes, and finally rinsed and returned to the developer. There should be no damage or loss of quality with this treatment, if done thoroughly.

* The acid properties of the used stop bath may be employed to neutralize and clean the developer tray. When the solution is discarded, rinse out the developer tray and pour the used stop bath into it; let stand for a few minutes, then pour out, wipe the tray with ordinary cloth, rinse in hot water, and dry.

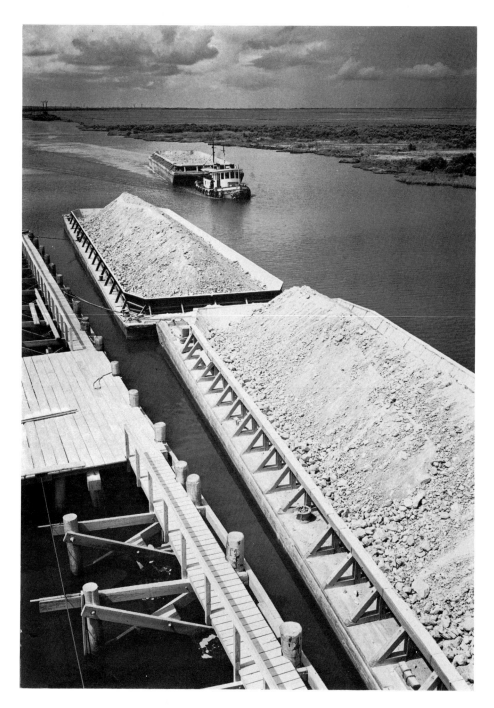

23. Sulfur Barges, Louisiana. Normal exposure, normal development. Average meter reading would indicate approximately correct exposure. Yellow filter was used to raise values of the yellow sulfur, deepen the sky, and reduce haze.

THE FIXING BATH

The exposed silver halides when reduced by the developer to metallic silver are "permanent." However, the emulsion still contains a considerable amount of unreduced halides still sensitive to light, which must be removed without affecting the reduced (metallic) silver of the image. These unreduced halides are removed by immersing the film in a fixing bath containing sodium thiosulfate (also known as sodium hyposulfite or "hypo") where it remains until the unwanted silver compounds are dissolved; then it is thoroughly washed.

The process of fixation is not so simple as it may seem. The chemical action of sodium thiosulfate on the silver halides is complex, and there are also residual actions and products of real importance to the appearance and the permanency of the negative or print.

According to some recent opinion, prolonging fixation much beyond the time necessary for clearing is actually harmful, for sulfiding of the silver is initiated, causing the image to fade with time. This is at variance with the popular concept that a film should remain in the fixing bath for twice the time required to clear. Prints clear rapidly—in half a minute or less in a fresh bath—but films require a considerably longer time. The basic reason for fixing "for twice the time it takes to clear" is to assure adequate fixation. It is difficult to judge the moment of complete clearance. However, in a fresh bath 10 minutes should ensure maximum fixation for negatives, and 5 minutes for prints. Of course adequate agitation is implied; if negatives or prints are allowed to lie on or against each other without constant movement, fixation will not be complete, and there will be a number of unfortunate results. Intermittent agitation is adequate for fixing negatives in a tank, constant agitation is necessary in a tray.

A fixing bath normally contains several carefully balanced ingredients. Although a simple solution of sodium thiosulfate will fix a negative perfectly, certain injurious effects may result from having no regulating ingredients. If the stop bath is omitted between developer and fixer, the developing solution continues to act in the emulsion while the film is in the fixing bath, causing stains and irregularities of density. Also, the bath itself is adversely affected. On the other hand, if an acid stop bath is used to arrest development, the acid carried over to a plain sodium thiosulfate fixing bath will decompose the thiosulfate, precipitating sulfur from it, so that the solution is ruined. Hence the fixing bath should be acid (preferably with a pH of about 5.6). Sodium bisulfite (or sodium sulfite and acetic acid) are the usual acidifying chemicals. The sulfite prevents precipitation of sulfur by the acid. In some formulas either boric acid or Kodalk is added as a buffer to keep the pH constant—especially for fixing solutions used after developers of high alkalinity.

Negative emulsions are rather delicate, and respond even to moderate warmth by frilling and other destructive effects. To prevent such damage, the emulsion can be hardened by the addition of alum (potassium alum) to the fixing bath. This is not really necessary in cool climates, or when the water used for washing does not exceed 68°F, but is a sensible precaution. We shall note in Book 3 that a hypo-bisulfite fixing bath may be more desirable for prints, since it frequently improves print color; but in a negative color has little meaning, and a hardening fixing bath is advisable.

The well-balanced fixing bath contains the following:

1. Sodium thiosulfate (hyposulfite)—fixing agent
2. Sodium sulfite—preservative
3. Acetic acid—acidifying agent
4. Potassium alum—hardening agent
5. Boric acid (or in some Kodak formulas, Kodalk)—a buffer

Special formulas (refer to PHOTO-LAB-INDEX) call for ammonium chloride, chrome alum, or other less usual ingredients—all are for special purposes. For general use, the standard formulas are perfectly satisfactory.

The fixing-bath formula must be mixed in the order given, to prevent precipitation of the thiosulfate. (See page 115 for fixing-bath formula.)

Following development and stop bath, the negative should be transferred to the fixing bath and agitated constantly for about 1 minute, and thereafter at frequent intervals if in a tank, constantly if in a tray. When cleared, immerse the negative in a fresh fixing bath for a minute or two more, then wash thoroughly. The purpose of the second bath is to ensure complete fixation by removing from the film silver salts that accumulate in the fixing bath with use. It is almost impossible to remove these salts by washing. Left in the emulsion, they will in time cause stains and fading. With a fresh fixing bath, the second bath is not necessary, but with a fixing bath which has been used to any extent, the second bath is recommended.

Temperatures should be kept at the optimum (68°F). Changes of temperature between the different solutions and the wash water may cause reticulation and frilling and undoubtedly coarsens the grain of the image.

Hypo is the cheapest chemical in the darkroom; it is surely poor economy to spoil a valuable negative by "stretching" a fixing bath beyond its capacity. While 100 4x5 negatives or their equivalent may be fixed in 1 liter of fixing solution (such as Kodak F-5), I would personally never use the bath for more than half that number, since a fixing bath may be capable of clearing a negative, yet contain a dangerous accumulation of residuals. Also, the instant a bath turns cloudy or changes color, discard it. Such effects are usually due to impure or incorrectly labeled ingredients, to improper compounding, or to contaminations.

Special hardening formulas are available for processing at higher temperatures. (See the PHOTO-LAB-INDEX.)

Refer to page 115 for the gold-protective formula, recommended when maximum permanency of the negative is required.

Rapid fixing formulas—some proprietary formulas, such as Quick-Fix (Edwal)—have definite advantages when time-saving is important. However, I have found that the actual time saved by fast-working solutions is not of much consequence in relation to the time required for the entire processing procedure (if truly permanent results are required). The basic procedures of unloading the film holders, loading the film developing hangers, stop-bath treatment, washing, and hanging up to dry, require a certain minimum time—perhaps 45 minutes to an hour. Saving a few minutes in the developing and fixing processes does not materially reduce the total processing time. Negatives and prints treated in the new Kodak Hypo Clearing Agent following fixation require considerably less washing time.

WASHING

For some reason many photographers think of negative and print washing as a perfunctory task, the sole purpose of which is to "wash out the hypo." Actually, it is one of the most important steps of the whole process, and on it, to a great extent, depends the permanence of the image.

Negatives require less washing than prints, for the simple reason that the impervious cellulose film base does not retain chemicals as do the fibers of paper. (Some new papers of waterproof stock, however, require a shorter than normal washing time). The negative *must* be washed properly for permanence.

The chemical processes of development and fixation are actually very complex, and the residuals of those processes varied and potentially harmful. We know (page 83) that complete fixation requires fresh baths, with treatment neither too long nor too short. After fixation, a complex silver salt remains in the emulsion, along with the fixing chemicals. The greater part of these unwanted materials can be removed by holding the negatives under a gentle stream of tap water, rinsing both sides thoroughly. Sludge should be removed by gentle wiping with cotton or soft chamois. (The latter will require frequent and thorough washing, the cotton should be discarded after use). Then wash the negative in a tank with ample running water for at least one hour. With the use of Hypo Eliminators after fixing (and rinsing) the washing time can be reduced to 20 or 30 minutes with safety.

The water temperature should closely approximate the temperatures of the developing and fixing solutions. Precise temperature control is especially important in miniature processing. With medium-size negatives a 5° difference plus or minus is of little consequence, but miniature negatives demand much greater care at each step. However, it is always advisable to hold the temperature of the washing water at, or slightly below, that of the fixing bath—especially in warm weather. If too warm, the negative tends to soften and frill. If too cold, washing time is slowed considerably.

Wash water need not be "pure" (free of mineral or vegetable matter) to remove silver salts, provided the negative is given a final rinse in pure water and thoroughly swabbed off before drying. Rust and oil are dangerous; "mud" and grit less so, provided films are not rubbed together while washing. In any case, a thorough final rinse is imperative.

Washing in a Tray

Efficient washing consists in having an adequate and a continuous flow of water around the negative. Merely placing negatives in a tray or a tank with a weak stream of water flowing into it cannot accomplish satisfactory washing. In a tray the films must be constantly moved about and separated from one another. If negatives stick together, the areas of adhesion *cannot* be properly freed of chemicals.

It is a good idea to use two trays in which water circulates fully, and to shift the negatives back and forth between them. After 5 minutes or so in one tray, the negatives should be hosed off gently on both sides, and transferred to fresh, circulating water in the other tray. Then after another 5 minutes they should be again rinsed off and returned to fresh water in the first tray, and the process repeated at 5-minute intervals until 8 or 10 changes are completed.

Here, as always, we must guard against scratching the films; the delicacy of the emulsion increases with the temperature. Negatives require much more careful handling than prints.

Washing in a Tank

Tank washing is the most efficient, provided there is ample circulating water reaching all parts of the negatives.* The ordinary developing and fixing tank is not a really satisfactory washing tank unless the film is changed back and forth from one tank to another, with a rinse between, and with a complete change of water on each transfer. (See 5 on page 79.) The input flow of water must be sufficient to create turbulence in all parts of the tank and over the surface of the films; the presence of air bubbles on the film surfaces indicates the water is stagnant at those places. Test the efficiency of circulation by slowly lifting a film out of the tank; if it has a fresh "rinsed-off" look the water circulation is probably adequate. But if bubbles, or chains of bubbles, remain on the surfaces the film is not being properly washed. IMPORTANT: No matter how efficient the washing tank, it is advisable to agitate the films occasionally during washing, and to empty the tank several times during the washing period.

DRYING

After washing, the negatives should be rinsed under a gentle flow of water, wiped with cotton or chamois on both sides—if this was not done before, or if there is any possibility of sludge in the washing water—and hung up to dry. Films should *not* dry in the developing holders.

Negatives should be hung by one corner to facilitate draining. They should be examined frequently during drying; any water drops forming on the surfaces should be gently removed with clean chamois or with an automobile windshield-wiper blade. Hanging negatives with sky or other uniform areas uppermost lessens the chances of spotting in these critical areas. Finger marks must be avoided, and films must be protected from abrasion or contact with other films during drying.

The temperature and humidity of the drying cabinet or room are important. I have found that with rapid drying there is greater danger of water drops forming on the negative than under cool, moderately humid conditions. Personally, I prefer to allow the negative to drain naturally rather than to wipe it when the negative is hung to dry—provided all sludge has been removed and the negative has been given a final rinse on both sides. It is helpful to treat negatives with a wetting agent—such as Kodak Photo-Flo—before drying.

The humidity of the drying room or cabinet should not be too high. On the other hand I have found that watermarks form more readily in an environment of excessively low humidity; 70% relative humidity at temperatures of not over 85°F will produce the most rapid drying with safety.

Dust in the drying area can be distressng. Usng a fan or placng the dry-

* Unequal washing will in time show itself in visible stains or fading, producing mottled, unequal values in the print. It would, in fact, be better for a negative to receive inadequate general washing than to be insufficiently washed in certain areas.

ing negative in a draft may cause serious dust troubles unless the air is thoroughly filtered. Heated air is not advised except when rapid drying is absolutely necessary. Infrared ("heat") lamps may be used, but the heat must be applied evenly to all areas of the negative, so as to avoid curling and the formation of drying marks. Adequate circulation of air is imperative.

Films must be thoroughly dry before being placed in envelopes or stacked together. In damp climates several days may be required for a film to dry thoroughly, and buckling and curling are the least of the injuries resulting from the storage of incompletely dried film.

Fully dried negatives are most satisfactorily stored when placed between folds of glassine paper; this "sandwich" can then be put into an ordinary negative envelope. The "joints" of the envelopes should not come in contact with either side of the negative. Most adhesives used, being hygroscopic, are almost certain to produce stains in the negative if they touch it. [Adhesives joining the envelope may accumulate moisture that will seep through the envelope paper to the negative within.]

Negatives sealed in envelopes invite mold and stain except where very dry conditions prevail. Of course, thoroughly dry and hermetically sealed containers assure maximum protection to thoroughly dry negatives.

For most efficient ventilation, negatives should be filed with the open end of the envelope *up*.

24. Detail of Cliff Palace Ruin, Mesa Verde National Park, Colorado. Example of total development. Values, excepting deep shadows, within 1 to 4 range. Isopan film; 30 minutes in Ansco 47 (page 99).

DEVELOPMENT OF THE MINIATURE NEGATIVE

The subject of the miniature negative could occupy an entire volume, but the literature commonly available on the subject is copious, and the scope of these books does not justify more than touching on the subject here. Certain fundamental considerations, however, may well be presented at this time.

The Problem of Grain

The principal consideration is: How should the miniature negative be developed to preserve optimum scale of values and optimum refinement of grain structure? We know that fineness of grain is limited in relation to the resolution of the optical image; with anything smaller than the optimum grain size a "halo" of colloidal silver is produced, which actually reduces definition. (For discussion of grain size and the illustration of definition, see Book 1, page 35.)

What is the optimum grain size in an image? It depends on 1) the size of the enlargement to be made from the negative, and the viewing distance thereof, 2) the definition and resolution desired in the image, 3) the contrast scale of the negative (the effective opacity range; this relates to the type of enlarger used as well as exposure scale of the paper), 4) the effective emulsion speed of the negative: usually the faster the film the coarser is the grain.

The last consideration is the most important. Almost without exception, the finer the grain produced by development, the less will be the *effective* emulsion speed. The whole range of values in the negative is moved downward on the characteristic curve when fine-grain developers are used, and those values normally falling on the toe of the curve are then likely to fall below the threshold. Of course if all important values have been placed well up on the straight-line portion of the characteristic curve, there is little or no change in the relationship between the opacities in the negatives.

The relationship of grain size and emulsion speed depends less on the type of developer used than on the emulsion itself. Panatomic-X, for example is much slower than a relatively coarse-grained high-speed film such as Super-XX. To produce relatively fine grain on a film such as Super-XX requires a fine-grain developer, which in turn may seriously reduce the effective emulsion speed of the film. There appears to be no way of overcoming this fundamental relationship between grain and emulsion speed, although it may be that in the future the actual emulsion speeds of fine-grain film may be increased through advances in manufacturing technique. Many questionable claims are made for developers giving high ASA speed values.

Grain results not so much from the size of the original silver particles; it is rather the cumulative effect of nonuniform distribution of the developed particles. The clumping together of these silver grains is perceived as "grain." If we could bring about uniform distribution of these particles, an effectively finer grain would result. In fact, grain size can be accurately evaluated, and under precisely controlled conditions can be produced at will. But the practical and creative photographer cannot afford to spend his time on such mechanical matters; he must set a reasonable limit of maximum grain size (determined in relation to his work) and proceed accordingly.

Since grain becomes coarser with increased development, the basic procedure should be founded on ample exposure and moderate development. For any given film and developer apparent grain size seems definitely related to gamma. Contemporary opinion holds that negative granularity depends on two major factors: the graininess of the particular film and the degree of development (gamma). Granting this true in the broadest sense, we still must consider the effects of special developers—such as paraphenylene-diamine and formulas containing silver solvents.

Factors Affecting Grain Size

Practical factors controlling fine grain in negatives may be set down briefly as follows:

1. *Emulsions.* The faster the film, the coarser the inherent grain.

2. *Developing Formulas.* Developing agents such as Metol and pyro-Metol (in solutions of low alkalinity) or Amidol (in considerable dilution) yield images of reasonably fine grain, provided the time of development is normal and that equal temperatures are maintained throughout the various solutions, and in washing and drying. The Edwal fine-grain formulas are excellent.

Paraphenylene-diamine is a developing agent which (alone or in proper combination with other agents, such as Metol or glycin gives truly fine grain.

Potassium thiocyanate (or sodium sulfocyanate) is used in many fine-grain developers to minimize the clumping of the developed silver grains.

In general, the lower the pH of the developer, the finer the grain. An interesting exception is pyrocatechin, which can be used with the powerful alkali sodium hydroxide, and—under proper processing—gives a thoroughly acceptable grain size. The addition of an acid salt (sodium bisulfite) to the Kodak D-23 developer (resulting in the Kodak D-25 formula) gives one of the best fine-grain developers available, although it reduces the effective emulsion speed of the negative by about one-half, and also reduces the acutance of the image.

3. *Development Time and Temperatures.* Prolonged development over the normal time in any developer gives increased grain size.

The higher the temperature of the developer, the larger the grain, also because of excessive gamma. However, the increase in grain size is not necessarily proportional to increase in temperature, but rather to increase in gamma, Kodak D-25 used at 75°F produces both low gamma and fine grain.

Variation in temperature from one solution to another (including wash water) should be kept to a minimum—certainly not more than 5°F (to avoid a form of incipient reticulation sometimes mistaken for graininess). Drying temperature also should be close to solution temperature.

4. *Effects in Printing.* The nature of the enlarging light has a great deal to do with effective grain in the final image. Grain is minimized by diffuse illumination, but resolution in the projected image is also diminished. Miniature-camera negatives are usually enlarged with condenser enlargers (see page 24).

The textural quality of the subject and of the printing paper used may influence the visibility of grain in the print. (See Book 1, page 35.)

Finally, the print-viewing distance determines the grain-size tolerance, just as well as the tolerance of definition.

The dividing line between "semi-fine-grain" and "fine-grain" developers is certainly indefinite, and any such distinction must be based on the anticipated degree of enlargement, as well as the character of the enlarging light. In enlargements of moderate size, different types of enlarging lights do not produce serious differences in apparent grain; above a certain degree of enlargement the nature of the light makes an important difference. Granularity is augmented by collimated light—that is, light directed into relatively straight beams by a condenser system. Also, the Callier effect decidedly influences the grain by intensifying image contrast (see Book 3).

A film such as Superpan Supreme (35mm) can be developed in a simple Metol formula such as D-23 (ample exposure, moderate development), and enlargements up to 5x7 are entirely acceptable if they are made in a condenser enlarger with a frosted lamp. Panatomic-X developed in D-23 can yield about 8x10 enlargements under similar conditions. These are personal opinions. Few photographers will agree on what constitutes really "fine" grain, or image quality.

Enlargements such as those suggested above are possible only with negatives processed under highly favorable conditions. Prolonged development, incorrectly compounded solutions, or harsh enlarging light will show more grain in the print.

Selecting a Developer

What developers, then, can be recommended? I can give you no definite advice. Each photographer must analyze his requirements, investigate the advantages and limitations of various developers, and select from them one that ensures results favorable to his own concepts and purposes. I personally favor Kodak D-23 for semi-fine grain, and for very fine grain. Edwal Super 20, Minicol and FG7 are excellent prepared developers for very fine grain. They have many advantages including very little sludging, and only slight fogging even with prolonged development.

Perhaps the best general work on fine-grain development is *What You Want to Know about Developers*, by Dr. Edmund Lowe [Camera Craft Publishing Company, San Francisco], which the serious student should read carefully. Dr. Lowe points out that any proprietary developer can be analyzed and duplicated, and most of the "secret formulas" are adaptations of standard and well-known formulas of fine-grain characteristics.

It is well for the student to begin with the simplest general-use fine-grain formula and explore it fully. Only when he has investigated all its possibilities should he try special developers for special purposes, or deviate from standard procedures.

Establishing an Individual Norm

It is important that the photographer make tests of the sort outlined here: Select a typical subject under average lighting conditions—a head in sunlight, for instance, is excellent. Take meter readings of the skin values in both sunlit and shadowed areas. Plan a set of 5 negatives, exposing for the sunlit values on Zones IV, V, VI, VII, and VIII, and make 5 or 6 sets with space enough between them on the roll (if 35 mm film is used) for cutting the film in the darkroom. For 120 size, it will be advisable to devote an entire roll to a set of exposures.

Then with the selected developer develop each set for different times— normal, that is, as recommended by the manufacturer for the film used; ¾ of

the normal times; $\frac{2}{3}$ normal; $1\frac{1}{4}$ normal; $1\frac{1}{2}$ normal—and determine which particular negative gives the most satisfactory print *in your own enlarger*. You may then consider that negative as your personal standard for such subject material.

You may find that placing sunlit skin on Zone VII and developing for $\frac{2}{3}$ the "normal" (recommended) time gives satisfactory grain but perhaps fairly flat highlights on No. 2 paper. On the other hand, placement on Zone V with $1\frac{1}{4}$ normal development time may give well-separated highlight values but more grain than is desirable. But normal placement with less than normal development and use of a No. 3 paper may give exactly the emotional and physical results you seek. From such tests you can develop an awareness of the practical limitations of any given combination of film, exposure, development, and printing. It is all a very subtle matter of personal decision, and cannot be evaluated in factual terms, nor determined by anyone other than the individual photographer.

Since fine-grain development reduces emulsion speed, a test for effective threshold should be made under your normal conditions of processing. The commonplace "empty" shadows seen in so much miniature photography are due chiefly to reduced emulsion speed—though they may result from excessively short development, which does not ensure adequate distinction of values in the toe of the curve. These and other undesirable effects may be avoided by recognizing and allowing for the limitations of miniature photography.

In work with miniature films there is much less leeway in altering development procedures for special purposes than with larger negatives. Therefore, visualization should not include reliance on special controls that may adversely affect grain size.

Care in Handling

Development and handling of miniature negatives require even more care than is necessary for negatives of larger size. Every blemish, pinhole, and dust spot is magnified equally with the image itself when the enlargements are made.

Cleanliness is essential; tanks and reels should be thoroughly rinsed with hot water after each use and thoroughly dried before being used again.

Agitation is of great importance throughout processing, but especially during development. Mechanical agitators may be useful or not, depending on the size and structure of the tank and the reel. An agitator that rotates the tank abruptly on a horizontal plane may set up patterns of flow that cause streaks and uneven densities in the negative; those turning the tanks with a combined rotating and tilting motion are preferable. But perhaps the best method is to rotate the tank manually for from 5 to 10 seconds, then turn upside down or tilt it, then rotate again, repeating these three movements every minute or so during development. Agitation is essential during development, for without it, streaks, areas of unequal development and reduced contrast will obtain. (See page 74.)

Developers for miniature film are improved by replenishment—to a certain degree. Developer residuals—which accumulate in a solution that has been repeatedly replenished—favor fine grain, owing to the reduction of the effective film speed, which becomes more apparent in miniature work than with larger negatives. It is important not to overreplenish the developer (see page 72).

Use of a chrome-alum stop bath following development is strongly advised, as this solution not only hardens the emulsion (thereby reducing danger of scratching, frilling, etc.), but also minimizes the production of blisters and

pinholes. It should be used with caution. With continued use green chromium hydroxide is formed (due to the rise in pH from the carried-over developer) and the negative may be stained. A *dilute* acetic acid stop bath is very satisfactory.

After washing, the film should be carefully and gently wiped with cotton or *clean* photo chamois, rinsed to remove any possible lint, immersed in a solution of a wetting agent in very clean water—to prevent water spots, which are very distressing on small negatives—and hung to dry. Excess water is removed with a chamois, or with a very soft, lightly applied rubber squeegee.

It is especially desirable to use distilled water in making up developer solutions for miniature negatives, and to filter the solutions before use. But stop baths and fixing baths need not be made with distilled water, nor is filtering necessary unless they contain visible sludge or other foreign matter. The use of "impure" water (that containing only inert organic or inorganic substances) does not necessarily affect the washing process, but film washed in it should be wiped carefully and rinsed in filtered or distilled water, before drying.

When dry, small roll-film negatives may be cut into strips of 4 to 6 exposures and filed in separate envelopes designed for that purpose. Filing miniature film in rolls is hazardous, owing to the danger of scratches from "cinching" the roll.

When working with individual exposures we may develop our film in relation to the exposures. When working with roll film we should plan our exposures in relation to Normal and Normal —1 development.

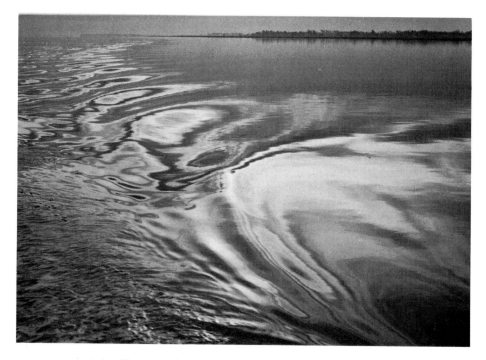

25. Water Detail, Albemarle Sound. Section of 2¼x2¼ negative. Normal-plus exposure; normal-minus development. High values slightly blocked. Less-than-normal exposure and normal development would have given crisper whites, but a higher-contrast paper would have been required. Normal-plus development would have increased the grain size.

LIGHT SOURCES INCLUDED IN THE IMAGE

A light source is far more brilliant than its reflection from any substance or surface—excepting mirrors and highly reflective surfaces—perhaps hundreds or thousands of times as bright as the reflection. Do not confuse the brightness of the light falling on a surface (and the percentage of reflectivity of this surface) with the intrinsic brilliance of a light source.

Light sources are normally excluded from the subject to be photographed, but sometimes—as in photographing interiors—their unavoidable or necessary inclusion presents problems. Most serious are flare and halation.

Ordinary halation is largely prevented by antihalation coating on modern films and plates, preventing reflection from the film base and consequent formation of a halo around the area of very high intensity. But in images of high intensity subjects the qualities of edge and texture may be spoiled by halation *within* the emulsion itself. Internal halation is due to lateral scattering of light by emulsion particles or to "contagious" activation of silver-halide grains next to those receiving intense exposure. Its effects, however, can be minimized by the use of a "surface-acting" developer, such as the pyrocatechin formula, page 117. This developer, in my experience, depresses emulsion speed at least 50%. See Figure 33, page 108, illustrating the control of the image of a light source.

A bright light source among generally low subject values may produce a "ghost" image in addition to diffuse flare. The ghost is hard to see on the ground glass (and in the finder). (An assistant directing an electric torch at the lens from the position of the light source helps to detect the "ghost"; if one exists, it may be revealed on the ground glass when the torch is moved about.) It is least conspicuous when superimposed on a fairly bright area in the image. If it cannot be thus hidden or reduced by a change in camera position, local reduction or retouching of the negative may be necessary.

In the final print of a subject including light sources, the sources themselves should appear brighter (whiter) than the brightest surface illuminated by them. The sources will usually be rendered as pure white, Zone IX and higher; the brightest reflecting object should be at least one or two steps lower in tone. Therefore visualization must account for the brightest illuminated objects, and their placement made accordingly. (If the brightest reflecting object were rendered in nearly the same tone as the light source, a most unsatisfactory impression of light and substance would result.) *Exception:* Mirrors, polished metal surfaces, or highlights on polished wood.

When exposure-meter readings of reflective values are being made of a subject including light sources, the instrument must be carefully shielded from direct light. If the values of the source itself, for example, a lampshade, are to be determined, the meter must be held close enough so that the shade fills (or more than fills) the angle of view of the meter. Should the brightness of the subject exceed the range of the meter, the cell opening can be half-covered by a card, and compensation made in the calculation. Or an extension tube (see page 44) may be used with proper calculation of its multiplying factor.

In Books 4 and 5 are described practical ways of photographing interiors, including light sources (windows, lamps, etc.), and the management of exceptionally bright areas, such as sky through trees.

COPYING

In the early days of photography, when negative materials were of inherent high contrast, an empirical but effective rule for copying was "Overexpose and underdevelop." Today, although negative materials especially designed for both line and continuous-tone copy work are available. we can make successful copies on standard films by suitable exposures and development.

In photographing a continuous-tone subject—such as a photographic print. a water color, or an oil painting—the subject has a definite brightness scale, just as has a landscape or other subject.* In a photographic print, the scale rarely exceeds 1 to 50 (and is usually much less than 50). In copying, this brightness range is considerably reduced by lens and camera flare, so that the image formed in the focal plane of the copying camera is of shorter scale than the original. It is best to place the subject brightness fairly low on the exposure scale and develop enough to assure proper opacity range in the negative. Assuming that the maximum reflective range of a photographic print to be copied is roughly from 1 to 50, placing the value of the white paper base on Zone VII will put the deepest tone on about Zone II (by inference). Developing so that the resulting range of the copy negative matches the scale of the printing paper will assure a very close approximation of the values of the original photographic print. The prime object is to preserve true clarity and purity in the whites of the original; there is something dismally depressing about the gray or blocked tones of a poor copy. Illumination of the print to be copied affects only the *absolute* brightnesses—it cannot change the range of the extremes. nor alter *relative* brightnesses. Ambient (scattered) light in the copy room should be avoided as it will reflect from the print and reduce contrast. The validity of the copy depends on proper exposure and development, just as in a direct photograph. The same necessity for proper exposure and development holds true for the reproduction of line drawings and printing type with ordinary process film. See Book 1 for copy setups, lighting, etc.

A valuable control which should not be overlooked lies in the practical effects of reciprocity departure (page 13) due to long exposure time. With reciprocity departure, the straight-line section of the curve appears to be lengthened, and a more accurate progression of values achieved. The value of this effect in copying (where truthful representation is important) is obvious. Hence, using light of low intensity and small lens apertures may be advantageous. The use of extremely short speedlight exposures (with attendant increase of development time) also favors the reciprocity-departure effect. Extremely intense lighting (speedlamps) also favor the reciprocity departure effect.

For discussion of specific copying techniques and examples of copy work, see Books 4 and 5. Suffice to say here that I have been able to make very satisfactory copies of line drawings, type, etc., on Versapan and similar film by proper placement of values on the exposure scale and appropriate development. To retain delicacy of line and edge, placement of the white paper must be as low as possible on the scale (Zone VI or VII, with full development).

* The new S.E.I. meter makes possible evaluation of the brightness of small areas of the copy subject. (With proper accessory equipment it can be used as a reflection-densitometer). Meter readings of the copy subject should be made from the axis of the camera lens after the subject has been set up, and properly lighted. Watch for false reflections from both lens position and metering position.

POLAROID LAND TYPE 55 P/N FILM, 4x5

At present, this is the only Polaroid Land material that yields a unsable negative of high quality. Details of the Polaroid Land processes are described in the POLAROID LAND PHOTOGRAPHY MANUAL (Ansel Adams, Morgan and Morgan, Inc., Hastings-on-Hudson, N. Y.). Suffice to say here that the effective ASA speed for Type 55 P/N is 64 for the optimum print, and 32 for the optimum negative. The exposure range of this material is fairly short, but the negative has exceptional quality. After processing (pulling the rollers of the 4x5 Adapter) development continues for 20 to 60 seconds, depending upon the temperature. The print (with mask) is separated from the negative: the latter is put without delay into a bath of 18% sodium sulfite and constantly agitated (perhaps 10 seconds) until the developer layer sloughs off. After ten minutes, the film can be transferred to plain water. At the end of the day the negatives should be washed for ten or fifteen minutes, swabbed off, put through Photo Flo and hung up to dry. All processes take place in broad daylight.

SOME PROBLEMS OF INTERPRETATION

The illustrations in this book and other books of the *Basic Photo* series represent examples of practical photography, and in most cases their captions include key facts of exposure and development that are elaborated in this book. It is of course difficult to give a detailed and complete description of procedures in the picture legend. While the character of this *Basic Photo* series is more related to technique than to esthetics, the reader is urged to keep in mind the fact that the photographer's expressive idea is always of greater importance than are technical rituals.

The thoughtful reader will benefit by visualizing each subject from the reproduction and the description and then imagining how he would have made his own interpretation of the same subject, not only in the mechanical control of values, but also in selection and composition. How else might it have been composed? How else might isolation or emphasis on the elements of the scene have been used to achieve a similar or a different interpretation? Would another point of view have been preferable in regard to arrangement, image size, or balance of value? Could a different mood have been imposed by a different treatment? Composition, as Edward Weston has said, is the strongest way of seeing. It is the functional organization of all expressive elements.

Normal Placement—Normal Contrast

"Normal" placement and procedures—implying normal exposure and development—result in images in which the relationships of the values are reasonably proportionate to the brightnesses of the subject. We are not concerned with absolute values of brightness, opacity, or brilliancy, but with the relationship between values in the print.

These relationships we determine by visualization of the final result before the negative is exposed, together with proper placement of subject brightnesses on the exposure scale, and the required development. Most of our work will be done with normal procedures. Figure 26 (overleaf) represents normal placement.

Experiment is imperative. I should be disappointed if the reader contented himself with an unimaginative adoption of these suggested procedures. I am only suggesting an *approach* to the problem, not establishing a rigid rule for its solution. I must re-emphasize that awareness and concept are strictly personal.

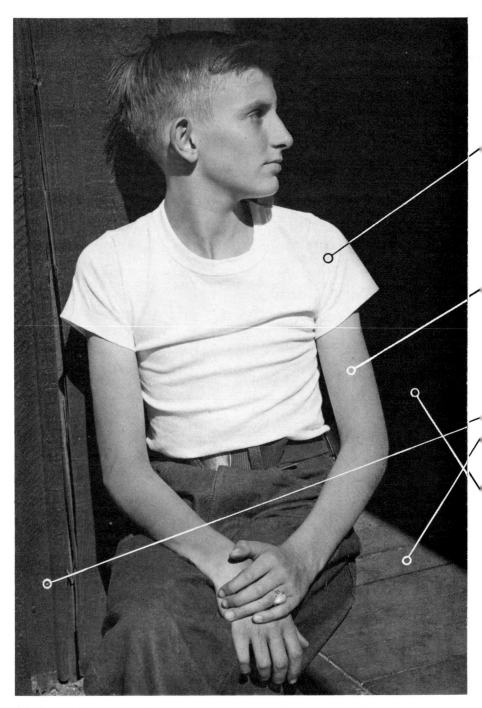

26. Seated Figure and Gray Scale. A typical problem of outdoor figure photography, se-
lected for demonstration because of its simplicity. The placement of the brightnesses is obvious.
Exposure and development were normal.

GRAY SCALE	EXP. ZONES	WESTON SCALE	EXP. UNITS	
	IX	—	256	No brightness in the subject relates to this zone.
	VIII	O	128	The measured brightness of the white shirt was 1600 on the Weston Master Meter dial. As a relatively coarse fabric, it should be rendered with a suggestion of texture.
	VII	—	64	No important brightness falls on this zone.
	VI	C	32	Skin value appropriately falls on this zone. Brightness was measured from the arm; the head is a complex of values (V, VI, and VII, averaging Zone VI). The measured brightness was 400.
	V	↑	16	The measured brightness of wood averaged 200.
	IV	A	8	The measured brightness of wood averaged 100.
	III	—	4	No important brightness falls on this zone.
	II	—	2	No important brightness falls on this zone.
	I	U	1	The deepest important shadow measured 13.
	O	—	½	No important brightness falls upon this zone (maximum black).

At times the intensity range in a subject is so limited that a photograph would not be satisfying unless the contrast were expanded. There are three ways to obtain increased contrast: 1) placing certain values on lower-than-normal zonal position on the scale and increasing development accordingly; 2) minimum exposure with total development, in which all exposed silver halide is completely reduced to metallic silver. Do not discount danger of excessive fog (page 52); 3) normal exposure and development and use of short-scale papers (see Book 3). The last method is, of course, the simplest and the most generally used. But it is my personal opinion that the most expressive results are obtained through contrast control in the negative and the use of but one grade of printing or enlarging paper.

Most negative emulsions respond adequately when developed to compensate for a 1-or 2-zone displacement of important values; a Zone VI brightness may be exposed on Zone V and yet rendered as the required Zone VI opacity by "normal-plus" development. Thus a range of brightnesses in the *subject* of 1 to 16—a 1-to-16 exposure range—can be represented by the same range of negative opacities as a 1-to-32 brightness range would be rendered by normal development. The developing time for this displacement can be determined by the tests outlined under Obtaining Optimum Opacity, page 39.

We have seen that as exposure increases—that is, as any given brightness is placed higher on the exposure scale, and is thus moved onto the shoulder of the characteristic curve—loss of subtle textural separations becomes apparent. This is due to the effective flattening of the curve by a greater exposure, to the approach to maximum emulsion density, and to a halation within the emulsion which reduces the resolution of very fine structural detail. This effect is generally termed "blocking," and is accentuated by the Callier effect in enlarging, evident in the all-too-familiar "chalk-and-charcoal" quality of many prints. It is safe to assume that any subject value placed on Zone VI or below can be given a very long development in ordinary developers without blocking; values placed on Zone V can be given total development with most negative materials.

This procedure of contrast control is not stated in sensitometric terms but is certainly applicable in practical photography. After all, a sensitometrist's gray scales are usually produced by direct exposure to light (without lens), so that not only are factors of lens transmission and flare excluded, but internal subtleties of tonal variations, textures, and the emotional factor are entirely ignored. There would be no place for personal expression in photography if all controls were as rigid as sensitometric procedures. It is often remarked that the motion pictures present a wide range of tonal effects, from the lowest to the highest key and from the softest to the most brilliant effects, and yet the processing of both negative and positive is always under the most rigid mechanical controls. I believe it will be found in practically every case that the effects are created in the set and in the lighting. The camera and the laboratory do a superb job in recording the controlled subject. But in creative still photography of natural (uncontrolled) subject matter the expressive controls lie in the process itself and are directed by the perception and imagination of the photographer. In Book 5 there will be found further discussion of this important distinction between control of subject and control of procedure.

Most expressive photographs include shadow and highlight values lying above or below the straight-line section of the characteristic curve (see page 10), So, although any group of values may be placed at any point on the straight-line section of the curve and yet preserve their *proportionate differences,* a great deal of practical work requires certain modifications of procedure to accommodate the extreme values. Further, it must be remembered that while sensitometric charts represent discrete units of exposure, we are confronted in nature with a *continuous* scale of values. We read our metered values from certain selected brightnesses, but the emotional relationships of these brightnesses do not necessarily correspond to their photometric values.

Total Development

Although total development (gamma infinity), involving complete reduction of all exposed silver halide to metallic silver, theoretically achieves the highest possible contrast, yet there are certain secondary effects that in practice may reduce its effectiveness:

1. *Increase of fog.* This varies with different developers. Prolonged high-energy development is certain to cause heavy fog. Low-energy developers with a high sulfite content produce minimum fog, but also may require very much longer developing times to achieve maximum reduction of silver. And, of course, there is a maximum opacity limit in different films and with different developers.

2. *Semiphysical development.* With a developer used to about half its effective life, we may find that highlight opacity is somewhat increased by a physical deposit of colloidal silver from the developer solution onto the reduced silver of the negative image.

3. *Stain.* Even with high-sulfite developers a certain amount of oxidizing stain may appear, effectively increasing the printing contrast.

If we are dealing with a subject contrast range of 1 to 8, or less, the highest textural values can be safely placed on Zone V (or slightly below) and given total development without blocking. Objects to be rendered pure white can be placed as high as Zone VI or VII. Given total development, the resulting negatives should have sufficient contrast to print on No. 2 paper; but with very slightly separated subject values (brightness ranges of 1 to 2 or 1 to 3) a No. 3 or No. 4 paper may be necessary to achieve a full-scale print. The maximum opacity of average negative material is limited; for a high maximum opacity, "commercial" type film is advised.

For close-value subjects up to a 1-to-4 range, we can place the average values on Zone V and give total development. The resulting negative may be fairly dense throughout, so that "printing down" is necessary to attain the desired print values in relation to the film-base plus fog density. (With subjects of very close range, process film may be used, carefully developed in a soft developer, such as Kodak D-23.) With process film the threshold is critical, and tests must be made to establish a working emulsion speed with the selected soft-working developer.

For very low-contrast subjects, it may seem possible to place the low values on their appropriate exposure zones and give total development. But the high

subject values may then fall far below their appropriate visualized zones and give a thin, weak negative requiring paper of highest contrast for adequate tonal separation, and hence losing subtleties in the lowest and highest values. In this case a more satisfactory balance is achieved by placing the average subject values on Zone V and giving ample development.

The effectiveness of total development in rendering textures can be demonstrated by photographing, for example, a piece of weathered wood in both flat sunlight and in shade, placing the average values on Zone V for each exposure. The values in either case may not exceed a 1-to-4 range, but the acute glistening highlights and small attendant shadows of the sunlit image are accentuated with total development. The textural effect is increased, but without appreciably altering the *average* tonality. Figure 28a represents rough wood in sunlight, averaging 200 c/ft²; Figure 28b shows the same material in shade, averaging 25 c/ft². Prints were made from both negatives on one sheet of paper with identical exposure.

Another test could be made on very light painted wood and on a very dark subject, such as old oak bark. Here are extremely different brightnesses, but if both are placed on the same exposure zone and receive total development, we shall have negatives of nearly equal average opacity. (A possible exception: If the values of the dark object are extremely low, then *failure of the Reciprocity Law* may slightly alter the allover opacity and tonal separation.) Figures 29a and 29b (page 101) show the strong textural effects obtained in very high- and low-brightness subjects, both placed on Zone V of the exposure scale, although the high-brightness subject reflected 1600 candles per square foot, while the low-brightness subject registered 6.5 candles per square foot. Again, both negatives were printed together. The images are of much greater contrast than their respective subjects.

With total development, it is necessary to recognize that high values may "block" if placed too high on the exposure scale. The use of staining developers

DEVELOPING INSTRUCTIONS

FILM _____ Speed 50 _____ METHOD _____ Tank _____ AGITATION PLAN _____ #1,#2,constant _____ TEMPERATURE _____ 68° F

SAMPLE LISTINGS NOT RELATED TO ANY PARTICULAR NEGATIVE MATERIAL

DEVELOPING TIME	DENSITIES OBTAINED FOR EXPOSURES ON VARIOUS ZONES										FILM-BASE PLUS FOG	DENSITY RANGE FOG TO MAX.	
	0	I	II	III	IV	V	VI	VII	VIII	IX	X		
11 min A.p2	0.30	0.40	0.60	0.90	1.20	1.50	1.80	2.10	2.40	2.60	2.70	0.20	2.50
5.5 min A.p2	0.20	0.30	0.45	0.65	0.90	1.20	1.45	1.75	2.20	2.23	2.40	0.15	2.25
4 min A.p1	0.15	0.23	0.34	0.50	0.70	0.95	1.20	1.40	1.60	1.80	2.00	0.10	1.90
3 min,25s Ac	0.13	0.20	0.30	0.45	0.65	0.83	1.00	1.20	1.40	1.60	1.70	0.10	1.60
2 min,55s Ac	0.10	0.15	0.25	0.40	0.55	0.72	0.90	1.15	1.20	1.34	1.45	0.10	1.35
ADDITIONAL													
SPACE FOR FURTHER DATA													
(WATER-BATH) etc.													

PRINTING PROCESS _____ Enlarging with diffuse light _____ PAPER _____ Chloro-Bromide _____ NO. _____ 2 _____ PAPER SCALE _____ 1-50
(with soft devel.)
ABOVE DEVELOPING TIMES BASED ON TEST NO. _____ 24 _____ CAMERA _____ View _____ LENS _____ Coated Anas _____ SHUTTER. _____ C.

REMARKS: Zone 0 value higher than Filbase-Fog density in all but last line; probably due to very slight image effect, plus flare. Filmbase-fog density taken from edge of negative. HIGH ENERGY DEVELOPER.

27. Record Sheet for Developing Times and Resultant Densities for Different Zones. For long development times optimum Zone VI densities must be adjusted to high film-base plus fog densities. This record sheet is attached to the particular formula to which it applies.

28a. Shingles. In sunlight. Average values placed on Zone V; given total development.

28b. Same. In full shade. Average values placed on Zone V; given total development.

It is obviously impossible to take direct readings with a conventional meter of very small shadow areas such as those shown in 28a. These values may be determined with a photometer, such as the S.E.I. meter (page 63). The shadows in 28a fell below Zone 0.

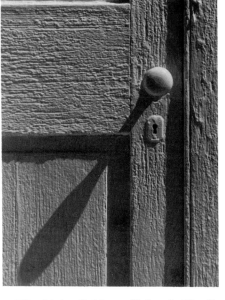

29a. Dark Subject (Oak Tree Bark). Shade: average on Zone V. Total development. Slight reciprocity departure.

29b. Light Subject (Painted Wood). Full sun; average on Zone V. Total development.

Both pictures have greater contrast than their subjects. In 29a the reciprocity departure (page 13) served to deepen the lower values. The same subject values with much higher illumination would have appeared much less contrasty. The average brightnesses were 6.5; placed on Zone V the deep values (0.8) fell on Zone II. At f/45, extension factor of 3, Isopan film, the exposure was 15 secs. Zone II placement resulted in Zone I opacity. There was apparently no reciprocity departure in 29b.

(such as pyro and pyrocatechin) is not recommended for long development, since the stain may produce unmanageable printing contrast.

High Placement—Reduced Contrast

Since the introduction of the dry plate, there have been numerous methods of "soft" development to control the negative values in subjects of excessive contrast. The following methods are most frequently used.

In general, excessive contrast in a negative may be avoided by 1) reducing development time, 2) employing a low-energy developing agent, 3) restricting the supply of developer to the exposed emulsion, or modifying its action (as in water-bath or two-solution processes), or 4) using "compensating" developers.

Shortened Development Time

If less than normal developing time is required, the degree of development is actually indicated by the tests for optimum opacity, outlined on pages 46–47. Suppose, for example, that we wish to decrease the opacity scale in a portrait. (*Example:* Elderly woman with facial blemishes requiring textural consideration). We can place on Zone VII skin values normally placed on Zone VI, and give the negative just enough development to render the Zone VII *exposure* as a Zone VI *opacity*. Then, although the brightness range of the subject may have been 1 to 64—from the subthreshold and threshold areas to the skin value arbitrarily placed on Zone VII—the reduced development results in a range of opacities equivalent to an exposure range of 1 to 32, normally developed. The skin values are rendered in the customary Zone VI gray, but the remaining values in the negative are compressed, so that total image contrast is less than normal for a subject of such brightness range.

Alterations in developing time will change not only the dominant Zone VI opacities but other values as well (see Fig. 14, page 40, and Fig. 2, page viii); the only values not appreciably affected lie on or near the threshold.

To control only high values without consideration of the final interpretation of low values violates good visualization procedure.

In most cases, if values normally relating to Zones IV to VII are placed one zone higher on the exposure scale, ⅔ to ¾ normal developing time will render them in "normal" opacities. With short development times it is important that agitation be followed strictly according to plan; otherwise uneven development is almost certain to occur.

Figure 2, page viii, is a very good example of reduced contrast. The values of the head in shadow were placed on Zone V; sunlit values falling on Zone VIII. Very dark areas remain black, but there is good quality in the white of the plaster. However, the allover effect is softened, and the mood of the subject is appropriately suggested. It represents an intentional lowering of the plaster values.

When the scale of the subject is very long and must therefore be strongly reduced in development, we encounter an unfortunate fact: The image may lack vitality and substance in the low values. Let us assume a subject of very high contrast has been softened by ½-normal development. The higher values have been confined within the required opacity range (an exposure range of 1 to 1200 is represented by an opacity range of 1 to 50), and within this total

range the image is fairly satisfactory. But the tonal progression in the lower values is dull and lifeless. The entire curve has been so depressed by short development that the shadow and middle values suffer from extreme compression. In general, severe reduction of development time is not really satisfactory; other methods of control, such as the water-bath system, or the use of "compensating" developers, provide better separation in the lower values.

Dilution of Developing Solution

An early method of securing softer negatives used highly diluted developers —extremely dilute hydroquinone solutions, for example, in which the plate remained for hours without agitation. Another method specified a pyro solution of low sulfite content, producing an image composed more of stain than of actual silver deposit. Very dilute Metol, Rodinal, and Amidol solutions are also effective.

Not all developers respond equally to extreme dilution; the problem is to retain developer activity on the surface (in the lower opacities) of the film but with reduced penetration of the emulsion.* Some developers show a marked loss of activity when greatly diluted, effectively lowering emulsion speed. Other developers, such as Metol, retain their activity surprisingly well in almost any practicable dilution without reducing emulsion speed.

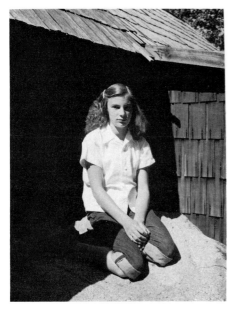 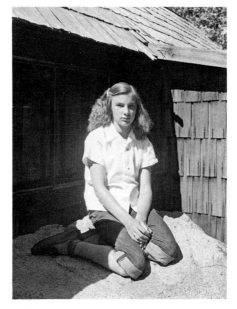

30a. Example of Normal-Minus Development Kodak D-23 68° F, tank, 10 min.

30b. Example of Water-Bath Development Amidol, 5 immersions, alt. with water.

The limitations of the halftone process make it impossible to show the delicate variations of tone in these images. The apparent flare back of the girl is merely reflection from her white jacket on the wall, strengthened by the water-bath development. In both negatives the skin value was placed on Zone VII. Shadow values fell on Zones I-II. Both negatives were printed together.

* When I use the terms "surface," "depth," and "penetration" in reference to the latent image, I do so more to suggest a graphic impression of developer action than to describe accurately the chemical and physical action of the developer on the emulsion—which is very complex.

A method of development affording excellent separation of shadow and middle-tone regions of the scale, with compaction of the total scale—though not favoring the best tonal separation in high densities—involves repeated transfer of the film from developer to water and back again.

There are several variations of the water-bath system. All depend on the fact that the emulsion is first saturated with developer, so that when placed in still water the absorbed solution continues to reduce exposed silver halide until exhausted. The most heavily exposed areas exhaust the absorbed developer more rapidly than do the more lightly exposed areas. The low and middle values are therefore more fully developed in proportion to the high values. After several minutes in the water, the film is returned to the developer, agitated and saturated anew, and is once more returned to the water. Development then continues in the water until the absorbed solution is exhausted. The number of times this procedure must be repeated depends on the strength of the developing solution and the degree of development required.

The proper development is judged by an examination of the negative, which should only be done when nearing the end of development, and in very weak light (the proper safelight). Desensitizing the negative before development is helpful, permitting brighter light and longer periods of examination (see page 111). A very efficient method of inspecting a negative in the water bath is to use a transparent glass or plastic tray over a well-insulated, lighttight box containing a safelight of the proper color and intensity for panchromatic or orthochromatic films. The light in this box may be operated by a foot switch.

The technique of the water-bath process is simple. A formula and a sequence of operation are given on page 117. See Figures 17, 21, 30b, 31, 32c, 34, and 36a.

The negative must remain in the developer only long enough for complete saturation; vigorous agitation is necessary. The negative is then placed (without rinsing) in the tray of water—deep enough to cover it amply—and allowed to lie without agitation for at least 2 minutes. Since a great part of the development will have been completed in that time, the negative can remain in the water for a considerably longer period without harm (totally submerged, of course).

If after the usual number of alternate treatments between developer and water, inspection shows the high values to be right but the shadows needing greater opacity, the negative may be given several short immersions in the developer solution, each followed by 2-minute periods in the water. Conversely, if examination shows adequate shadow but insufficient high-value opacity, the negative can be given longer immersions in the developer—being placed in the water only for examination—until the proper densities are obtained. To judge a negative during development requires considerable experience; high opacities are particularly misleading. Placing a finger between the negative and the safelight will suggest the opacity; the difference between the shadow of the finger and the highest opacity in the negative will be apparent, and with practice a basis of judgment will be established.

One possible drawback to the water-bath process is the oversuppression of highlight gradation. If the subject contains naturally sparkling highlights, they may be seriously flattened by water-bath development. In such cases a full water-bath development can be carried out normally and the negative then given sev-

eral minutes' immersion in the developing solution. All densities are increased, of course, but the brightest highlights may be sufficiently intensified to produce pure whites in the final print, while the lowest and low-middle values have been more or less fully developed by the water-bath treatment.

The use of staining developers for the water-bath process is not advisable. Stain, a result of oxidation, is increased by the amount of air in the water, and appreciably so by the period during which the film is exposed to air while being passed from developer to water and back again. If a staining developer is used, the printing qualities of the negatives will be very inconsistent.

Developers containing hydroquinone are not recommended; its low reduction potential serves to nullify the advantages of the water-bath process.

Windisch recommends the Amidol formulas listed on page 117. Amidol, having a very high reduction potential permits ample development of areas of low exposure in a strong "bromide environment." However, in developers of low reduction potential, the free bromide may inhibit development of the weaker values, so that the water-bath effect is not fully realized.

Figure 32a-d, page 106, shows he comparative results of normal, half-normal, and water-bath developments, and compensating development.

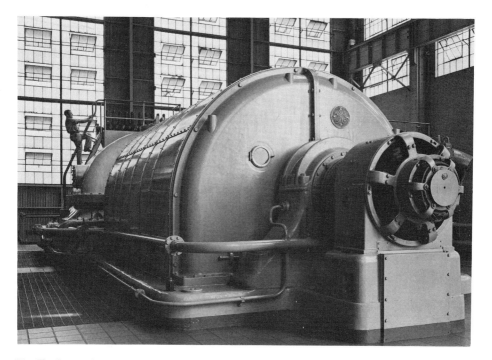

31. Turbine Generator. A fine example of water-bath development for the purpose of restraining high values and achieving good separation in the low values. No artificial light was used. The range was extreme; 0.8 in the deepest shadow near the figure (placed on Zone I); 200 in the windows (placed on Zone IX). Indicated exposure with Isopan film was 3 secs. at f/45, but exposure of 4 secs. was given to compensate for possible reciprocity departure. The windows were therefore placed slightly above Zone IX. A feeling of substance and environmental light obtains.

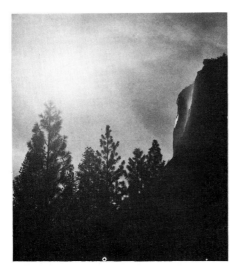

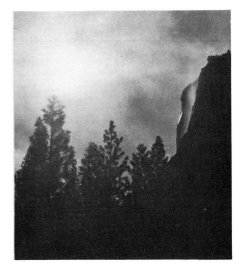

32a. Extreme-Contrast Subject. Normal development given in Kodak D-23.

32b. Same. One-half normal development in Kodak D-23. More separation in sky.

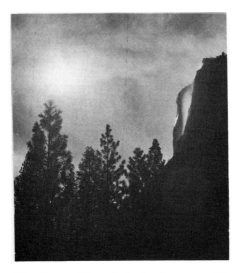

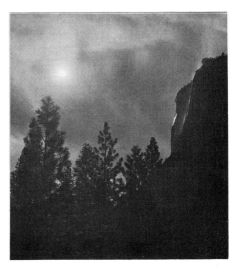

32c. Same. Water-bath development with Amidol. Good separation of sky and clouds.

32d. Same. Pyrocatechin compensating developer used. Note that the film has caught the sun's disk, actually better than in 32c.

These 4 films were made on Isopan film with a coated Eastman Commercial Ektar Lens. The range of brightness was extreme—from 3.2 in the tree shadows to 5000 and more in the clouds near the sun. The brightnesses were placed intentionally high on the scale—3.2 on Zone I, and the blue sky (400) on Zone VIII. The negatives were of course "printed down"; the sky values were matched in each print. The hazy light by the cliff is spray from a waterfall; it varies in each picture. Note that in the water-bath negative there is evidence of a flare halo; the very slight residual flare in a coated lens becomes apparent when extreme brightnesses are involved. The white clouds fell between Zones XI and XII; the sun, of course, was very much brighter. Some flare under such conditions is unavoidable. The water-bath process, favoring the lower zones, revealed this slight flare. Only in the pyrocatechin compensating developer does the disk of the sun appear; this represents the unique ability of pyrocatechin, as a compensating developer, to control extreme brightnesses.

Divided, or two-solution methods of development are worthy of serious consideration. There are three general types: 1. Divided solutions, each containing developer agents, in which the negative is immersed for various times depending upon the contrast desired; 2. A solution of developer agent and minimum required amount of preservative in which the negative is immersed until fully saturated, and then transferred to an alkaline bath which activates the developer absorbed in the negative emulsion; 3. A process whereby the negative is moderately developed in Kodak D-23, then immersed in a 1% Kodalk solution. The object of divided development is to achieve a "compensated" effect: a proportionally greater development of the low-density (shadow) areas of the image in relation to the development of the high-density areas.

The first two methods have merit and formulas for them may be found in standard reference books. The third method, in the opinion of the author, is superior in that it offers a positive system of high-value control consistent with the application of the Zone System. (Refer to page 117 for formulas and the tables which suggest the degree of development in solution 1 required to control the density ranges of the negatives within optimum limits for a wide range of subject brightnesses.) However, tests are advised for various negative materials, printing and enlarging procedures, etc., in relation to personal requirements.

Kodak D-23 contains a large amount of sodium sulfite which serves not only as the preservative, but creates a mild alkalinity; hence the developer functions without the addition of strong alkalies such as sodium carbonate. D-23 yields a "soft" negative with full shadow density. Used in conjunction with a 1% Kodalk (or Borax) solution, the developer absorbed by the emulsion is activated to exhaustion, building maximum density in the shadows with but slight increase in highlight density. Three minutes immersion in the 1% Kodalk solution is optimum; longer immersion has little effect. Other alkalies *can* be used.

Compensating Developers

The much abused term "compensating developers" properly suggests control of both very low and very high values. Such control implies satisfactory gradation in both low and high opacities in the negative, not merely an extremely compacted range, as given by ordinary soft development.

Solid shadow and middlle-tone values and fairly good separation in the high values can be achieved by use of the Windisch Metol formula (page 116). It is a Metol-sulfite developer, requiring 25 to 30 minutes' developing time, and is an excellent compensating developer. However, because of its dilution and low alkalinity, it depresses the effective emulsion speed of the film to some extent. The Kodak D-23 (Metol-sulfite) formula (page 115) is more active, retaining a high emulsion speed, and producing fine shadow values. It is semicompensating.

A formula of extraordinary characteristics—although not always controllable —is the pyrocatechin-sodium hydroxide formula listed on page 117. It is an automatic compensating formula, working largely as a "surface" developer, and therefore minimizing halation and the scattering of light within the emulsion. I have found that the emulsion speed is reduced about one-half, so far as shadow and middle values of the scale are concerned. This is an excellent developer to use when working directly into the light or when light sources appear in the subject. I do not recommend its use, however, until the photographer has made careful

experiments with it, as the effect varies with different negative emu sions. Due to the tanning action of the agent, pyrocatechin, there is little danger of reticulation of the emulsion (sometimes encountered in developers containing sodium hydroxide). However, with some films some reticulation of the back (anticurl) gelatin coating takes place. This is harmless, but always handle negatives with great care.

Since this developer definitely stains the negative, the type of printing light may considerably alter the contrast in the print. The stain prevents accurate evaluation of printing density by a densitometer, so that the photographer must experiment, under controlled conditions of development and printing, to establish a satisfactory norm. In Book 3 is described a practical method of determining the opacity scale of a stained negative.

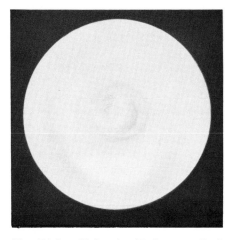
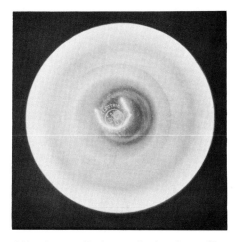

33a. Light Globe in Reflector. Background placed on Zone III. Normal development.

33b. Same. Background placed on Zone III. Pyrocatechin Compensating Developer used.

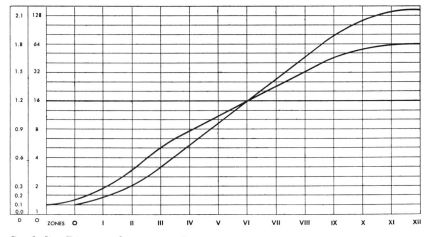

34. Symbolic Diagram. Suggesting effect of water-bath and semicompensating developers. The compensating curve shows the increase of opacity from Zones 0 to VI, and decrease from Zones VI up.

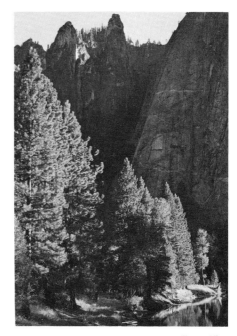

35a. Cathedral Spires, Yosemite Valley. Normal exposure and development (D-23). **35b. Same.** With pre-exposure on Zone II. Then exposed and developed the same as 35a.

Both negatives developed together and printed on one sheet of paper. Prints keyed to light values. The reproduction process cannot fully convey the enhancement by pre-exposure of the delicacy of shadows in the forest.

Pre-exposure

In photographing extremely contrasty subjects, in which shadow areas fall below the effective scale of the film—but where there is no chance to support these shadows by reflectors or by the addition of photoflash lighting—we must find a way to bring these low values into the exposure range of the film, without at the same time overexposing the higher values. For subjects containing large, important shadow areas, water-bath development is helpful, although the clogging effect of overexposure in the higher values can never be entirely avoided. If any brightness value is placed below the effective threshold of the negative exposure scale, no printable opacity can be achieved for that value with any standard developer. There are some proprietary developer formulas which claim to increase the emulsion speed of the negative. Some may work, but unless the photographer knows what the speed rating of his film is with the developer he is using his exposures will be uncertain, to say the least. Knowing the response of his film—its effective "speed" with the developer used—and having accurately measured the brightness of the subject, he will know at a glance at his chart what values are on or below threshold. In subjects of great brightness range we must obviously sacrifice satisfactory rendition of values at one extreme or the other of the scale. When both extremes are important we can partially solve the problem by placing the high values as high on the scale as we can without seriously "blocking" them, and then support the low values by pre-exposing the film to a definite degree, as described below.

109

The problem is to supply enough units of exposure to the low values, thereby causing them to register as something more than empty, transparent areas. In such instances, pre-exposing the entire film to a given amount of light is helpful. An addition of, say, 2 units of exposure can easily be achieved by photographing a gray card, placing its metered value on Zone II, so that the allover diffuse opacity is equivalent to 2 units of exposure (see page 49). Of course these 2 units are added to all values in the scene photographed, but are inconsequential in the higher opacities of the negatives. For instance, if a certain high value in the subject is placed on Zone VII, representing 64 units of exposure, the extra 2 units (raising the value to 66 units) are negligible.

Figure 35a shows a normally exposed subject in which the few small deep scattered shadows in the foreground and the middle distance should have revealed some detail and tonal values in the final print. Figure 35b shows the effect of pre-exposing the entire film for a Zone II opacity. Here the dark shadows under the trees, normally falling below Zone I, are rendered as average Zone II values containing certain minor variations of tone corresponding to brightness variations in the subject.

Pre-exposure is thoroughly satisfactory for supporting small areas of shadow in which an impression of substance and texture is not imperative; but for large shadow areas it may show a false tonality, in which the appearance of a considerable area of uniform tone without texture or substance gives an illusion of allover fog. Pre-exposure apparently is more effective than postexposure.

36a. Compaction Example. Bright sunlight and deep shade. Water-bath development.

36b. Expansion Example. Flat interior light. Average placed on Zone V. Very full development.

Two subjects, one with range of 0.8 to 400 (1 to 500), the other with range of 0.4 to 6.5 (1 to 16), controlled by planned development. Both negatives printed on No. 2 Kodabromide with full tone scale.

SPECIAL METHODS AND TREATMENTS

Desensitization

It is sometimes desirable to inspect a film frequently during normal development, or essential to do so during water-bath development. For such examination to be possible, the film must be desensitized, so as to avoid fogging by exposure to the safelight. The developer itself partially desensitizes a film as development nears completion, and during the last part of the process all except the most rapid emulsions can be examined briefly by the proper safelight. But if development is to be continued for any considerable time after examination, there is danger of allover fog unless the film has been desensitized.

It is theoretically possible to desensitize the emulsion so that it is immune to considerable exposure during development even though a fairly high intensity of light is used in examining the negative. *Transmitted* light of considerable strength (I use a 40—or 60—watt light directly behind a Series 3 Wratten Safelight for viewing desensitized negatives) is necessary to judge adequately the degree of negative development, and such judgment, moreover, must be based on experience and a certain amount of intuition as well.

There are many desensitizing agents available, some more effective than others, but I advise the photographer to use pinakryptol green or pinakryptol yellow (Ansco) or the Kodak Desensitizer, all of which are simple to prepare and use. The directions accompanying the packaged product, or published in PHOTO-LAB-INDEX, should be followed carefully, and allowance be made for the fact that a 50% or more increase in development time may be necessary for desensitized film. The desensitizer can sometimes be added directly to the developer solution, but not to those developers containing hydroquinone, as this chemical is destructive to the desensitizing agent. I prefer a separate predevelopment bath.

Reduction and Intensification

A philosophy of straight photographic procedure does not allow extensive darkroom manipulation. A "corrected" negative seldom possesses the qualities of a well-exposed and properly developed negative, and the photographer should employ these "crutches" only when necessary. Yet by reduction or intensification it is possible to save a negative that, through some mishap, is too dense or too thin or of unprintable contrast.

Reduction in the photographic sense is a scaling down of the opacities of the developed image by treatment in a bath that dissolves part of the silver deposit from the emulsion. It must not be confused with the chemical term "reduction"—applied to the action of the developer in reducing silver halides to metallic silver.

There are three general types of reduction formulas:

1. *Contrast or "cutting" reducers*, which effect greater reduction in the thin areas of the negative than in denser parts, thus *increasing contrast* and removing fog. They are especially useful for overexposed negatives. *Examples:* Ansco 310; Kodak R-4 and R-4a. I find that in making copies of type, line drawings, etc., on regular film (low placement and full development) it is advisable to use a cutting reducer to "clear" and sharpen the low-density areas.

2. *Proportional reducers,* reducing all of the image in proportion to its original opacities, so that contrast remains essentially unchanged. They are used to correct overexposed and overdeveloped negatives, or when the allover opacity of a negative is too great for practical enlarging and printing. These reducers also remove fog, but remember that they also lower the high opacities of the negative. *Examples:* Kodak R-4b and R-5.

3. *Superproportional reducers,* which act more vigorously on the high opacities of the negative than on the lower opacities, and hence decrease contrast without seriously lowering shadow values. They are useful in equalizing negatives that are overdeveloped or otherwise of too great contrast. They are erratic in action, and it is difficult to predict or to control precisely the required degree of reduction. *Examples:* Kodak R-1 and R-8.

A negative to be reduced must be thoroughly fixed and washed, as well as free of grease and finger marks. In most cases, treatment before reduction in a formalin hardener is advised, such as the Kodak SH-1 (formalin) formula (see page 116). Presoaking in water is advised if the hardening bath is not available.

Since it is difficult to judge the degree of reduction—the wet negative may look more contrasty and less dense than when dry—the negative should be studied carefully before treatment. The opacities and contrasts of various important parts should be noted and compared with their appearance in the wet negative.

The negative should then be immersed in the reducer (in a white enamel tray for easy observation), agitated vigorously, and examined frequently by a diffuse viewing light. As with the water-bath development process, a transparent plastic or glass tray over a diffuse light will aid in judging progress of reduction—or intensification. Treat only one negative at a time. If reduction is fairly rapid, the negative should be removed from the solution frequently and rinsed in clean water to stop reduction, then examined and replaced in the reducer solution if necessary. When reduction is complete, the negative must be rinsed carefully to remove visible traces of the solution, then thoroughly washed. (Some formulas also require use of a fixing bath following reduction.) Negatives must not be allowed to lie in contact with each other before the reducing solution is thoroughly rinsed off, for unwanted reduction may take place, causing streaks and uneven areas that ruin the negatives. If washing is not complete, stains eventually will appear on the negative.

Local reduction is best done by applying the reducing solution to the wet negative with a brush, which should be kept in constant motion. The negative must be rinsed and examined frequently. Direct-intensifier solutions (see below) may be similarly applied.

These are many methods for reducing negatives, but the formulas given above are standard, and suffice for all general work. For "harmonizing" and other special techniques, consult the bibliography of PHOTO-LAB-INDEX. A method of reducing the effective contrast in a negative through the use of dyes is discussed in Book 3, as it relates to specific printing techniques.

Intensification is an increase of contrast and opacity. It cannot so completely overcome underexposure as to supply subthreshold values, though in subproportional intensifiers a small effective increase of emulsion speed is suggested by the strengthening of the lowest opacities.

Intensifiers are grouped in three classes:

112

1. *Subproportional intensifiers,* the action of which increases the opacity chiefly in the lowest part of the curve, and appears to augment the emulsion speed. They lessen contrast without decreasing highlight opacities, and are useful in balancing underdeveloped negatives of great contrast—in which further development would have blocked the highlights. *Example:* Kodak In-1.

2. *Proportional intensifiers,* most often employed, whose effect approximates greater original exposure and development of the image, increasing all opacities, thus serving to correct underexposed and underdeveloped negatives. *Example:* Kodak In-5 (the Crabtree and Muehler silver formula), and certain proprietary intensifiers. (Formula for Kodak In-5 on page 116.)

3. *Superproportional intensifiers,* which increase the opacity of the highlight areas of the negative more than the opacity of the shadow areas, and thereby increase contrast. (This may be considered equivalent to increased development.) *Examples:* Copper or tin intensifiers.

One problem that must be considered in intensification is image permanence. Some proprietary intensifiers are not satisfactory, as they contain copper or uranium and, although increasing opacities effectively enough, may seriously affect the permanence of the image. Also, some intensifiers give yellow or brown images of relatively low physical opacity but very high optical opacity, and therefore produce prints of a contrast considerably greater than would be expected normally. Colored negative images are difficult, if not impossible, to judge visually or evaluate on a densitometer. Perhaps the best intensifier—for color and permanence—is the Crabtree and Muehler formula (Kodak In-5). It requires cleanliness and great care in compounding and use.

If image color is not objectionable, the simplest method is to bleach and redevelop the negative as in sepia-toning prints (see Book 3).

The photographer should not forget that from the straight photographic point of view, such special control processes as reduction and intensification (local or general), dye treatment, "harmonizing," and masking should not be counted on as standard procedure. Proper exposure and development will almost always produce the desired results; subsequent manipulations are potentially dangerous, from practical as well as esthetic considerations. Many workers delight in mechanics for its own sake, and without consideration fo the real necessity of many processes.

It is frequently advisable to harden the negative before reduction or intensification. The Kodak SH-1 (formalin) formula is excellent for this purpose (page 116). Such treatment is necessary in hot weather, when both air and water are warm. Some of the chemicals employed in reduction and intensification are definitely poisonous, and must be handled accordingly.

I strongly urge that the photographer use corrective processes only as a last resort. If he entertains from the start a clear concept of what he is after in negative and print, little need should arise for corrective procedures.

SPOTTING AND RETOUCHING NEGATIVES

Spotting is the correction of physical defects—pinholes, scratches, air bells, watermarks, etc.—in a negative. *Retouching* involves modification of line, texture, or value. Either can be done by knife, pencil, abrasive, or airbrush. However, spotting is done to set right the flaws in the photographic image, whereas retouching modifies its character.

The difference is perhaps more esthetic than practical or mechanical. Negative reduction and intensification are grouped with spotting and retouching; in fact, every step of the photographic process should lead to a control of values and a certain perfection of image. Esthetically, such controls are only invalidated by nonphotographic results. By this criterion, then, spotting is legitimate; retouching (in the usually accepted sense) is not, and will not be discussed here.

Spotting of the negative may work more harm than good unless expertly done. For negatives to be enlarged, spotting must be done with utmost care. The technique of spotting both negatives and prints is similar. (Detailed description of print spotting will be found in Book 3.) Difficulties arising from surface tension—when the spotting material does not adhere to nor spread satisfactorily on the negative—may be solved by mixing a wetting agent with the ink, opaque, or dye. Regular retouching varnish (retouching medium) may be applied to the negative and some spotting accomplished with retouching pencils.

Negative defects printing darker than the surrounding area can be corrected by spotting. A scratch on the emulsion (except a superficial abrasion) prints darker than neighboring areas, a pinhole appears as a black speck. A watermark prints as an irregular dark mark with a light edge. A pinhole can be eliminated by deftly touching the film with a fine brush charged with concentrated India ink or opaque. In case of "cratering," the spotting substance can be applied to the back of the film, directly over the area, thus completely hiding it. At times a very small spot can be concealed by abrading the back of the film, restraining the passage of light through that area in printing.

Negative defects that print lighter than the surrounding area are more difficult to deal with. With specks and scratches on either the front or the back of the film, and with some emulsion defects, it is preferable to spot the *print* rather than risk spoiling the negative. The necessary etching requires considerable skill. I personally use a very slightly roughened blade and *abrade* rather than "excavate" the area to be treated, but it is a slow and exacting process. I prefer to entrust my work to an expert whenever possible.

The use of New Coccine, or other dyes, to build up weak areas of the negative by withholding actinic light from the paper emulsion in printing or enlarging has certain advantages in emergencies. However, to apply such treatment to Zone 0 areas will result in a false blank gray tone in the print. Only areas that have texture and substance should be treated, and then with great restraint. The effect is somewhat the same as obtained by dodging the print (see Book 3).

In truth, most negative defects can be avoided by care and skill in processing. But accidents will happen and the photographer should be equipped to make minor "repairs" when necessary.

FORMULAS

Only a few essential standard formulas are given here; for others, consult the PHOTO-LAB-INDEX. Some special formulas mentioned in the text are included in this list. Some of these formulas may not work satisfactorily with all types of film; be sure to make adequate tests before using them with important negatives. The following formulas I use in the greater part of my photographic work:

DEVELOPER: Kodak D-23	32 ounces	1 liter	4 liters
Water (125° F or 52° C)	24 ounces	750.0 cc	3000.0 cc
Elon (Metol)	1/4 ounce	7.5 grams	30.0 grams
Sodium Sulfite, desiccated	3 ounces, 145 grains	100.0 grams	400.0 grams
Water to make	32 ounces	1.0 liter	4.0 liters

My developing time for Kodak Super Panchro-Press, Type B film, for optimum density (1.10 density above film-base plus fog density) at 68° F for Zone VI placement is:
Tray (constant agitation) 12 minutes; Tank (agitation plan 3) 15 minutes.

NOTE: Other types of film, and other batches of the same film, may require different times of development. The above times are listed only as a point of departure.

REPLENISHER: Kodak DK-25R	32 ounces	1 liter	4 liters
Water (125° F or 52° C)	24 ounces	750.0 cc	3000.0 cc
Elon (Metol)	146 grains	10.0 grams	40.0 grams
Sodium Sulfite, desiccated	3 ounces, 145 grains	100.0 grams	400.0 grams
Kodalk	290 grains	20.0 grams	80.0 grams
Water to make	32 ounces	1.0 liter	4.0 liters

I use 3/4 ounce (22 cc) of this replenisher for every 80 square inches of film developed in a 4-liter volume of Kodak D-23 developer. This replenisher is also used with the Kodak D-25 fine-grain developer (see PHOTO-LAB-INDEX).

STOP BATH: Ansco 210	32 ounces	1 liter	4 liters
Acetic Acid 28%	1 1/2 ounces	45.0 cc	180.0 cc
Water to make	32 ounces	1.0 liter	4.0 liters

Glacial acetic acid (99.5%) may be diluted to 28% by mixing 3 parts of glacial acetic acid with 8 parts of water. Glacial acetic acid is very irritating; protect hands and eyes from liquid and fumes.

FIXING BATH: Kodak F-6	32 ounces	1 liter	4 liters
Water (125° F or 52° C)	20 ounces	600.0 cc	2400.0 cc
Sodium Thiosulfate (Hypo)	8 ounces	240.0 grams	960.0 grams
Sodium Sulfite, desiccated	1/2 ounce	15.0 grams	60.0 grams
Acetic Acid, 28%	1 1/2 ounces	48.0 cc	192.0 cc
Kodalk	1/2 ounce	15.0 grams	60.0 grams
Potassium Alum	1/2 ounce	15.0 grams	60.0 grams
Cold water to make	32 ounces	1.0 liter	4.0 liters

A convenient way to mix the hypo in the warm water is to suspend it in a clean cheesecloth bag in the upper part of the solution and let it dissolve in the water. Or, it can be put in a fine-mesh, rustless collander and the warm water poured through it into the container. The solution rapidly drops in temperature as the hypo dissolves. Always mix the chemicals in the order given. Use only when cool (68° F).

FIXING BATH: Plain Hypo Bath

Water (125° F or 52° C)	25 ounces	750.0 cc	3000.0 cc
Hypo	8 ounces	250.0 grams	1000.0 grams
Water to make	32 ounces	1.0 liter	4000.0 cc

Consult PHOTO-LAB-INDEX for other formulas, and for stock solution of acid hardeners, etc.

GOLD PROTECTIVE SOLUTION: Kodak GP-1		
Water	24 ounces	750.0
Gold Chloride		
(1% stock solution)	2 1/2 drams	10.0 cc
Sodium Thiocyanate	145 grains	10.0 grams
Water to make	32 ounces	1.0 liter

A 1% stock solution of good chloride is prepared by dissolving contents of 1 tube (15 grains = 1 gram) in 3 1/4 ounces (100 cc) of water. Dissolve the sodium thiocyanate separately in 4 ounces (125 cc) water, and add it slowly to the gold-chloride solution while rapidly stirring the solution. Some photographers use the Hypo Eliminating formula (Kodak HE-1) with their negatives, but I hesitate to advise it; I have had small blisters result from it. As the negative can be more easily washed than the print (paper fibers retain chemicals), I believe that a thorough washing followed by the gold-protective treatment is adequate for permanency.

REDUCER: Kodak R-4a (Cutting Reducer, increasing contrast)

STOCK SOLUTION A:

Potassium Ferricyanide	275 grains	18.75 grams
Water to make	8 ounces	250.0 cc

STOCK SOLUTION B:

Sodium Thiosulfate (Hypo)	8 ounces	240.0 grams
Water to make	32 ounces	1.0 liter

For use: take

Stock Solution A	1 ounce	30.0 cc
Stock Solution B	4 ounces	120.0 cc
Water to make	32 ounces	1.0 liter

(Do not combine solutions until they are to be used.)

Pour the reducer over the film (or immerse film quickly in it) and watch reduction carefully (see page 112). The negative should be thoroughly fixed and washed and free from scum or stain. It should not have been treated with the gold-protective solution. It is advisable to harden it first in the formalin hardener (SH-I, listed below) before treatment. After reducing, the negative should be rinsed, washed thoroughly, and wiped off before drying.

For other reducers see the PHOTO-LAB-INDEX and other sources.

FORMALIN SUPPLEMENTARY HARDENER: Kodak SH-I

Water	16 ounces	500.0 cc
Formaldehyde (37% solution)	2½ drams	10.0 cc
Sodium Carbonate, desiccated*	73 grains	5.0 grams
Water to make	32 ounces	1.0 liter

After hardening for 3 minutes (at 68° F) negatives should always be rinsed and placed for 5 minutes in a fresh acid fixing bath, and well washed before further treatment.

* If monohydrate carbonate is used, increase the quantity above to 85 grains (5.9 grams).

INTENSIFIER: Kodak In-5 (Proportional Intensifier)

STOCK SOLUTION No. 1 (Store in a brown bottle)

Kodak Silver Nitrate, crystals ...	2 ounces	60.0 grams
Distilled water to make ...	32 ounces	1.0 liter

STOCK SOLUTION No. 2

Kodak Sodium Sulfite, desiccated ..	2 ounces	60.0 grams
Water to make ...	32 ounces	1.0 liter

STOCK SOLUTION No. 3

Kodak Sodium Thiosulfate (Hypo) ..	3½ ounces	105.0 grams
Water to make ...	32 ounces	1.0 liter

STOCK SOLUTION No. 4

Kodak Sodium Sulfite, desiccated ..	½ ounce	15.0 grams
Elon ..	350 grains	24.0 grams
Water to make ...	96 ounces	3.0 liters

Prepare the intensifier solution for use as follows: Slowly add 1 part of solution No. 2 to 1 part of solution No. 1, shaking or stirring to obtain thorough mixing. The white precipitate which appears is then dissolved by the addition of 1 part of solution No. 3. Allow the resulting solution to stand a few minutes until clear. Then add, with stirring, 3 parts of solution No. 4. The intensifier is then ready for use and the film should be treated immediately. The degree of intensification obtained depends upon the time of treatment, which should not exceed 25 minutes. After intensification, immerse the film for 2 minutes with agitation in a plain 30% hypo solution. Then, wash thoroughly. The mixed intensifier solution is stable for approximately 30 minutes at 68° F (20° C).

PRECAUTIONS: Stains are sometimes produced during intensification unless the following precautions are observed: 1. The negative should be fixed and washed thoroughly before treatment and be free of scum or stain. 2. It should be hardened in the formalin hardener (SH-I) before intensification treatment. 3. Only one negative should be handled at a time and it should be agitated thoroughly during the treatment. Following the treatment, the negative should be washed thoroughly and wiped off carefully before drying.

SPECIAL FORMULAS

METOL COMPENSATING DEVELOPER (Windisch)	32 ounces	1 liter
Warm water (52° C or 125° F)	24 ounces	750.0 cc
Metol (Elon, Pictol, etc.)	37 grains	2.5 grams
Sodium Sulfite, desiccated	¾ oz., 37 grains	25.0 grams
Add cold water to make	32 ounces	1.0 liter

Developing time about 25 to 30 minutes at 68° F (agitation plan 4), depending upon film and personal requirements. Be sure to make adequate tests. The quantities are about 25% of those used in the Kodak D-23 formula, which accounts for the compensating action.

PYROCATECHIN COMPENSATING DEVELOPER. (This developer is primarily used to retain definition in negative areas representing Zone IX and higher. It is especially useful in control of values represented by Zones XIII to XV.

Solution A

Water (distilled or boiled)	100.0 cc
Sodium Sulfite, desiccated	1.25 grams
Pyrocatechin	8.0 grams

Solution B

Sodium Hydroxide	10.0 grams
Cold water to make	100.0 cc

This is a 10% solution. I prefer a 1% solution, which I find easier to measure in compounding the working developer. It is:

Solution Bx

Sodium Hydroxide	1.0 gram
Cold water to make	100.0 cc

This developer is primarily used to retain definition in areas of Zone IX and higher values. Especially useful in control of Zones XIII to XV (very high placements).

For use with extremely contrasty subjects (tank development):

20 parts of A
5 parts of B (10% solution)
or
50 parts of Bx (1% solution)
500 parts of water
Try: 12 to 15 minutes in tank at 68° F (agitation plan No. 3).

NOTES: Use only once, then discard.
Emulsion speed reduced about 50% in lower part of scale.
Stain increases printing contrast; be not deceived with apparent low opacity of the negative.

WATER-BATH DEVELOPER

Water	75.0 cc	750.0 cc
Sodium Sulfite, desiccated	2.0 grams	20.0 grams
Amidol	.5 gram	5.0 grams
Water to make	100.0 cc	1.0 liter

To use: **Plan 1.** Immerse negative in developer (constant agitation) for 40 seconds; then to tray of water (no agitation) for 2 min.; then in developer for 50 seconds; then to tray of water (no agitation) 2 min.; then in developer for 90 seconds; then to tray of water (no agitation) 2 min.

Plan 2: A sequence of short immersions in the developer (with constant agitation), alternating with 2-min. immersions in water (with no agitation) as follows:

30 secs. — W — 15 secs. — W — 15 secs. — W — 15 secs. — W — 15 secs. — W.

With prior desensitization (followed with rinse) the negative can be easily examined at the end of the sequences, and further treatment can be given if required. To be fully effective, the negative must lie flat in the water with no movement whatever. It is not efficient to have the film in a development hanger for this process; the edges of the negative may be unequally developed. And the negative **MUST** be constantly agitated when in the developer.

TWO-SOLUTION DEVELOPER

There are several standard two-solution developers listed in the PHOTO-LAB-INDEX (Kodak and Ansco formulas). I have found the formula listed here very effective and favorable to rapid action, good grain, and compensating action.

Solution I

Elon-(Metol)	7.5 grams
Sodium Sulfite des.	100 grams
Water to make	1 liter

Solution II

1% Kodalk (10 grams to 1 liter)

NOTE: This formula is superior to the two-solution formula appearing in the first printing of Book 2 Immerse negative in Solution I for a period of time determined by the placement of the highest brightness on the exposure scale, then immerse in Solution II for at least 3 minutes.

I am indebted to Mr. Frederick Quandt, of the Photography Department of the California School of Fine Arts, San Francisco, for the up-to-date control table below.

SUGGESTED DEVELOPING TIMES FOR TWO-SOLUTION DEVELOPER AT 68°F.

Standard panchromatic film (Royal Pan, Super Hypan, Verichrome Pan, etc.)
Zone VI Controls (for condenser enlargers). Zone VI brightness placed on various higher zones, but developed to retain density of 0.9 above film-base-fog density in every case.

Zone VI brightness on Zone VI (normal)	Solution 1	Solution 2
Zone VII (N-1)	7 min.	3 min.
Zone VIII (N-2)	4½ min.	3 min.
Zone IX (N-3)	3½ min.	3 min.
Zone X (N-4)	2½ min.	3 min.
	1¾ min.	3 min.

Zone VIII Controls (for condenser enlargers). Zone VIII brightness placed on various higher zones, but developed to retain density of 1.35 above film-base-fog density in every case.

Zone VIII brightness on Zone VIII (normal)	Solution 1	Solution 2
Zone IX (N-1)	7 min.	3 min.
Zone X (N-2)	4¾ min.	3 min.
Zone XI (N-3)	4 min.	3 min.
Zone XII (N-4)	3 1/3 min.	3 min.
Zone XIII (N-5)	2¾ min.	3 min.
	2 min.	3 min.

Constant agitation in both solutions important

Threshold (Zone I) density drops from 0.1 above film-base-fog density at 7 min. (1st development) to 0.06 above film-base-fog density at 2 min. (last development).

With this process, always place the important shadow brightnesses well up on the exposure scale—Zones V or VI—and calculate the developing times on the position of the brightest textured high value—unless there is special emphasis on skin values. Then use table for Zone VI controls. It is advisable to experiment with different films and developing times to assure optimum personal results. This technique is also useful with large negatives.

NOTES: If film shows tendency to fog, prepare solutions with potassium bromide in Solution 2.

For softer results, immersion times can be reduced, preferably in Solution 2.

Longer immersion times will not make much difference, except that if the negative is too long in Solution 2 it may frill and soften.

All of the above formulas should be tested carefully before using on important work. I have found them most helpful, but I always try to work with the simple standard formulas first.

Frequent reference herein is made to the PHOTO-LAB-INDEX, edited by John S. Carroll, which is the most advanced and comprehensive formulary in existence. The photographer should have it and keep it up to date through quarterly supplements, regularly issued. Encyclopedic inclusiveness is by no means within the scope of the six books of the *Basic Photo Series*.

NEGATIVE DEFECTS

Most defects in the negative image result from careless processing or exceptionally erratic conditions. With formulas mixed from high-quality chemicals and used according to directions, there is small chance of trouble in processing except by careless handling. This often results in scratches, abrasions, etc.—all of which are inexcusable. Chemical defects are difficult to trace, but a careful analysis will usually reveal the cause.

Negative defects resulting from faults in camera or lens can usually be avoided by routine examination and care (see How to Check Equipment, Book 1).

Pinch marks, usually vague crescent-shaped areas of less opacity in the negative are frequently due to bending or pinching of the film during loading or unloading of the film from the holders. Such bending causes some desensitization of the sensitive emulsion.

Static marks may come from discharge of static caused by too-rapid withdrawal of the film holder slide.

Water-marks, due to drops remaining on the film during drying may be removed or minimized by re-soaking the film for an hour or so if the mark is discovered before the film is entirely dry. If the film is dry, soaking in a weak sodium carbonate solution (10%), then washing for an hour or so, may help.

If the non-halation backing is not completely dissolved, and appears as a faint color on the film after washing and drying, the film should be soaked in a weak carbonate solution (10%) for 5 minutes, then rinsed in a stop-bath, and washed for 30 minutes.

For specific descriptions of defects and remedies, refer to Section 18 of the PHOTO-LAB-INDEX, and to authoritative textbooks such as the *Handbook of Photography* by Henney and Dudley (McGraw-Hill, New York).

INDEX

119